ON ARTISTS AND THEIR MAKING

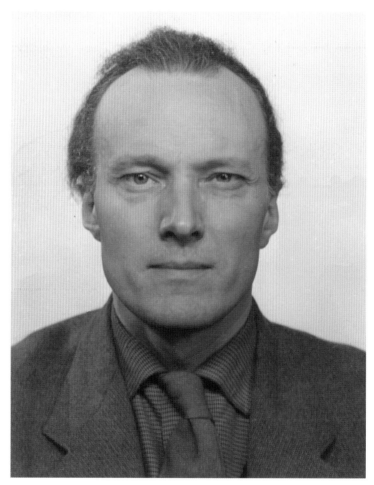

Passport photo circa 1960

ON ARTISTS AND THEIR MAKING

Selected Writings of Maurice de Sausmarez

Compiled and edited by Hilary Diaper
In collaboration with Jane de Sausmarez

Unicorn Press
London

Unicorn Press
66 Charlotte Street
London W1T 4QE

Published by Unicorn Publishing Group
www.unicornpress.org

ISBN 978 1 910065 84 6

Set in Univers LT Std

Design by Nick Newton Design

Printed in Poland by Legra

Front cover: *Self Portrait*, 1966, oil on canvas, 50.8 × 40.7 cm
Back cover: Covers of various editions of *Basic Design*

Contents

Preface

Maurice was an exceptional man. A tremendously talented painter, of course, but his real genius was an uncanny ability to know what a person was good at, even if they themselves hadn't the faintest inkling. It was this nose for ability that set both myself and my wife Deirdre along the paths towards our respective careers.

In spite of her love of art and Deirdre's personal request for advice from her headmistress, she was steered towards commercial exams. And so, straight after leaving school aged 16, she began secretarial work at an architectural firm. Five years later Deirdre applied to the Byam Shaw School of Art, where Maurice was Principal. With her slim portfolio, and the wrong entry exams, Maurice could have laughed her out of the door. Instead, he saw only her determination and potential – and offered her a place at the school on condition that she took the required GCEs at evening class. He gave her a scholarship for the second year. Deirdre went on to study a three-year diploma course at Wimbledon School of Art and is now a fine artist and a carpet designer with her own business.

In my case, it was Maurice who sat me down after my year at Byam Shaw and forced me to think about the future. At that time, I wanted to be a painter. It had never occurred to me that there were other options open to me – but suddenly, there was Maurice telling me that I should be a designer. I hadn't the foggiest idea what a designer was – it was 1966 and I was from a small village in Norfolk. But Maurice seemed to think I would have an aptitude, and enthusiastically suggested furniture or industrial design at the Royal College of Art. I opted for furniture, I thought it sounded interesting and figured, as you do at that age, that having sat in a lot of chairs I could probably design them too!

Luckily, Maurice had a good deal more insight into my passions than I did. Almost 50 years later I have built a global technology company on Maurice's instinct that I would make a good designer. I am but one of many who owe much of their success to his unwavering belief that talent will shine through – if you just open the right doors.

Sir James Dyson

Foreword

Every Friday all the students would pile into the top studio at Byam Shaw and Maurice would give a talk. I was a student there in 1965/66 and these talks, (I don't think of them as lectures, it was as if he was communicating to each of us individually) are still etched on my memory. In one he played some Stravinsky on a gramophone, showed slides of Picasso and the Cubists while speaking very specifically about the time and place of their creation. Through making these connections he made culture come alive. He spoke with passion and a total belief that creativity was an absolute necessity in making the world a better place. As he writes in *The Artist in a Scientific Society*, one of the brilliant essays in this collection: 'Only an acceptance of the work of art as being intimately related to the whole field of human activity of its day can open the way to fruitful work'.

He created an extraordinary atmosphere of seriousness about the making of art and as a by-product, a deep enjoyment in its creation. As is demonstrated in his essays he was involved in any number of educational and theoretical debates of the time, yet to us students he always seemed to be available to discuss our work and our emotional problems. I was sixteen when I went to the Byam Shaw and had my fair share of emotional entanglements and can well remember Maurice, who must have had better things to do, taking the time to advise me and gently get me back on a more even keel.

It's interesting to be reminded in the essay *Diploma Daze*, written in 1963, that Maurice was already railing against the bureaucrats and politicians involved in art education. Although Byam Shaw continued as a small art school, much loved by its students, it was finally swallowed up by Central St Martins and destroyed in 2010. In the previous year students had occupied Byam Shaw to support its autonomy as a college. They had seen the writing on the wall, but by then the management of the school was weak and Byam Shaw celebrated its centenary as an art school by witnessing its own obliteration.

It's not difficult to guess what Maurice would have thought of student fees and of the pen pushers and accountants who run our art schools today. At Byam Shaw, Maurice created a non-hierarchical environment where practicing artists and students could meet and exchange ideas as equals. Increasingly this is being lost in our art schools. Crazily inappropriate modular marking systems have been instigated by clueless number crunchers frightened of the creative atmosphere of a living studio and desperate in their ignorance to turn out art students on a production line as if they were cans of beans. For the tutor, marking student work and ticking boxes supersedes looking and teaching in a non-legislative environment. I'm sure that Maurice would still have believed that our art schools are worth fighting for, even now, with the growing weight of top-heavy management attempting to crush the life out of them.

Maurice ends his essay *The Painter and the Analytical Attitude*: '… one can justifiably speak of the logic of the emotions and the passion of the intellect.' To me this phrase expresses the essence of Maurice's inspirational effect on all who came into contact with him. He believed that artists should be aware of themselves as citizens and understand that art does not happen in a void. He also believed that artists should have a passionate engagement with society, as he did himself and that the artist should always analyse their work in relation to many different disciplines as well as to its own aesthetic form. In this way they would not just be concerned with the history of their own medium. The total emotional engagement that he thought was a necessary prerequisite for making art also needed to be tempered by intellectual rigour. This is how Maurice operated both as a teacher and an artist.

Maurice's paintings and drawings exhibit both a rigour of thinking and a passionate engagement with trying to pin down the structure of the material world. His art, it seems to me, is totally at one with his being in the world. It analyses what we see, it is aware of its historical position post–Cézanne, post-Cubism as well as relishing natural form painted in superb

muted and subtle colours. Like him, it has a lightness of touch, dealing with the weight of the world but in a direct unpretentious manner. I am trying (and failing) to describe his painting and all the time I am also thinking of him and how he was, there is no gap between the two.

In the fifty years I've spent both as an art student and teacher in art schools I've never met anyone with such intellectual curiosity, humanity, humour and deep passion for art. I know how lucky I was to be taught by him at the beginning of my life as an artist and how he deeply influenced my whole understanding of what art could be. He taught me that you can work against the grain of fashion and that thinking must go hand in hand with deep investigation of the materials and processes of making art. He taught me that art history is not a distant thing to be learned by rote and that artists in the past are as much part of one's community as one's contemporaries we are not just lone individuals locked away in studios. These insights, and so much more I learned from Maurice. A great teacher is an inspiration for the rest of one's life.

Peter Kennard

Acknowledgements

A very special debt of gratitude is owed to Sir James Dyson, who has not only written a memorable preface but also given the financial support that has made this publication possible.

Jane de Sausmarez has been continually kind and generous in allowing access to the Maurice de Sausmarez Archive. It has been a great privilege to share it with her, and I am immensely grateful to her for all the ways she has helped. My thanks also to her family, especially Emma de Sausmarez – who has been the mainstay of Team MdeS and contributed so much of her time and energy to research on illustrations as well as keeping the project on track. We are also indebted to Beth Williamson, both for her advice and reading of the first draft and for her introduction to, and editing of, the section on Maurice de Sausmarez and art education. Thanks also to Viv Lawes, for her initial work on the MdeS Archive and her contribution to earlier discussions on the book, and to Lucy Duckworth at Unicorn Press.

There are, of course, many others who have contributed in various ways towards the preparation of this book. Warm thanks go to all of the following: – staff at Leeds University including the Alumni Office, the Brotherton Library, Special Collections, University Archive and the Central Record Office, especially Nick Brewster; staff at the Royal Academy Library, particularly Jennifer Camilleri; Leonard Bartle and his team at the National Art Education Archive at Yorkshire Sculpture Park; Rachel Hickson at the Leeds College of Art Archive and Jane Hartzig, for access to Hornsey College of Art Archive at Middlesex University, and Judy Lindsay for access to Byam Shaw School of Drawing and Painting Archive at Central St.Martin's, UAL. To Diana Armfield, Stuart Berkeley, Peter Green, Wynn Jones, Roland Piché and David Noble, who all shared their memories of Maurice; and to Peter Kennard for his foreword. To those who have provided photographs or given permission for pictures from their private collections to be reproduced – Georgina Blandy, Martin Bloomfield, Rabiya Nagi, Antonia and David Noble, and James Poke.

To all who have given information, practical help, and professional advice – Layla Bloom, Justin Grossman, Margaret and Scotford Lawrence, James Lomax, Helen Loveday, John Schwarzmantel, Rodney Seddon, Michelle Stroobant, Georgina Whiteley, and Thelma Winyard. To the artists who have allowed images of their work to be reproduced – Bridget Riley, Margaret Benyon, Bill Culbert, and Peter Sedgley; to Victoria Gibson, for permission to reproduce the drawing by Peggy Angus, and to the various public collections who have made available images of works by Maurice de Sausmarez.

H.D.

CHRONOLOGY

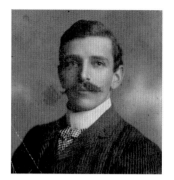

Monty de Sausmarez

Jessie Macdonald née Bamford

Maurice aged 3

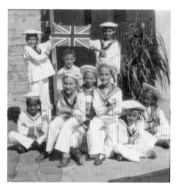

At school concert in Grenada c.1923

1915

Born on 20 October in Sydney, Australia. His parents, Clarence Montgomery de Sausmarez (Monty) and Jessie Rose Macdonald (née Bamford) were British nationals. Jessie (born 1878) was the widow of the explorer G.A.McDonald. She had travelled with him in South America, and after his death in 1904 returned alone to England and worked as a piano teacher, when she met Monty (born 1880). A marine engineer in the Merchant Service, Monty was detailed to work on the de-silting of Sydney Harbour. He proposed to Jessie by letter, and she travelled alone six weeks by boat to Australia to marry him in 1909. Their older son, George, was born in 1910.

1916

Family moves to Grenada in the West Indies.

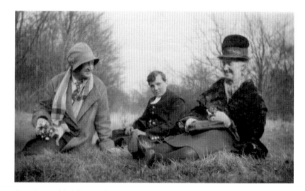

Aged 11 with his mother and aunt

1918

Monty disappears during his daily swim, presumed eaten by a shark. Jessie waits 5 years before returning to England with Maurice in 1923. Maurice attends St James Primary School, Highgate. His brother George is already a pupil at Christ's Hospital.

1926

Educated at Christ's Hospital, Horsham 1926–1932. Confined to bed in the school due to rheumatic fever from April 1927 until the spring of 1928.

1931

Spends vacation studying in Belgium and Holland.

At Christ's Hospital (on the right) with a friend

With his brother George

1932

Student at Willesden School of Art, under Ernest Heber Thompson, 1932–1936. Awarded Board of Education Certificate in Drawing (1934) and Painting (1936).

1935

Completes mural painting (25ft × 3ft 6ins.) with Dudley Holland for Children's Room at Kensal Rise Library, commissioned by Willesden Public Libraries Committee. Exhibits for the first time with the Artists' International Association (AIA).

1936

Student at the Royal College of Art (RCA). Royal Exhibitioner in Painting until 1939. Taught by Barnett Freedman and Percy Horton, lecturers at the RCA and also active members of the AIA. Introduced to Peggy Angus and becomes a regular visitor to her cottage at Furlongs, staying in one of the caravans brought there by Eric Ravilious. Studies Etching and Engraving as a subsidiary subject with Malcolm Osborne and Robert Austin, and awarded RCA Certificate in Etching (1938). Work exhibited with the Association of Students' Sketch Clubs at the Whitechapel Art Gallery, and at Willesden College exhibition (wins Special Prize for Portrait Painting, and the Gilbert Spencer Landscape Prize). Work also exhibited in the English Section of an international exhibition in Amsterdam.

1937

Commissioned by Bromley Little Theatre to design the costumes and sets for the production of James Elroy Flecker's *Hassan* in May, and to paint panels in oil for the Nursery School, Braintcroft. In July and August, travels with his former piano teacher, John Hunt, to assist as page turner for Hunt's concerts in Nuremberg, Halle, Wittenberg, Potsdam and Berlin. Records in his diary the disturbing proliferation of anti-Semitic and pro-Nazi graffiti.

1938

Treasurer of RCA Theatre Group, and organiser and secretary of RCA Students' Group exhibition held at the Imperial Institute Gallery. Spends summer vacation studying in France. Work exhibited for the first time with the New English Art Club (NEAC).

Aged around 18

Maurice (far right) with mother (2nd left) & cousins

With fellow students and friends, 1934

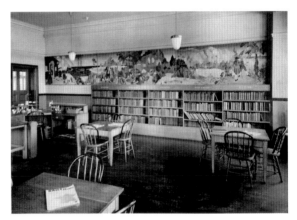

Mural in Children's Room Kensal Rise Library

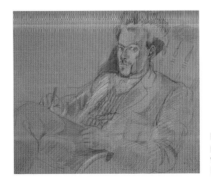

Peggy Angus's portrait of Maurice while drawing Peggy Angus

RCA graduation 1939

1939

Awarded Diploma of Associateship by Royal College of Art (ARCA). Wins RCA Annual Painting Prize, and awarded a Continuation Scholarship which has to be relinquished on account of the war. In November, appointed full-time Art Master at King Edward VII Grammar School, Sheffield. Exhibits with AIA and the Sussex Branch of the National Society of Art Masters.

1940

Marries Kate Elizabeth Lyons in January. Applicant before the Conscientious Objectors' tribunal at Leeds, placed on a Special Register for Non-Combatant Service in either Royal Army Medical Corps or Pay Corps. Exhibits with AIA and NEAC. *Haystack* drawing accepted for the planned (but unpublished) second series of AIA Everyman Prints.

Identity Card 1941

1941

Birth of daughter, Philippa Judith. Fails to pass Armed Services medical examination and continues work as a teacher; called on from time to time by Army Educational Corps as civilian instructor. Carries out fire picket duties by night as well as teaching by day. Resigns from teaching post on account of ill health. Invited by the Central Institute of Art and Design (CIAD) to contribute to an exhibition of *Contemporary British Art* to be shown in New York, and commissioned to undertake drawings of Bedfordshire as part of the Recording Britain Scheme funded by the Pilgrim Trust.

1942

Works part-time at Willesden School of Art until 1945 as teacher in charge of preparing students for Ministry of Education examinations and RCA entrance test. Drawings made for the Recording Britain Scheme included in exhibition at the National Gallery; exhibits with NEAC.

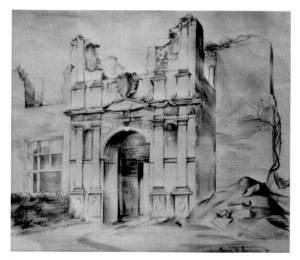

Ruined Renaissance Porch, Elstow, Bedfordshire 1941. One of the drawings made for the Pilgrim Trust Recording Britain Scheme

1943

Buys house in London, which remains thereafter the family home. *The Artist* publishes the first of his series of six articles on *Post-War Mural Decoration*. Work exhibited with AIA, NEAC and London Group.

1944

Works in Thames-side Boys' Club, and invited to become a member of the Advisory Committee for Arts in the National Association of Girls' Clubs and Mixed Clubs (NAGC), 1944–45. Starts working as a free-lance designer and design consultant to Herbert Licht, manufacturer of Lichtex Textiles. Textile designs exhibited at the Cotton Board Centre, Manchester, through the agency of the National Register of Industrial Art Designers, and reproduced in *International Textiles*. Commercial art executed for Clement Dane Studio; auto-lithographic illustrative work commissioned by Chatto & Windus, book illustrations and pictorial programme covers produced for Odhams Press, Ltd. Work exhibited through the agencies of the Council for Encouragement of Music and the Arts (CEMA) and CIAD, and with NEAC and London Group.

1945

Leaves Willesden School of Art to work full-time as Master-in-Charge at Horsham School of Art. *Look this Way*, his introduction to the appreciation of painting written for youth clubs, is published by the NACG. Invited by CIAD to submit designs for exhibition organised in association with the Wallpaper Industry. Member of the AIA Central Committee 1945–46, and works on AIA sub-committees for Exhibition and Selection for *This Extraordinary Year*, held at the Whitechapel Art Gallery in September. Work exhibited at the Leicester Galleries, and with NEAC, AIA and London Group.

1946

Resigns from teaching post at Horsham in August. Takes up several part-time teaching posts in different London art schools, including Goldsmith's College, City and Guilds of London, Camberwell, and London County Council School of Photo-Engraving and Lithography at Bolt Court. Also teaches evening classes in advanced figure composition and history of art at Harrow School of Art. Co-opted a member of the Council of Sussex Association of Youth Clubs,

Cartoon for mural by Maurice
Reproduced in *The Artist*, Vol 26 No 2 Oct 1943, as part of his series of articles on Post War Mural decoration

Lord Wakefield Scout Headquarters, Horsham c.1945 (Maurice 3rd from right)

Stricklands Ltd, watercolour on paper, 46 × 61 cm
Reproduced in *The Saturday Book*, 4, Hutchinson 1944

and runs a youth course. Tutor for the Workers' Educational Association (WEA) Southgate Branch on *Foundations of Contemporary Art*. Elected Painter-member of the Art Workers' Guild. Chairman of the AIA Central Committee, 1946–47 and AIA Special Exhibition *Painters Today* Sub-Committee. His drawing of *Smeaton's Little Bridge at Cardington* is reproduced in the first volume of *Recording Britain*, published by Oxford University Press.

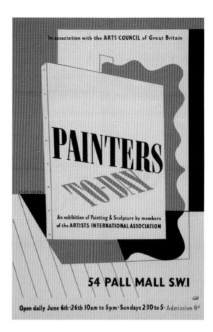

1947

In March, appointed Head of the School of Drawing and Painting at Leeds College of Art. Booklet on *Painting* (written with Roger Manvell) is published by the NAGC; article on *The Pen Drawings of Thomas Hennell* is published in *Alphabet and Image*. Spends summer vacation painting in France. Serves on selection committee for the Objective Realist section of the AIA Members' Exhibition held at its new premises in Lisle Street in September. Work exhibited for the first time at the Royal Academy of Arts (RA) Summer Exhibition. Also exhibits with London Group, NEAC and AIA. Principal Speaker at the Society for Education in Art (SEA) Conference held at Harrogate.

1948

Gives lecture on *Modern Art* at a weekend course held at County Youth Centre, Stafford House, Hassocks. Undertakes illustration work for Odham's *Children's Own Nature Book*. Work exhibited at RA Summer Exhibition. Serves on selection panel for the West Riding Artists' Show at Wakefield City Art Gallery.

1949

Lectures on 'Art and Criticism' at the National Union of Student's Festival at Leeds University in January. Organises and chairs a series of 12 public lectures on *French Painting in the Nineteenth Century* for Leeds College of Art, giving five of the lectures himself. Organises and directs Summer School in Painting for North Riding County Council, at Scarborough. Continues this annually until 1953. In October, applies for post of lecturer in Fine Art at University of Leeds with letters of support from Percy Horton, Gilbert Spencer, and William Coldstream. Appointed with effect from January 1950. Gives lecture 'Artist and Pupil' at Graves Art Gallery Sheffield. First one-man

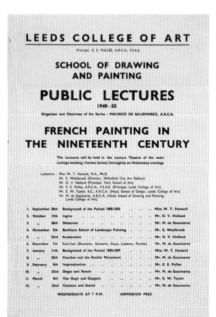

exhibition held in London in November, catalogue introduction written by Percy Horton.

1950

Arranges public lecture programme and exhibitions for the University of Leeds, as well as the University Union Art Society. Prepares course of ten University Extension Lectures at Leeds on visual art in England between 1851 and 1951, to relate to the Festival of Britain and 'designed to lead to further study of fine art'. Gives an address on 'Art and the Community', when opening the *Pictures for Schools* exhibition at Wakefield City Art Gallery; speaks at the CEMA conference on *Art Appreciation in Yorkshire*. Takes part in 'Viewpoint' with the novelist Phyllis Bentley and economic historian Maurice Beresford to discuss 'What's in a View No.3 Jervaulx Abbey Yorkshire', broadcast on June 16 on the BBC Home Service. Contributes essays on Camden Town Painters to *Leeds Arts Calendar* and for the Lefevre Gallery; starts to contribute articles to the *Universities Quarterly*. Continues to direct Summer School in Painting for North Riding County Council, at Scarborough. Chatto and Windus publish F.G. Thomas, *The World and You, Book 1, Part 2, Historic City*, with illustrations by de Sausmarez. Elected Member of NEAC. Work exhibited at RA Summer Exhibition and NEAC. Contemporary Art Society purchases *Kate Reclining* from the RA Summer Exhibition (presented to the Ferens Art Gallery in 1952).

1951

Illustrations published in *Time and Tide* to accompany poems by James Kirkup. Broadcasts a talk on *Art in the North* for BBC Northern Programme. Directs Summer School in Painting for North Riding County Council, at Scarborough. Lectures on art and society at a 2-week course on *Modern Citizenship*, organised by Helen Asquith (H.M. Inspector, Ministry of Education), and held at St.Edmund Hull, Oxford. In October, University of Leeds confers title of *Lecturer and Head of the Department of Fine Art*.

1952

Elected a Member of the Royal Society of British Artists (RBA), and voted member of the Executive Committee of the NEAC until 1957. In May, invited by the Inter-University Council for Higher Education in the Colonies to visit the University College

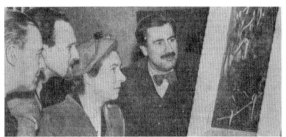

Judging Leeds district artists competition. L to R Ernest Musgrave, Leeds City Art Gallery, Maurice de Sausmarez, Theo Moorman, Arts Council, Edward Pullee, Leeds College of Art

'Beautiful Weeds', one of the illustrations produced by Maurice for the *Countryside Companion*, published by Odhams Press, 1948

of East Africa, Makerere, Uganda (affiliated to University College London in 1949) to advise on the development of the School of Art. Leeds University grants leave of absence from mid-June to the end of July. Afterwards travels in Kenya and Uganda. Returns to teach with Harry Thubron at the residential North Riding Summer School in Scarborough. Makes first of three contributions in recordings of the *51 Society* for the BBC Northern Programme. Works exhibited at RA Summer Exhibition and NEAC.

1953

Makes second of three contributions in recordings of the *51 Society* for the BBC Northern Programme. Teaches with Harry Thubron at the residential North Riding Summer School in Scarborough. Appointed a Governor of Leeds College of Art. Member of selection committee for *Yorkshire Artists' Exhibition* at Leeds City Art Gallery. Work exhibited at RA Summer Exhibition. The Contemporary Art Society selects a work for inclusion in the exhibition *Figures in their Setting* at the Tate Gallery. Wakefield Art Gallery purchases *Apples and Tomatoes*.

1954

Makes third contribution to meeting of the *51 Society* (*Modern Sculpture – is it Art?*) broadcast on the BBC North of England Home Service in January. Lecturer at Anglo-German Conference on Art Teaching. Undertakes illustrations for A.N. Shimmin's book, *The University of Leeds the First Half-Century* (Cambridge University Press, 1954). Gives course of 10 lectures on French Painting at Russell Gallery, Hanley, for University of Oxford Delegacy for Extra-Mural Studies. Assessor of West Riding Art Scholarships. Promoted to Senior Lecturer and Head of the Department of Fine Art.

1955

Guest speaker at meeting of the Leeds Art Collections Fund, Temple Newsam House, and at a weekend course for teachers, at Woolley Hall, near Wakefield. Chief examiner, Leeds University Institute of Education. Assessor of West Riding Art Scholarships. Appointed a Governor of Harrogate School of Art. Visits Harry Thubron on experimental Basic Course at New Earswick and as Chairman of the Advisory Board supports Pullee in the

Parkinson Building, one of the illustrations for Shimmin's book

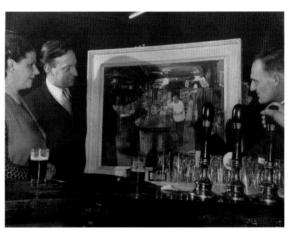

Bar staff at Whitelocks pub, Leeds, with a painting by Maurice

Kate and Philippa while on painting holiday with Maurice abroad c.1955

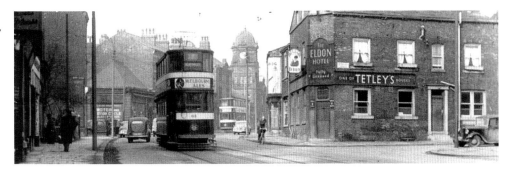

The Eldon pub, Woodhouse Lane, Leeds 1956

appointment of Thubron as Head of the School of Painting at Leeds College of Art. Vacation spent painting in Italy (Rome, Siena, Florence and Venice). Work exhibited at RA Summer Exhibition and at the Ferens, Hull. Leeds City Art Gallery purchases *Winter*. Thubron lives with Maurice and Kate for his first term at Leeds College of Art.

1956

Awarded Degree of MA at University of Leeds and made a member of University Senate. Principal speaker at SEA Conference, and at the North of England Education Conference. Teaches courses on *Looking at Pictures* with Sir Herbert Read, Carel Weight and David Lewis, and *Painting for Amateurs* with Eric Atkinson at Wrea Head College in August. Teaches a course in Bradford for University of Leeds Extra-Mural Studies. Chief examiner, Leeds University Institute of Education; Assessor of West Riding Art Scholarships; External Examiner in Fine Art to University of Edinburgh and Edinburgh College of Art Joint M.A. Work selected by the Contemporary Art Society for inclusion in *The Seasons* exhibition at the Tate Gallery.

Maurice and Kate separate.

1957

Taken ill in March, hospitalized much of the time until July then again in the autumn. Involved with development plans for Leeds University's precinct and Weetwood Farm site. Made a member of University Senate for a further year. Chief examiner, Leeds University Institute of Education and Durham University Institute of Education; Assessor of West Riding Art Scholarships. Guest lecturer at a weekend course held at Missenden Abbey. Guest lecturer at Burslem College of Art, Stoke on Trent in October.

At 12 Lombard Street, Rawdon

With his mother, 1959

1958

In January, the University makes arrangements for his gradual return to work after hospitalization. This includes the use of a room (in Beech Grove Terrace) for a studio. Harold Shelton, Principal of Hornsey College of Art in London, asks de Sausmarez to apply for its post of Head of Fine Art. In November, de Sausmarez confirms his decision to resign from Leeds at the end of the academic session. Serves on the Board of Studies for Leeds University Institute of Education, and as Chief Examiner for Durham University Institute of Education; Assessor of West Riding Art Scholarships. Teaches at Summer School with Harry Thubron, visiting lecturer at Royal College of Art. One of the speakers for 'What Kind of Art Schools?' the second of two programmes considering the future of art education in the light of proposed change by the Ministry of Education, broadcast on the BBC Third Programme in September. The National Art Gallery of New Zealand purchases de Sausmarez's landscape, *Country Lane*, through their London representative E.Heber Thompson.

Hornsey College of Art, Crouch End

1959

Broadcasts *Dissipated Octopuses – On the Teaching of Art to Adolescents* on the BBC Third Programme. Co-organises, with Jon Silkin, an exhibition on *Isaac Rosenberg 1890–1918*, held at the University of Leeds (May–June), and contributes texts to the catalogue.

Gives two illustrated lectures (*The Paradox of 19th century Realism* and *Georges Seurat*) at Leeds City Art Gallery 'in recognition of the friendship and stimulus he has found in Leeds art circles'. The *Leeds Arts Calendar* publishes de Sausmarez's article on Seurat. Guest speaker on 'The Fine Arts as Foundational Training' at a weekend conference on *Fine Art in the Training of the Full Time Student*, held at Harrogate School of Art. Gives opening address at the Federation of Northern Art Societies' Annual Exhibition in Newcastle. Co-tutor with Harry and Diane Thubron at a residential summer course on *Colour-Forms* at Groton Hall, near Colchester in Essex. Runs weekend course with Hubert Dalwood on Modern Sculpture, at Grantley Hall Adult College, Ripon in September. Takes up appointment as Head of the Department of Fine Art at Hornsey. Makes first visit to Bridget Riley's studio.

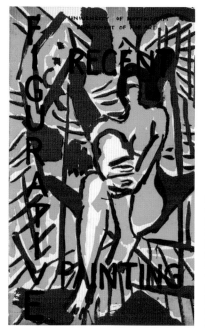

Cover of the catalogue for the exhibition *Recent Figurative Painting* held at the University of Nottingham in 1960, for which Maurice wrote the introduction. Cover designed by Cyril Reason

1960

Broadcasts *Artist and Public* in BBC series *Talks for 6th Forms* in January. Special Lecturer at the Royal College of Art Painting School giving 3 talks on *Topics suggested by the 50th anniversary of the Futurist Manifesto* at the Science Museum. Writes the first of a number of articles published in *Motif*. Teaches at Summer School with Harry Thubron, then on vacation painting in Italy (Rome, Siena, Florence, Venice) with Bridget Riley. Discovers pile of abstract paintings by the young artist John Hoyland in the basement corridor of the Royal Academy, and offers him his first teaching post at Hornsey College of Art.

1961

Special lecturer at the Royal College of Art Painting School, giving 3 talks on *Surface and Structure* at the Science Museum; Chief Examiner, Leeds University Institute of Education. Spends summer holiday painting near Prades, SW France.

1962

Starts work as Principal of the Byam Shaw School of Drawing and Painting in January. At Easter, buys house in the Luberon Valley, France. Takes Byam Shaw students to visit Sir Kenneth Clark's collection at Saltwood Castle in July. Teaches at Summer School with Harry Thubron, and at Westonbirt Summer School during August. Takes part in *I am going to work in a creative job*, a careers programme produced by Associated Television Limited on 9 October. Continues to write for *Motif*, and writes an introduction to the catalogue for Bridget Riley's first exhibition.

1963

Marries Jane Boswell. Their daughter Emma Louise born the same year. Guest speaker at the *Conference for Art and Craft Lecturers in Training Colleges*, organised by Manchester University School of Education. Chief Examiner for Leeds University Institute of Education. Invited by Lancaster and Morecambe College of Art and Crafts to join an advisory body concerned with future courses for the Diploma in Art and Design. Attends meetings of Joint Matriculation Board to review GCE advanced syllabuses in art; advises at Nottingham University on setting up a joint BA course. Invited to organize a winter school by Bernard Bertschinger, Director of the

Exterior view of the newly built Byam Shaw and Vicat Cole School of Art, 1910

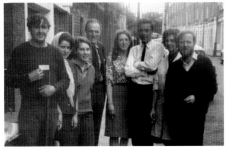

With Byam Shaw students

With friend John O'Reagan in the Camargue, 1962

Croagnes, in the Luberon valley, France

Art Foundation. *Drawing with the Figure* takes place at Byam Shaw School, with Harry Thubron, Hubert Dalwood and Terry Frost. His article, *Diploma Daze*, is published in the *Guardian*. Writes on Ben Nicholson's drawings for *The Connoisseur*. His mother Jessie dies in December at the age of 85.

1964

Elected an Associate of the Royal Academy in May. The first performance of Leighton's *Seven Variations for String Quartet Opus 43*, commissioned by de Sausmarez in memory of his mother, is held in the main gallery at Byam Shaw at the close of the students' exhibition. Takes Byam Shaw students on a trip to Vicenza with John Allit in August. Teaches tutorial classes on the history of art at Brookmans Park and Friern Barnett, as part of the University of London's Extra-Mural Studies programme in association with the WEA. Visiting lecturer at Royal College of Art, and Harrow School of Art. Succeeds Sir Herbert Read as President of the Society for Education through Art. *Basic Design The Dynamics of Visual Form* is published by Studio Vista, who from then on consult de Sausmarez regularly for author recommendations and as reader.

1965

Birth of son, Simon Benedict. Turns down invitation to succeed Percy Horton as Ruskin Master at Oxford. External Examiner for Leeds University Institute of Education (Bretton Hall) and for Cambridge University Institute of Continuing Education. Records a talk on Cézanne for the BBC series, *Talks for Sixth Forms*. Teaches tutorial classes on art and art theory for London University/WEA Extra-Mural Studies programme. Serves on selection committees for *Pictures for Schools* and the *Café Royal Centenary Exhibition*. RA purchases *Towards Roussillon*.

1966

Takes Byam Shaw students for a 3-week summer school at Le Château des Clos at Bonnelles, Haute Vallée de Chevreuse (south of Paris). Mornings spent painting in the countryside, followed by afternoon visits to museums and galleries in Paris. Teaches tutorial classes on history of art for London University/WEA Extra-Mural Studies programme. Gives talks to Hatfield Art Society; Oxford Art Society, Dartington College, Harlow Arts Festival, Epsom and

With Jane

With Simon Willis & Jane, Croagnes, 1963

Byam Shaw student trip to Vicenza

Working on the house in Croagnes, c.1963

Ewell School of Art. Serves on selection panel of *Northern Painters* exhibition at the Laing Art Gallery, Newcastle.

1967

Guest speaker at the *Annual Conference of Art and Craft Lecturers from Scottish Colleges of Education*, held at Callender Park College of Education. Adviser to Nottingham University Department of Fine Art and external assessor at Leeds College of Art. Joins GLC Arts Sub-Committee, and participates in the Schools' Council 3rd International Curriculum Conference. Teaches tutorial classes on the history of art for London University/WEA Extra-Mural Studies programme at Friern Barnet. Member of Hanging Committee for RA Summer Exhibition. Turns down invitation from Studio Vista to write a documented historical survey of Op Art due to lack of time. Commissioned by publishers Marshall Cavendish Ltd., to write the entries on *Landscape and Marine Painting* and *How to Visit an Art Gallery* for *Mind Alive* (an encyclopædic work of reference). Work exhibited at RA Summer Exhibition, and Upper Grosvenor Galleries.

1968

Birth of second son, Daniel Maurice. Studio Vista commissions book on Bridget Riley. Cassell & Co. commission study of Poussin's *Orpheus and Eurydice* for the Painters on Painting Series. Invited to edit Studio International Special Volume on Ben Nicholson. Member of Hanging Committee for RA Summer Exhibition. Arranges, in association with the British Council, a 3-week course at Byam Shaw for a group of students from the University of Alberta. Leads a second summer course at Bonnelles. Examiner at the Royal College of Art School of Painting and for B.Ed. courses at Liverpool and Newcastle universities and Goldsmiths' College (University of London). Resigns from Schools' Council chairmanship; continues involvement with GLC Arts Sub-Committee. Accepts invitation to become a member of National Council for Diplomas in Art and Design (NCDAD). Chairs the Working Committee of Space Provision Artistic Cultural and Educational (SPACE) and the Arts Information Registry (AIR), founded that year by Bridget Riley, Peter Sedgley, de Sausmarez and others to improve artists' working conditions and provide studio space, and to enable the independent

Le Château des Clos, Bonnelles

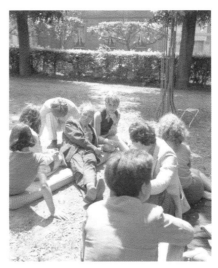

With Simon Willis and Byam Shaw students, Paris, July 1968

Writing outside, Croagnes

organisation of exhibitions and presentations of art. Gives after dinner speech for RIBA Annual Dinner.

1969

Publication of *Poussin: Orpheus and Eurydice* and *Ben Nicholson*. Adviser for Nottingham College of Art and Design and visiting external examiner for Trinity & All Saints' College, Leeds. Gives talk on *Innovation and Continuity in Art Education* for Department of Education and Science at Dartington Hall. Completes book on Bridget Riley in August. Taken ill in France, dies in London Heart Hospital on 28 October. Friends and admirers launch an appeal for funds to set up The Maurice de Sausmarez Family Trust. Chaired by Carel Weight, it aims to offer some support to de Sausmarez's family until the youngest child reaches school age. A Thanksgiving for the life of Maurice de Sausmarez is held at St Paul's Church, Covent Garden WC2 on Monday December 15.

1970

Works exhibited posthumously at the RA Summer Exhibition and at the NEAC 123rd Exhibition. Publication of book on Bridget Riley.

1971

Homage to Maurice de Sausmarez exhibition held at Upper Grosvenor Galleries.

With (L to R) Benedict, Daniel & Emma

INTRODUCTION

Maurice de Sausmarez once described himself as 'one of those sports or freaks amongst painters, one who enjoys using words'.[1] He was not the first, nor will he be the last of that mutant species. But often, in horticultural terms, the sport turns out to be a lot more interesting than the rest of the bunch, and this is the case with de Sausmarez. He was gifted in the creative arts and believed unswervingly in the vital role they played in every civilized society, and he fought to protect the values of individual creativity and expression, particularly against the corroding effects of institutionalized art education. The interconnectedness of his perceptual and intellectual capacities – fluently and often wittily articulated – made him a powerful advocate for artists and their making, and an influential voice in the campaign for the reform of art education after the Second World War.

Gifted in both art and music, particularly piano and organ, de Sausmarez chose to study art at Willesden School of Art (1932–36) and at the Royal College of Art (1936–39). His training was rigorous and disciplined, and included the study of the human figure, still life painting and composition. At the Royal College, life classes were held four afternoons a week and de Sausmarez also studied printmaking as a subsidiary subject. The outbreak of war curtailed all thought of post-graduate study, although he had been awarded a continuation scholarship.

After a period of teaching at a boys' grammar school in Sheffield, de Sausmarez returned to Willesden School of Art to teach and was appalled at the 'textbook strangulation' of his students. 'Clearly, in such cases, education had not been an organic development but a superficial plastering, imprisoning the individual, and likely to lead either to a gradual crumbling so that eventually there is scarcely a trace of cultural influence, or to a rigid wall behind which the spirit rots in frustration'.[2] This led to the development of an experimental programme aimed at helping his young students release their individual voices. He had shown skills in theatre design while still a student, producing settings and costumes for the Bromley Little Theatre's production of *Hassan*, and his understanding of music often led to analogies with painting. His experimental programme at Willesden integrated art, mime, music, and dance, attracting the attention of the *Times Educational Supplement*, who asked him to write about it.[3] It was the beginning of his life-long interest in teaching art to adolescents and young adults.

Fig 1 Releasing the individual – experimental teaching at Willesden School of Art 1944

In an interview made for the British Library's Oral History collections, the artist Bernard Gay gives a vivid description of de Sausmarez in action at Willesden:

'He was the sort of teacher who would come in and say, "Oh how are you getting on?" and when you said, "Fine," he'd turn around and go out again and say, "That's good". But he was a different kind of teacher. I mean I remember him for example giving a talk on drawing, and it was marvellous … he talked about Old Master drawings and illustrated his talk … then in the middle of the talk he would talk about things like line, form, interval, shape and so on, colour, and then he would go over to the piano, he would dash off a Bach toccata and a fugue you see, and say, "You know, the same principles which underlie great drawing, underlie music as well; that's all about form and line and so on," … And then he would say, "By the way, there's an absolutely marvellous exhibition on at so-and-so, you ought to go and see that. Go to the British Museum and have a look at these drawings." And then he'd say, "And incidentally, of course the Proms are on, you ought to go to some of those, and there's a wonderful Bach concert on tomorrow night", … and all the kids would go dashing off … he was that kind of teacher, the kind of man who opened your mind to all kinds of possibilities … not a hands-on teacher … but he was a wonderful inspiring teacher in that he opened your eyes and your mind to all kinds of relationships and possibilities and excitements and so on that you otherwise might not have discovered, you know, you wouldn't have discovered them for yourself. So he was a fine teacher I think'.[4]

From the outset of his teaching career, de Sausmarez wanted to gain a wide experience of art education in all its aspects. He taught at a number of London art schools and with various youth groups before moving to Leeds in 1947, where he was Head of the School of Drawing and Painting at Leeds College of Art. He had been successful at Willesden in preparing students for higher examinations in painting, some of them gaining entrance to the Royal College of Art, the Slade School, and the Academy Schools, and he continued this at Leeds. In 1950, however, he turned his attention to a different kind of challenge when he started work as a lecturer in Fine Art at the University of Leeds. Here he was presented with the problems of devising courses and planning the future of a newly instituted department of Fine Art. In a letter to his mother he wrote:

'Of course I am tremendously excited about prospects at the University but it will have to be a very gradual development. At present there is *absolutely nothing at all* except a rather moribund Art Society – it is very strange being appointed to a department which does not exist to develop the powers of students who do not exist with equipment that does not exist and no one seems to have the remotest idea what sort of thing they want to make of it all. With tact I should be able to shape the whole thing to my design but even I am not quite sure what sort of shape a department of Fine Art within a University should take'.[5]

At that time, very few Universities taught fine art as an academic subject. Even fewer – Reading, Durham, Edinburgh, – had established Honours Schools of Fine Art, or any element of practice in the curriculum. Leeds University had in mind the promotion of an interest in Fine Art in the student body generally, as well as making it available as part of a general Bachelor of Arts Degree on the 'pure' side, and for the existing degree course in textile design on the 'applied' side. The staff list for the department consisted of de Sausmarez, the newly-created Gregory Fellows in Sculpture and Painting (Reg Butler and Martin Froy), and the Director of Leeds City Art Gallery, Ernest Musgrave as Honorary Adviser on Art Treasures. De Sausmarez set about collaborative work with the Gregory Fellows, arranging series of public lectures and exhibitions of pictures in various parts of the University as well as drawing up and arranging the necessary courses and delivering most of the teaching himself. After two years there was an additional part-time visiting lecturer in the History of Art, Arnold Hauser, working concurrently on volume two of his *Social History of Art* and another book, *Philosophy of Art History*. There was no studio practice in the teaching curriculum, although de Sausmarez had the use of

a room in the University as a studio and encouraged any student who was interested to learn something about the practical sides of the subject. He also directed residential summer schools in painting for North Riding County Council, gave lectures on art to various groups and societies, and became increasingly involved with the Society for Education through Art and the work of the University's Institute of Education.

However successful his work was in Leeds, de Sausmarez was frustrated by the rising flood of administrative responsibilities, and longed to be back in direct contact with painting – both for himself and in the instruction of students. So when Harold Shelton, the Principal at Hornsey College of Art, wrote and asked de Sausmarez if he would take on setting up a department of Fine Art there, he moved back to London in 1959.

At the same time, art education in Britain was becoming more formalized, bound by bureaucratic regulations and standards, and de Sausmarez was disturbed by what he considered the reduction of opportunities for talented young people who failed to fit an artificially imposed standard. He argued vehemently that creative potential could not, and should not, be equated with academic achievement, and in 1961 he successfully applied for the post of Principal at the Byam Shaw School and started work there in January 1962. The Byam Shaw was a small, successful independent school and allowed de Sausmarez the freedom to take on promising students who failed to meet the entrance requirements of the art schools recognized by the local education authorities. By the time of de Sausmarez's death seven years later, the number of students had risen from 60 to over 200, and funding bodies had been forced to accept that the standards set at the School warranted financial support for its students: over 90% received LEA grants.

At the same time, de Sausmarez continued his extra-mural teaching, his public lectures and radio broadcasts, conference speeches, and external examining. In 1964 he succeeded Sir Herbert Read as the President of the Society for Education through Art. As he gained increasing recognition as a public figure in art education, so he was invited onto more committees and governing bodies, including the GLC Arts Sub-Committee and the National Council for Diplomas in Art and Design.

De Sausmarez enjoyed using words. He spread them through his teaching, and through his writing, which from the late 1930s onwards appeared regularly in specialist journals as well as general periodicals and newspapers. Central to his writings about art and education were several passions: to dispel misconceptions about the nature of art and refine its definition; to advocate a continuous progression in art education from childhood through adolescence that encouraged individual creativity rather than mere conformity to rules or fashions, and finally, to retrieve appreciation of art's role at the centre of civilized life.

In the letter already quoted at the beginning of this introduction, de Sausmarez continued: 'but really I am a practising professional painter and needed to have my hands in the viscous stuff, hence my translation to London as Principal of a school of practice'. He had started exhibiting his own work in the 1930s, initially with student groups and then with the Artists' International Association, the New English Art Club, and the London Group. The Royal Academy accepted his work for the first time in 1947. During his time in Yorkshire, he continued to exhibit with these organizations in London as well as with artists' groups in Yorkshire. He had his first one-man exhibition in London in 1949 and a second in Wakefield in 1951 – the same year that the Contemporary Art Society bought one of his paintings from the Royal Academy Summer Exhibition, and he was made a Member of the Society of British Artists. Nevertheless, after this initial flush of success he began to feel he was losing touch with 'the viscous stuff' and the London art scene proved a more powerful magnet than the one in Leeds. He had been in the thick of it in the 1930s and 40s: a member of the circle of Peggy Angus, Jim Richards, Barnett Freedman and Percy Horton; Secretary of the RCA Students' Group and a Member of the Students' Commission for the First British Artists Congress, and active in the Artists' International Association, serving on its exhibition sub-committees and as Chairman of its Central Committee. He had thrived in the wartime atmosphere of joint councils, the bringing together of artist and designer associations – particularly for those who did not find employment in camouflage or official propaganda. And in the spirit of post-war reconstruction, through the work of organizations such as the Society for Education through Art,

the Artists' International Association, the Central Institute of Art and Design and the Council for the Encouragement of Music and the Arts, art had been promoted as a fundamental part of education – for life, rather than simply for career – through travelling exhibitions, lithographic prints cheap enough for everyone, art in canteens and restaurants, murals for schools, libraries and hospitals, art on blitzed sites. De Sausmarez had fallen in with this campaigning spirit, and it had moulded his beliefs. In the 1930s he had been involved in mural projects, and in the 1940s he wrote a series of articles for the *Artist* magazine giving technical advice on mural decoration; he spoke up for the rights of the artist, joined the guild of artist-workers, the band of brothers. He had played his part in the University academic world, but it wasn't the world for him.

Back in London, he plunged back into the company of artist-teachers and practitioners. His enthusiasm for painting found new fuel in the work of a younger generation of artists, who looked to him for informed dialogue and sponsorship, which he gave unreservedly where he felt it was deserved. And he continued his lifelong commitment to opening up the world of art to the young, the general public of all generations, through speaking, writing and spreading more words. The same letter again: 'since being permanently in London I have completed a book for Studio Vista [*Basic Design*], many articles for the fitful quarterly *Motif* and *The Connoisseur*, and two or three broadcast scripts, and a few other published pieces. I have all sorts of projects buzzing about in my bonnet and only wished I had a situation that promised possibilities of a sabbatical period occasionally – but alas I find it hard to de-buzz, time-wise. You ask what other areas of special interest I have – all aspects of the graphic arts (drawing, etching, lithography etc), the education of the artist and the growth of academies, my special periods in the art of painting are Seventeenth, Nineteenth and Twentieth Centuries, a particular interest in Cubism and Futurism, the development of Portrait Painting and Still-Life Painting and Mural Painting.'

Sadly, at the time of writing that letter he had only two more years to live. But in that short space he completed studies on Poussin, Ben Nicholson and Bridget Riley. And having been elected an Associate of the Royal Academy in 1964, he served on its Hanging Committee for the Summer Exhibitions in 1967 and 1968. He supported the Academy Summer Exhibition as one of very few favourable exhibiting opportunities available to younger artists, and actively encouraged them to submit their work. It is tempting, but futile, to wonder what else de Sausmarez might have achieved had he lived longer. Far better to consider his true legacy and let him speak again now in his own words. Three aspects of his extensive writings are represented here: first, the crucial role of the creative arts in any civilized society; second, how they are to be defined and understood, and third, how to prevent the erosion of the individual creative impulse by institutional regulators. We need only to think of some of Sir Ken Robinson's recent observations that people are 'educated *out* of their creativity' to realize that de Sausmarez's thinking has as much resonance today as it did half a century ago. And with the current growth of publications that re-examine influential mid-twentieth century British artists and educators, it is time that Maurice de Sausmarez took his rightful place among them.

H.D.

1 THE NATURE AND VALUES OF ART

In the decade following the Second World War de Sausmarez engaged vigorously in the widespread debates surrounding the regeneration of post-war Britain. Driven by an unshakeable belief in the formative role played by the creative arts in any civilized society, he deplored the dominance of materialistic concerns, the preoccupation with technological and scientific advance, and the consequent erosion and deadening of sensibilities. He argued for a redress of balance, urging the unity of all fields of enquiry and the interconnectedness of art and science in the life of human spirit.

The first of the texts reproduced here was printed in *The Universities Quarterly*, which was established in 1946 as an organ for the free discussion of ideas and proposals to address the urgent debates then surrounding the philosophy of university education in Britain. Its editorial board was chaired by the British industrialist, politician and public servant, Sir Ernest Simon. Intended for all engaged in public life – teachers at all levels of education, civil servants and local government – it provided a forum for discussion on how teaching and research could meet the demands of a changing society. The article by de Sausmarez was written some eight months after he had taken up the invitation from the University of Leeds to establish its own department of Fine Art.

In the context of the universities, the increasing specialization of knowledge during the previous century had engendered the professionalization of study in every discipline. Its impact in the field of fine art shifted focus towards a fostering of *formal analysis*, which tended not only to marginalise the social and moral concerns of an earlier generation, but also to heat up the debate as to who was best equipped to teach Fine Art: the professional artist or the *amateur* – the critic. It could be said that de Sausmarez had a professional foot in both camps – he was a well-educated and informed lover of the arts, but in his view it was his status as a trained practitioner that gave him not only the authority to speak, but also to claim an equal status for artist and scientist.

De Sausmarez expounded his passionate belief in the value of the creative impulse and the imperative of supporting it through education with eloquence, good humour and a winning enthusiasm. As a consequence, he was in constant demand as a principal speaker in conferences of art educators and education reformers throughout the 1950s and 1960s, both regionally and nationally. 'The Painter and the Analytical Attitude' was delivered at a conference organized by the Institute of Education at Leeds University and afterwards published in *Researches and Studies*, a periodical published twice yearly by the Institute with the aim of stimulating and contributing towards general educational interests, particularly in the region it served.

De Sausmarez once commented:

> the thesis that the arts today have their true importance in 'education for leisure' is wholly contrary to my conception of the arts. They are not the tinsel decorations on the top but rays of light which strike upwards from the foundations of a civilization illuminating every stage and aspect of its life and growth. So it should be in terms of the individual. It is in this very fact, of the existence in all ages of an irrepressible surge of creativeness and aspiration, that the future is as full of hope as it is of danger.[6]

It was on the basis of such a conception that he refused to limit his forum to the academic world, but reached out to the wider public. 'How to visit an Art Gallery' was commissioned in 1967 from Marshall Cavendish for a popular encyclopædia of knowledge, *Mind Alive*. Having received his piece on landscape and marine painting for the art section, the editorial team asked de Sausmarez for a further text, to be included in the encyclopædia's complementary section that discussed the subject of visiting an art gallery for the general reader. The publishers' brief offered a number of guidelines, such as suggesting 'for stimulus and excitement go to Turner or Rembrandt', or encouraging readers to search for the 'interaction of influences among artists' so that

they might 'gain some feeling of the continuity and progress of painting'. De Sausmarez did none of this – telling evidence of his belief that education should foster the individual spark rather than feed pre-judged qualities.

In 1959, de Sausmarez was invited to take part in *Talks for Sixth Forms*, a series of broadcasts provided by the BBC for the School Broadcasting Council in the United Kingdom. 'The Artist and Public Today' was his introduction for the pamphlet to accompany the series on *Modern Art*, and 'Artist and Public' was his script for the first talk, broadcast on the BBC Home Service on 22 January 1960. Four further weekly broadcasts followed, given by Carel Weight, Ceri Richards, Reg Butler and Denys Lasdun.

In his closing comments in 'Artist and Public' de Sausmarez emphasized the role that the creative arts play in shaping our environment for living and working. He returns to the subject in the last of the texts in this section – another piece for the *Universities Quarterly* – but its message, and its warning, remain more widely applicable.

<div align="right">H.D.</div>

1.1 *The Artist in a Scientific Society* (1950)

Published in *The Universities Quarterly*, Vol.4, No.4, August 1950, pp.360–66.

Eighty years ago in the Hilary term John Ruskin delivered at Oxford his *Inaugural Lecture* as Slade Professor.[7]

Fine Art had entered the English universities, still deeply conscious of their humanistic traditions. Ruskin was not only impressed by the special significance of Fine Art being included 'among the elements of education appointed in this great University'. He was anxious about the possible consequences of the introduction of this branch of study, which was 'not only new, but such as to involve in its possible results some modification of the rest'. He need not have worried. Until comparatively recently, with few exceptions, Fine Art received little attention in our universities. It was left to continental and American universities to develop the subject.

In the intervening years the universities have themselves undergone a rapid change and are now, as we know, predominantly scientific and technological. Has this change made Fine Art's claim to recognition any less valid? Ruskin might now alter slightly the wording of one of his 'fondest dreams', that he might succeed in making some of the English youths 'like better to look at a bird than to shoot it'. The essential aim would remain unaltered.

Intelligence and sensibility

There is good reason to believe that the influence of painters, sculptors, poets and musicians is more than ever necessary in a society that is mainly scientific. Is it not possible that an exclusive concentration on problems of technology and scientific research, though it may quicken the intelligence, may deaden the sensibilities? Darwin's pathetic admission in his autobiography is a salutary one. He writes: 'I have also said that formerly pictures gave me considerable, and music very great, delight. But now for many years I cannot endure to read a line of poetry … I have also almost lost my taste for pictures or music … My mind seems to have become a kind of machine for grinding general laws out of large collections of facts, but why this should have caused the atrophy of that part of the brain alone, on which the higher tastes depend, I cannot conceive … The loss of these tastes is a loss of happiness, and may possibly be injurious to the intellect, and more probably to the moral character, by enfeebling the emotional part of our nature'.[8]

The artist can make the greatest contribution to this society by maintaining the essential differences between the processes of art and science yet realising their relatedness in the unity that is the life of the spirit. What could be more healthy for a student of science than to learn of a field of serious work where the word 'progress' is almost without meaning? The Paleolithic cave paintings are as vital and as full of sensibility as the decorations in the Sistine Chapel or anything produced by the School of Paris this century.

The idea of progress is so rooted in contemporary thought that we find it hard to accept seriously an activity that claims at once to get nowhere and everywhere. As Whistler said 'art is limited to the infinite, and beginning there cannot progress'[9]; which is simply another way of expressing Schopenhauer's 'so ist dagegen die Kunst überall am Ziel. Denn sie reizt das Objekt ihrer Kontemplation heraus aus dem Strome des Weltlaufes und hat es isolirt vor sich'.[10] Even Italian Renaissance art is capable of

interpretation as progress only by mistaking content for form. A Duccio is often more beautiful and more moving than a Raphael.

The arts and the idea of progress

It is significant that when a scientist writes about art (e.g., Professor C.H. Waddington – *The Scientific Attitude*) he should applaud the contemporary artists who are 'busy liquidating the outworn traditions'.[11] But the most 'progressive' artists have never made such claims. On the contrary, Picasso has fed continuously on the past and has referred to himself as 'the Don Juan of Art', Moore has paid tribute to the influence of Masaccio, Giotto, Blake and Mexican carving in his development, and both Sutherland and Piper have felt the inspiration of Samuel Palmer and the earlier Romantics. Sickert has replied for all serious artists in writing that 'the error of the critical quidnunc is to suppose that the older things are superseded. They are not superseded. They have been added to. That is all'.[12]

Sir Kenneth Clark has rightly said 'Facts become art through Love, which unifies them and lifts them to a higher plane of reality'.[13] This is the essence of the creative process. What is more, the fact and its aesthetic form are indivisible. If we attempt to separate them, we are left with something which might have value for the scientist since 'the fact' remains, but which certainly is without value for the artist. Beauty is intimately related to integrity and the process of integration. A work of art must be grasped in its totality; it is perceived by sensitive emotional awareness, by the intuitive non-rational self. Today it is too often assumed that the artist's work should demonstrate some valid proposition, that its content should be as rationally analysable as the work of the scientist. True, both scientist and artist are concerned with an object, but whereas the scientist is concerned with things as agents producing effects, the artist is concerned with things for their own sakes. This distinction is fundamental and when Professor Waddington, writing of 'scientific habits of thought' includes among others 'the lack of interest in things for their own sakes' he is stating that which separates most completely the two fields of work.[14]

The artist is not committed to an inexorable rule of logic imposed from without on the matter in hand; he has to discover afresh in each work the logic peculiar to it. Only to a limited extent does the completion of a work provide him with a general hypothesis applicable to future problems. The painter each time is confronted with the white canvas, the sculptor with his block of stone, and from the first stroke of the brush or mallet there is a search for relationships satisfactory in terms of the evocative occasion and the nature of the medium. His making is exclusively ordered to the good of the individual work. The problem during the process of making is always 'how can this thing be made perfectly as a thing expressive in itself and in conformity with its own nature?' Even when the artist lends his skill to some other field his aim is unaltered and only venal susceptibility will cause him to renounce it. Functionalism is not incompatible with this aim.

Creative imagination and the sciences

There is a danger that the artist in stressing the differences may be missing the aesthetic content of science and the scientist's work. Few artists will have failed to be excited by the beauties of scientific apparatus, and there can be little doubt that the scientist in building it experiences something akin to the sculptor's delight in formal relationships. There is, in the conclusion of his work, a process of integrating the results of analysis that clearly relates to the aesthetic satisfaction of 'making'. As George Sarton puts it […] 'it is true that most men of letters and, I am sorry to add, not a few scientists, know science only by its material achievements, but ignore its spirit and see neither its internal beauty nor the beauty it extracts continually from the bosom of nature … A true humanist must know the life of science as he knows the life of art and the life of religion'.[15]

The propositions of science have in the past provided the artist with a springboard for his aesthetic impulse. The Italian Renaissance is full of examples, the Neo-Impressionist Seurat is a more recent case and there will undoubtedly be many others in the future. But it will be found that the 'scientific' element is relatively superficial; the artist has been moved more by the inherent beauty than by the validity of the thought. His aim has been always to further some primary aesthetic impulse, not to demonstrate some law.

The limits of analysis

Analysis is essential in a critic's work but even here there are dangers in overestimating the scope of scientific method. We may become so interested

in classification, so concerned with trends rather than with individuals, with technical problems, with attributions and comparisons that we miss the central creative power, the aesthetic communication. Tags such as Impressionism, Cubism, Classicism and Romanticism can obscure the all-important fact that the history of art is the history of created things, and our approach to the individually created object should, in the first instance, be direct and unprejudiced. Rossetti writes in one of his letters, quoted with approbation by John Piper in his *British Romantic Artists*, 'Many men spoil their enjoyment of Art by looking on it as something to pull to pieces, rather than something to enjoy and lead them to enjoy nature, and through nature to enjoy God. How wretched is that feverish, satiated, complaining spirit of criticism. Never contented, never at rest. Is this better than that, these than those? Is this a great man, and if great, *how* great? All the while avoiding *The Thing* and its relish; not thinking art, but about art; not conversing with nature, but with names'.[16]

Because the work of art is born of a constructive intellectual activity wedded to an aesthetic emotional activity there are factors that can be analysed. Such analysis is of value but in our craving to 'know' we may often be in danger of suffocating the intuitive and instinctive responses. The artist today struggles hard to keep these vital instinctive responses alive and alert. The intuitive faculty alone relates us vitally in direct awareness to the world of substance. It brings us back from the world of abstraction, analysis and dissection to the world of sensuality and projects us as far again into non-rational mystical realms.

Analysis and an interest in causal systems give us certain forms of knowledge but there are spheres of human experience that cannot be represented or interpreted by these rational processes. It is precisely in these fields that the power of the imagination allows the artist to create forms that symbolise experiences or qualities. The transitory and elusive can thus be given monumental significance.

The universities and the concern for values

This then, in a general sense, is Fine Art's primary value in the life of predominantly scientific universities – through exhibitions of fine work to educate and nurture the sensibilities, to show the life of the imagination embodied in the works of creative genius and to act as a constant reminder of that intuitive non-rational side of our natures which we neglect at our peril.

But what can it do in its own specialised field? The completely subjective view outlined above while it intensifies personal reactions is dangerously limited for more concentrated study. Only an acceptance of the work of art as being intimately related to the whole field of human activity of its day can open the way to fruitful work.

Some universities play a vital part in the field of direct creative work by providing facilities for the practical study of painting and sculpture. The emphasis elsewhere has been placed, and rightly so, on art's relationship with industry and commerce and the demands of the teaching profession. University establishments like the Slade School of Fine Art are almost unique today in concerning themselves primarily with the education of sculptors and painters. Because of this specialisation an unusually high standard is possible. In a university the young artist is offered a contemporary equivalent of Renaissance society where scholars, poets, mathematicians, scientists, philosophers and artists met together in day-to-day exchange of opinions. How vital this intercourse is has been established more recently still by the School of Paris. The confluence of the genius of painters – Picasso and Braque; poets, Max Jacob and Jean Cocteau; musicians, Stravinsky and Milhaud; architects, le Corbusier and Lurçat; and the mathematically inclined Princet and Apollinaire – provided the tinder for the blaze of creativeness that characterised the earlier part of this century. A university is one of the only establishments today in which concourse of this kind is possible.

The universities have a concern for 'values'. By encouraging the study of the Fine Arts of Painting and Sculpture they help to preserve the disinterested search for aesthetic value. This in spite of the scorn poured on it by pre-war functionalists, is a necessary school of humanity.

A university also provides the right environment for the study of the History of Art. This is a subject in its own right but it is hardly necessary to mention how much of our knowledge in the wider field of history is derived from pictorial records and artefacts. A knowledge of the artist's contribution is essential in any study of civilisation. The subject is closely related to anthropology; the literature of all countries is rich in allusions to the Plastic Arts.

The study of the relationship between works of art and the circumstances which determined their character and the attempt to relate them to the wider field of human effort; problems of iconography, of the changes in vision to be discovered in the analysis of composition and attempts to reconstruct the intellectual and emotional states which gave rise to works of art; the relationship of the artist to society and the Plastic Arts to the other arts, the bearing of media and materials on the form of the work – all these and many other questions arise.

The proper study of the History of Art requires not only a study of the philosophy of art, which in turn demands a wider training in philosophy, it requires a practical knowledge of materials and processes, a training in art. It is one of the gravest mistakes to assume that the study of the History of Art can be meaningfully pursued without this understanding of the deeper secrets of practice. R. G. Collingwood writes: 'No event in the so-called history of art can be explained by reference to the principles of art itself … To explain the history of painting we must begin by asking what people have painted with, and upon what they have painted, and why' – And again, 'the student must learn to draw and compose. Without this artistic training the philosophy of art must perish from lack of matter; the philosopher is trying to reflect without having anything to reflect upon … The notion that it can be mended by psychological observation of other people's experiences is a childish blunder'.[17] Hazlitt, Fromentin, Ruskin, Roger Fry and others might be regarded as amateurs and primarily men of letters with a sensitivity to works of art by the new school of 'scientific' art-historians. But the fact that each one of these men had struggled with problems of creative work, had approached art essentially from the inside, gives to their work and judgments authority and a sympathetic understanding of the deeper issues. They at least made the effort to relate themselves to the central bloodstream of art and appreciated the work of art as a living organism, not as a corpse ready for a post-mortem.

Whatever is done in the future it is to be hoped that, in this subject particularly, no attempt will be made to sever theory from practice. Studio and workshop should stand side by side with lecture room, library and laboratory. Art needs to be 'understood' and studied in its totality. It does not contradict science, it supplements it.

The work of the creative artist should be inextricably woven into the fabric of any society deserving the name civilisation. A concern for a living art should be as fundamental to a university as it is to a civilisation.

Herbert Read condenses all this admirably when he writes: 'Do not let us make the mistake of assuming that a civilisation can be based on rationality or functionalism alone. The foundations of a civilisation rest not in the mind but in the senses, and unless we can use the senses, educate the senses, we shall never have the biological conditions for human survival, let alone human progress.'[18]

1.2 *Art and Criticism* (1949)

Quoted in the report of a lecture on Art and Criticism delivered by de Sausmarez at the National Union of Student's Festival at Leeds University on 7 January 1949, while he was still Head of the School of Drawing and Painting at Leeds College of Art. [W.T.Oliver] 'Judging a Picture', *Yorkshire Post and Leeds Mercury*, 11 January 1949.

Criticism is subject to fashion, and there is no justification for critics attempting absolute judgments […] The 18th century connoisseur 'knew' that a picture should be a rich golden brown 'like an old violin': the 19th century connoisseur demanded that pictures should be poetical, rich in sentiment and 'finished' all over; today's counterpart often only appreciates pictures if they are very rough with heavy outlines, or in free brush-work or very naïve, or done in spots and squares, or some other modish recipe.

The essential difference between practising artist and critic is that the one thinks in 'images' and the other in 'concepts': the two are quite distinct and the barrier is inevitable.

1.3 *The Painter and the Analytical Attitude* (1955)

Published in *Researches and Studies*, No.11, January 1955, pp.26–31.

The most important contribution in the field of art in the past half-century has been the firm re-establishment of the freedom of the imagination as a basic necessity.

Earlier in the century when André Breton wrote, 'all that rightly or wrongly can be charged to superstition or fancy has been banned from the

mind', he was pointing to the disastrous severance of the rational processes from the intuitive processes in contemporary society.[19] In our efforts to correct this we have reached a point where we are in danger of falling into a new heresy – the belief that art is all imagination and all freedom, identifying imagination solely with non-rational processes and freedom with automatic or near-automatic activity. This conception has resulted in a disregard, at times contempt, for the conscious analytical and synthesising processes that we know to have been the vital springboard for many of the great works produced in Europe since the fourteenth century. No one would be so foolish as to suggest that this analytical interest was always a primary concern of the artist in his work but on the other hand no one can deny that since the fifteenth century it has been a fundamental element in the education of the artist.

When the contemporary artist, Francis Bacon, writes, 'I think that painting today is pure intuition and luck and taking advantage of what happens when you splash the stuff down', it represents the furthest point of this swing of the pendulum of opinion.[20] Painting is the only art in which such a statement is conceivable without some important qualifications. It might be said that Francis Bacon's statement can be justified by reference to Leonardo da Vinci's advice to the painter to 'look into the stains of walls, or ashes of a fire, or clouds, or mud, or like places, in which, if you consider them well, you may find really marvellous ideas. The mind of the painter is stimulated to new discoveries, the composition of battles of animals and men, various compositions of landscapes and monstrous things, such as devils and similar things, which may bring you honour, because by indistinct things the mind is stimulated to new inventions'.[21] Certainly it is an interesting parallel but, to Leonardo, it was only one of many ways of striking the spark that could be fanned into flame by all the contributory disciplines of analysis and construction and factors of sensibility that made up the phenomenal equipment of the typical Renaissance artist. In the case of the modern painter it is often a beginning and an end, and the disciplines of rationality are neglected as either valueless or harmful.

Sir Herbert Read's paper on *Conflicts in Contemporary Art*, in administering a merited rebuke to the social realists, raises the issue of 'feeling and knowing' in a direct way. 'I cannot believe', he says, 'that art functions by transforming states of mind … into states of feeling. Art works the other way round. It begins with states of feeling, usually obscure states of feeling, and it gives them concrete reality – it materializes them'.[22] There is in this an uncomfortable suggestion that states of feeling and states of mind can be separated out and function in isolation. But any presentation of the creative activity as a clear choice between states of mind and states of feeling, mutually exclusive, is an oversimplified abstraction that has no validity in actual experience. An artist, uninhibited by chronic illness or artificial constraints, does not shut off one level of experience in order that another level may operate. There is constantly an infinitely subtle interpenetration of one by the other, a flow between conscious and unconscious processes, between mental and sensory processes, and the profundity and complexity of a work of art is, in no small measure, due to the shifts of emphasis between these polarities. The

Fig 2 Francis Bacon (1909–1992) *Dog*, 1952

occasions on which an individual, however sensitive, experiences a feeling so unrelated and so unspecific as to merit the term *obscure* are certainly too rare to justify the qualification *usually*. Feeling is far more usually accompanied by intimations of the factors in experience that have generated it. Unless these intimations can be brought to a point of vivid concentration, it is difficult to see how the painter or sculptor can be in a position to materialise the particular feeling. And it is significant that, two sentences later, Sir Herbert Read writes: 'Art usually transforms a specific feeling into a specific symbol'. This must imply that there is a direct relationship not only between the feeling and the symbol but also between the artist and the feeling and the artist and the symbol. If this is not so, it suggests that the artist abdicates and becomes an unconscious agent of a quite miraculous transference – an amorphous abstraction 'Art' being responsible for the completed work. It is true that the artist surrenders some part of himself, of his consciousness, but there are important and extensive preconditions for this surrender. Van Gogh in a letter of 1888 writes, 'the emotions are sometimes so strong that one works without knowing one works, when sometimes the strokes come with a sequence and coherence like words in a speech or a letter'.[23] But anyone who will take the trouble to read all his letters will see that the strokes came with a sequence and coherence (and note that he attached importance to this, that he was not interested in their merely coming) by virtue of a long and arduous course of disciplined study. In fact they were preceded by eight years of unremitting self-training. Degas, the most methodical, the most logical and deliberate of late nineteenth-century painters said a similar thing – 'Only when he no longer knows what he is doing does the painter do good things'[24] – and it is clear that statements like these are only valid and intelligible when we realise that they are dependent on knowledge derived from early training and experience working subconsciously, when there is complete reciprocity between conscious and unconscious processes, between mentality and sensation.

It is Sir Herbert Read's use of words like *Art*, *feeling*, *symbol* as though they were self-generative and self-motivating that often confuses the issue. When he writes 'the feeling finds its equivalence in a plastic image'[25] we are bound to ask the question

– how does a feeling find anything? If it is *the feeling* that finds its equivalence, then the artist has abdicated, the surrealist cat is out of the bag and we are back again with automatism and the mystical doodle. But if Sir Herbert Read intends *the artist*, a complex of faculties of 'feeling' and 'knowing', to be involved in finding the equivalent plastic image for his specific feeling, then the artist must not only have some conception, however vague, of what that feeling is or what has generated it, but also be in sufficient command of his material and the technique of materialisation for him to fashion, not any vague symbol but this specific symbol. This statement of the relation is supported by the great traditions of the past. It implies that the artist's stature is measured not only by the profundity of his own feeling but also by the degree of understanding and control with which he translates this into material form – the traditional relationship between vision and craftsmanship.

Sir Herbert Read is undoubtedly right when he says 'What goes on in the artist's mind cannot be accounted for by the simple psychology of perception and expression',[26] but the fact that we are now aware of a far greater complexity does not mean that the perception-expression relationship has lost its validity or its importance. Are not the artist's intuitions, feelings and fantasies essentially related to, and largely dependent on, the world external to him? Leonardo da Vinci wrote, 'the imagination stands in the same relation to reality as the shadow to the body which casts it'[27] – and by that, he signified that whatever the fantasy, be it monster or deluge, it is dependent on observations of the logic of form and structure in nature or it will fail in its power to convince. The basic connection is not one of superficial imitation but of equivalence in the system of relationships. And further, since the 'self' is largely formed by the impact of external factors, it is as important to concentrate as much attention on the processes which sensitize our perception of the world external to us as to explore the world of internal subjectivity. William Blake wrote 'the tree which moves some to tears of joy, is in the Eyes of others, only a Green thing which stands in the way … To the Eyes of the Man of Imagination, Nature is Imagination itself'.[28]

The popular notion of an unavoidable antagonism between 'knowing' and 'feeling' has vitiated ideas

about art education during adolescence, a stage in development that has received singularly little attention from art educational theorists. With the approach to adolescence there is often a rapid development of the logical and critical faculties and with it a desire for work to conform to rational standards. Art teaching which fails to establish a continuity of expressive work during these years means that there has been a failure to provide opportunities for satisfying the intellectual aspirations while yet assisting and supporting the qualities of feeling. […]

Expression is not a mindless gushing out. There is a relationship between a process of in-taking and outpouring, a qualitative as well as a quantitative relationship. In the period of in-taking, the conscious analytical processes, exemplified in Renaissance Italy, are as potent as any other. Again, the word 'expression' clearly means 'pressing out.' How can we conceive of pressure without a resistant element? There is no pressure in a spring that is fully relaxed and the idea of art as play contains only a partial truth. Might it not be the contact of the intuitive emotional element with the conscious purposeful directing element that is the source very often of that pressure – the relationship of forms of emotionalism to forms of intellectuality? R. E. Collingwood answers this affirmatively in suggesting that art does not originate in either the emotions or the intellect but is generated at a level of experience between the psychic and the intellectual.[29] This conception resolves what otherwise would often appear to be inexplicable contradictions in the recorded statements of artists. To take but one example. Cézanne, who at one time says, 'If I think while painting … then everything is gone,'[30] and at another time, 'Get to the heart of what is before you and continue to express yourself as logically as possible'.[31] The truth is discovered only where the two statements are combined. There is considerable support for this point of view:

Goya – 'United with reason, imagination is the mother of the arts and the source of their wonders'.[32]

Delacroix – 'Art is no longer what the vulgar think it to be, that is, some sort of inspiration which comes from nowhere, which proceeds by chance, and presents no more than the picturesque externals of things. It is reason itself, adorned by genius'.[33]

Van Gogh – 'Even if one knows much by Instinct that is just the reason for trying hard to come from Instinct to Reason'.[34]

Juan Gris – 'The senses provide the substance of knowledge, but the mind gives it form'.[35]

Braque – 'I like the rule that corrects the emotion'.[36]

All these statements imply a complete reciprocity between states of mind and states of feeling, though it is better characterised as a level of experience in which both factors lose their separate identities and are inextricably interwoven, rational and non-rational faculties coalescing to produce that revelatory quality that distinguishes the great work of art.

There is today a widespread belief that knowledge kills art, though it may not always be expressed in this direct way. It is understandable so long as the processes of knowing are conceived as separable from, and diametrically opposed to, the processes of feeling. It stands in contradiction to the evidence of

Fig 3 Francisco Goya (1746–1828) *The sleep of reason produces monsters. United with reason, imagination is the mother of the arts and the source of their wonders.* No 43 of *Los caprichos*, 1797–9

six hundred years of European art, a period teeming with masterpieces produced from a background of enquiry and investigation of a variety of phenomena. But enquiry and investigation were seldom divorced from feeling and intuition. The artist took these factors and faculties for granted; he felt no need to make a special parade of feeling and non-rationality. It is perhaps the fear of the easy transition of scientific analytical thinking into determinism or the fear of degeneration into academic 'naturalism' that has created today what is often an hysterical rejection of attempts to bring rationality and art together. But artistic analytical thinking is clearly not synonymous with scientific analytical thinking; neither has it any connection with contemporary 'academicism'; and it is difficult to believe that it can for long be excluded without resultant stagnation. 'The bow is drawn in vain if you have nowhere to aim'.[37]

The potent symbol is arrived at by a process of compression rather than by a process of reduction, but compression and synthesis necessitate an understanding of that which is to be compressed and synthesized. Paul Klee wrote in 1929: 'One learns to look behind the facade, to grasp the root of things. One learns to recognise the undercurrents, the antecedents of the visible. One learns to dig down, to uncover, to find the cause, to analyse'.[38] And Van Gogh in a letter to his brother says, 'We have an inclination to analyse things. It is I believe just the quality one needs for painting – in painting or drawing we must exert that power'.[39] The power of this analytical element is one of the mainsprings of the great traditions of European art and places the conscious processes, states of mind, where they rightly belong as the handmaids to states of feeling. There is in the greatest works of art a continual interpenetration of these two factors so that one can justifiably speak of the logic of the emotions and the passion of the intellect.

1.4 *How to Visit an Art Gallery* (1967)

The extracts reproduced here are from the original manuscript drafted for Marshall Cavendish in October or November 1967, rather than the edited version afterwards published in *Mind Alive* in 1970. (Maurice de Sausmarez Archive).

The image of art galleries has changed remarkably everywhere over the last two decades. No longer are they merely repositories of works of art mainly of the past, they have now adopted an inviting freshness in display and an intriguingly demonstrative role, demonstrating in an easily accessible yet authoritative fashion the historical and stylistic phases and interrelationships not only in the great art of the past but also in the controversial field of contemporary achievement. And this is right, for Art is as much for enjoyment as for edification […] In some of the major art galleries throughout the world audio-visual linkage offers the visitor an unseen guide that he carries with him during his tour of the galleries. But this […] raises serious issues in terms of art appreciation. Since painting, the graphic arts, and sculpture are visual and plastic arts it is essential that the primary response should be through the sense of sight and the deeper levels of sensuous experience and not through the ear with its demand for auditory attention and intellection. And since the audio-guide machine is usually programmed to complete coverage there is less opportunity for concentrated attention on a selected number of works; instead of discovery through visual enjoyment the visitor may be diverted and seduced by packaged information through the ear.

One or two guiding principles for gallery going may result in greater enjoyment and a more intelligent use of the facilities offered.

Firstly, there is no doubt about the fact that the eye becomes fatigued to the point of insensitivity after too long a period of continuous looking and attention, and so it is better to attempt to get maximum enjoyment from twenty pictures than confused exhaustion from looking at fifty. After an hour of attentive looking, break off, sit quietly looking out of a gallery window for fifteen minutes or make your way to a refreshment room and return visually revivified and ready to approach a further group of works.

Secondly, as with human relationships, the more you get to know about individual works of art the more you enjoy being in their company and the deeper your response to them becomes. And this 'getting to know the object' includes a more searching enquiry into its intrinsic nature, i.e. its design and its colour as a vehicle for its expressiveness and its particular dramatic qualities, and also some knowledge of its maker, the painter and his development, and the place this individual work has in his total output and in the context of the art of the time when it was painted. To the enthusiast

this tracking down of information often has the thrill of more popular forms of detection […]

Thirdly, the initial approach to each object should be as far as possible devoid of pre-judgments and prejudice, and this is particularly important in the case of contemporary work. We do well to remember that our acquaintance with the most forward-looking works of our time has been extremely limited and their very unfamiliarity claims our unprejudiced attention […]

Fourthly, it is a considerable help to know something about the media or processes of making – for example the difference between carving and modelling, between oil painting and fresco, between etching and engraving and so on – and this knowledge can be acquired by reference to encyclopedia entries. The character and nature of a material and the appropriate ways of working with it influence the ways in which the artist envisages his work. Finally, the unprejudiced initial response needs following up […] The annotated catalogue of the gallery may give immediate information and […] there are to-day many excellent paper-back publications in almost all countries dealing with the history of art and these will help to put individual paintings in perspective and give extended range to one's understanding.

The great works of creative genius are the result of experience in depth and demand in return a prolonged period for their true assimilation. What is too quickly absorbed is likely to prove shallow and just as quickly forgotten. Above all remember that painting speaks to us of the total range of Man's experience and humanity […] Never expect from Rembrandt what you will find in Poussin, and remember that the naturalistic traditions have occupied only a fraction of the total field of the art of painting. Start with those paintings that seem to echo something in your own temperament and then attempt to extend the boundaries of your sensibility and understanding; you will never exhaust the richness that is there.

1.5 *The Artist and Public Today* (1960)

Introduction to the booklet accompanying the series *Modern Art*, BBC Broadcasts to Schools, Spring Term 1960, pp.3–8.

It is not easy for a painter or sculptor, or any artist for that matter, to talk about his work because in a very real sense the paintings, sculpture, poetry, or music contain in themselves and in their own terms all that he has to say. The visual arts during the past hundred years have been uncompromising in their determination to assert the autonomy of their particular 'languages', or modes of communication, and one of the difficulties which a predominantly literate public experiences in approaching modern painting or sculpture is the fact that these arts are essentially non-verbal. The first prerequisite is a sensitivity to shape and colour and to variations in the feel of things. He would be an extraordinarily insensitive person who could experience no difference in 'tension', in 'dynamism', between the visual impact of a splash of black ink and a neatly confined black circle, or between some lemons and oranges on a pink cloth and a bunch of green grapes on a grey surface. It is not merely a physical change that has been made in each of these instances; the modern painter would argue that a psychological change has occurred – we are conscious of a change of 'mood'.

These are very simple and obvious examples but they indicate the type of experience that the modern artist accepts as a sort of 'vocabulary' of visual signs capable of inducing states of feeling, states of awareness. Such a vocabulary is not as limited as one might at first imagine because it is infinitely varied by unconscious references to the experience of living – a patch of red, for instance, is not merely a decorative unit, it may suggest blood, it may be used as a marker in organizing space, it may stimulate a feeling of warmth, or may simply describe the outside of a tin of baked beans. The artist may use it in any one of these ways – decorative, symbolic, functional, structural, or descriptive – or he may play on a duality of meaning using the ambiguity to lead us to new experience. But all this is really the language of the imagination and must ultimately be 'read' by the imagination.

Through the phenomenal multiplication of naturalistic images in our time – photographs, posters, television, films, commercial art – it has been easy to lose sight of the fact that art is essentially addressed to the imagination, it is a symbolic language and the modern artist is usually dealing with symbols. It is true that the symbolism has not the established universality of that of earlier ages and that it often appears to be a private language personal to the particular artist. But there has always been

a strong conviction on the part of the artist that his experiences and his emotional reactions to life are as valid for the community to which he belongs as for himself. His artistic effort in consequence becomes more than a private affair, it is an expressive act on behalf of an artistically inarticulate community of people like himself.

Art is a symbolic way of showing what living in the world feels like to him. It makes little difference whether an artist is ordered to paint a picture as he often has been in the past, or whether he is working as a free agent as he often is today, the work that he does is the vehicle for saying something about life, material existence or spiritual experience. If, in each successive period of the art of the past, we seem to be able to distinguish a more closely knit consistency of outlook, of expression and style, than we can see in the art of today, the difference is a natural consequence of radical changes that are taking place. The artist is no longer serving a master (church, prince, or patron) nor is he fulfilling a necessary social obligation. Freedom from the pressures of working for a master has also meant freedom from imposed subject matter; the painter or sculptor today is free to make what he wants in the way that he wants. And there are two other freedoms that have influenced the situation; the camera has freed the artist from any concern with factual recording, and the phenomenal extension in the range of our knowledge of art through abundant photographic references and museum facilities has freed the artist from an established tradition. Prehistoric art, Japanese art, Peruvian art are having a greater influence on many modern artists than the work of the Italian Renaissance.

Old beliefs have been thrown into confusion; old notions of space and time, old patterns of social organization, and a hundred and one other sources of earlier conviction and certainty have been destroyed. [The sculptor] Barbara Hepworth has said 'the solid object, the impervious object doesn't belong to the world in which I live any more … the concept of solid substance ended with the end of the nineteenth century … we live in an age in which the concept of fission of the smallest particles of matter as matter is a day-to-day awareness'. It is easy to understand how thoughts and feelings of that kind may very well change the entire character of works of art. There would surely be something false in such a situation

were the arts to continue to present an untroubled unified picture. It is a world of continuous conflict, anxiety, experiment, and change and the creative arts effectively mirror this state.

A very important characteristic of contemporary work in the arts is its experimental nature. As early as 1836 Constable expressed what was to be the guiding principle of many of the great artists of the nineteenth century when he wrote 'Painting is a science and should be pursued as an enquiry into the laws of nature. Why, then, may not landscape be considered as a branch of natural philosophy, of which pictures are but experiments?'

Monet, Rodin, Cézanne, Seurat, all in their various ways were striving to realize the image which would adequately re-present reality, what the eye actually sees. This is not as simple a business as it sounds. Being absolutely truthful to our sensations, to our unique visual experience, ridding ourselves of all preconceptions, not only of nature but also of methods of producing pictures, and allowing each painting to develop its own structural coherence distilled from the experience of looking has led naturally enough to an interest in the psychology of visual perception.

Another group, following the lead of Gauguin, rejected the idea that form and structure were to be discovered in nature and asserted that the imagination was the source of all things for the creative artist. This attitude was in the sharpest contrast to that of Cézanne but led to 'experimental' work in another direction, in the direction of what Gauguin referred to as 'the mysterious centres of thought', the source of contemplative images and dream images – it was essentially a symbolist standpoint.

Although he shared some of the symbolist aims of Gauguin, Van Gogh contributed another factor to the foundations of modern art. It is now widely known how he intensified, distorted, compressed, and contracted colour and forms in order to express more potently the inner character and quality of an experience. Writing of his painting of a peasant, he says 'I think of the man I have to paint, terrible in the furnace of the full harvest, the full south. Hence the stormy orange shades, vivid as red hot iron, and hence the luminous tones of old gold in the shallows … and the nice people will only see the exaggeration as caricature'.

It is interesting to find the sculptor Henry Moore writing 'Between beauty of expression and power of expression there is a difference of function. The first aims at pleasure, the second has a spiritual vitality which for me is more moving and goes deeper than the senses'.

From these three roots of realism (if we include the element of geometrical abstraction latent in Cézanne's last phase), symbolism, and expressionism most of the impulses in our century have come (e.g. cubism, fauvism, surrealism) – extensions and amplifications of the principles inherent in the three attitudes discussed. Only non-figurative abstract art can be said to have arisen almost unheralded in this century.

In much the same way that Science, having once broken through the crust of external appearances and broken down the anthropocentric emphasis in our conception of Nature, has continued to reveal an endless succession of new images, new forms, so Modern Art, having moved behind the screen of descriptive realism to the level of abstraction common to all great art, has revealed a world of potential images and 'energies'. These images and 'energies', for all perception is dynamic, are used to express our experience of the world 'equivalently', no longer illusionistically or even symbolically. The abstract artist is creating equivalents for our experience. In this respect painting has moved very much closer to music and we find artists like Matisse, Kandinsky, Klee, and many others, frequently using musical analogies in discussing their work and ideas. The abstract artist believes that without making any descriptive references, his painting or sculpture through its vital organization of shapes, colours, and lines, i.e. in its very organization, touches the deep responses and echoes the experiences of the human spirit. The 'tachistes' or action-painters have taken this to the furthest extreme accepting the idea of the picture as an automatic register of psycho/physical energy. The element of magic, in the sense of invoking images purely through the action of painting, has now become an accepted feature of contemporary art theory. Art is man's way of internalizing the external world and of externalizing his internal world. The two activities or processes are operating simultaneously in all good work and it is only false theory or false practice that separates them or denies either of them. The work of art contains human experience rather than describes it.

The American philosopher, Susanne K. Langer, has written 'Imagination is probably the oldest mental trait that is typically human – older than discursive reason; it is probably the common source of dream, reason, religion and all true general observation. It is this primitive human power – imagination – that engenders the arts and is in turn directly affected by their products'.[40]

This series of talks will provide an opportunity of hearing a number of practising artists talking about their work in the context of mid-twentieth-century life and thought.

1.6 *Artist and Public* (1959)

Original manuscript for the talk recorded on 10 December 1959, for the BBC Broadcasts to Schools on *Modern Art*, Spring Term 1960 (Maurice de Sausmarez Archive).

When you read about the art of this century it seems to be full of 'isms' – fauvism, expressionism, cubism, futurism, surrealism and a host of others. I feel I should begin by saying that the artists who will be speaking to you in this series of talks have not been invited as spokesmen for any of these particular movements. They will be speaking as individual creative artists who will be able to give you some idea of what it feels like to be a practising artist in the middle of the 20th century, what excites their interest, what their problems are and how they work.

It is always so vitally important to realise that the 'isms' you may have read about are composed of individual artists. All these individuals differ in their ways of working and in the things they want to say through their work. It is perhaps even more important to recognise the fact that each object that they make is an individually materialised experience – This means that we must never rush to put a label – expressionist, cubist and so forth – on a painting or piece of sculpture; we must first try to see what unique experience it offers us.

Now this emphasis on strongly individual characteristics, on the creative personality of the artist, on uniqueness of experience is typical of Modern Art. It is one of the things that distinguishes it from so much of the art of the past. But before developing this point I ought perhaps to remind you that the reverse tendency has characterised modern architecture. Architecture is becoming increasingly the product of teams of specialists, all working of

course to materialise the vision of the architect, but this vision itself has to be seen today in terms of standardised structural units, mass-produced elements. This does not mean that the modern architect is any less creative than his predecessors but it does mean that his creative talent works in a different context; the modern architect has to approach his work bearing in mind the many impersonal factors which present-day living and production impose upon him.

But to return to this emphasis on individual creative personality and uniqueness of experience. I have said that it is one of the things that distinguishes Modern Art from so much of the art of the past. In the medieval world one could say that art was spelt with a small 'a'. The artist was an anonymous craftsman who made what needed making. He didn't make a piece of exhibition sculpture or painting, he didn't compose a piece of concert music; he carved an image of a king or an angel, he painted the holy Virgin and saints, he invented a chant for a choral Mass.

What he did was needed by the society in which he lived and was valued for its effectiveness in serving the two-fold purpose of teaching the people and praising God.

Later on, after the 15th century, when the artist was working as much for wealthy men as he was for the Church, pride in individual performance and the value of individual genius became important. But even in this situation the artist was supplying a known demand; he was paid for providing an interpretation of a particular subject, or decorating a ceiling or painting a portrait. There was a common ground of understanding between artist and patron.

Today the situation could not be more different. The majority of artists are self-employed, working to satisfy themselves, setting their own problems and evaluating their own answers. They now make what they want to make and hope that someone will respond sufficiently to it to want to buy it in a public exhibition. The artist has become more and more concerned with his own experiences, his own private world of dreams and images, his own exploration of the materials and means of expression of the art he practises.

You may well ask, 'If the painter paints to satisfy himself why should society be in any way concerned about what he does?' It is not an easy question to answer but I'll try.

Our civilisation has developed an almost fiendish mania for doing things to materials, for concentrating its energies on directing, controlling and breaking down the forces of nature, for 'getting places' (and it often doesn't seem to matter much where), for knowing more, for having more, for doing more things more quickly. These are what we have come to consider real values – this is the real world.

The artist on the other hand asks us to stop, to look and listen to another reality – to experience the qualities of things rather than their functional value, to feel intensely and freely rather than to extend our knowledge, to concern ourselves with matters of value rather than with matters of fact. The artist argues that when you have pulled a butterfly to pieces, looked at it under a microscope, arranged it all on a setting board, you are really no nearer knowing either what a butterfly is, or what a butterfly is for – you may only know more about how it works. To know what a thing is, we have imaginatively to enter into its life or special form of existence.

This act of imagination is the cornerstone of art. To suggest what a butterfly is and what it is for, the artist will need to express himself symbolically. In fact once we have left the realm of matter-of-fact description and we try to express feelings we find that feelings have no agreed shape or colour; the painter or sculptor has got to invent shapes and colours that will suggest those feelings. And so we arrive at the idea of the work of art being an equivalent, a symbol of experience.

Now, of course, this is nothing new. By far the greater part of the history of art presents us with an art of symbolism as against realism (or representing objects as the camera might see them). When people denounce Modern Art as being against tradition, one can at least say that, in being mainly symbolist in character, it is closer to the great traditions of the past than most people realise.

Look, for instance, at the three illustrations on page 4 of the pamphlet. The first is a traditional King of Spades from a pack of playing cards (perhaps you know that these designs are survivals of Gothic art). The second is a similar card from a Victorian pack but here a realistic portrait of George III has been used. Now you will notice two important things about the comparison. The first picture expresses the idea of a royal personage, of kingship – it is universal in its implication; the second is a specific person, it is a

particular instance and in consequence strictly limited in its reference. In the first we grasp immediately the substance of the message – king, majesty, power. We grasp it immediately through the design. In the second we say 'Who is it?' We have to look at the two crowns in the margin and read the words 'George III, King 1760–1820' and even then the ideas 'King, majesty, power', are not conveyed visually at all.

Look at them again – the first is a splendid regal pattern of shapes and colours which fills and decorates the shape of the card; the second is restricted in its use of shape and colour, restricted by the need to describe the anatomy and insignia of George III. Now modern painters too are frequently attempting to make universal rather than particularised statements.

Look at the third of these illustrations – Picasso's 'Weeping Woman'. This was painted in 1937 during the Spanish Civil War. In it Picasso has not presented us with a particular woman in tears. He has expressed the very substance of human anguish, the torture of inner feelings too strong to bear. Surely no one could fail to respond to the terrible tensions in this image. If you stop to think about it, he has used the most direct means of affecting us visually. Through contorted shapes, convulsive lines and discordant pictorial elements the interior feelings that give rise to tears have been represented. It is as though he has dissected with his brush and shown us the anatomy of human grief and suffering. To paint a woman with her head in a handkerchief would be merely to give the external result of that inner state of conflict. Look at the picture again. I think you will appreciate how the shapes fill the picture area so powerfully, so dynamically, and so monumentally that it would be difficult for you to estimate the size of the original. You will also see that it is much closer to the Gothic tradition of symbolic statement than it is to nineteenth-century naturalistic portraiture. To this extent Picasso's art is traditional.

All art is a form of communication and every artist when he makes something expects that there will be someone else who will ultimately see what he is driving at. In fact he assumes that his experiences, his reactions to life are as valid for other human beings as for himself.

When people complain of the unintelligibility of modern work it usually means that either they are not making sufficient effort to, as it were, 'tune in to the artist's wave-length' or that they are expecting a certain sort of content; they are looking for an answer to a problem that the artist never set himself.

Beauty and ugliness are words often used in response to visual art but so frequently it is a question of the conventional being set in opposition to the unfamiliar, what one has learnt to expect as against the unexpected. All art that has real value is essentially an enlargement of experience and the modern artist is frequently attempting to enlarge the intensity of our experience, the intensity of feeling or to revise our conception of balance, of space, to extend our ways of interpreting the world in which we live.

And don't forget that the world we live in has been vastly extended by science. There is now not merely the landscape visible to the eye but the strange new worlds revealed by the telescope and electron

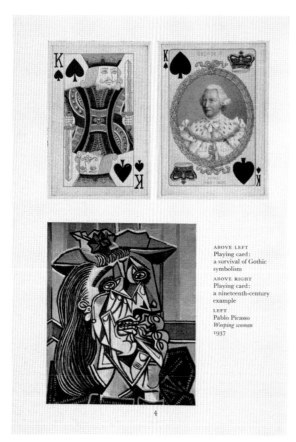

ABOVE LEFT
Playing card:
a survival of Gothic
symbolism
ABOVE RIGHT
Playing card:
a nineteenth-century
example
LEFT
Pablo Picasso
Weeping woman
1937

Fig 4 *Playing cards and Picasso*. Page 4 from the booklet produced to accompany *Talks for Sixth Forms*, BBC Broadcasts to Schools Spring Term 1960

microscope, the changed conceptions of space; and we ourselves have been made more aware of the labyrinth of our own inner resources of knowing and feeling.

For example, if you look at a landscape by Constable you are a spectator looking, as it were, out of a window on all the loveliness of the external world. If you look at a certain kind of modern painting based on landscape you will find that you are the centre of the space created, freely moving about, and that the location of things is suggested sometimes in plan, sometimes in elevation, sometimes as superimpositions; there may be no hint of sky, no light and shadow and no indication of North, South, East or West; the pervading colour will give the mood of the experience but the resulting image will not be at all descriptive in Constable's terms and yet it will have an unmistakable feel of landscape. It will be a symbolic arrangement of shapes, lines, patterns, colours – all that we imply when we use the word 'form'.

I wish I could find a simple way of suggesting what this word 'form' signifies. The *Concise Oxford Dictionary* takes over 250 words to cover the varieties of meaning. One or two extracts might perhaps help to suggest why it is so important to the modern artist. Here we are … 'FORM: Shape, arrangement of parts, visible aspect … conditions of a thing's existence by knowing which we can produce it … formative principle holding together the elements of a thing'.

If you now look at the illustrations in the pamphlet on page 6, and the colour plate of Victor Pasmore's painting you will recognise a common 'formative principle holding together the elements' of these three works. The common form is the spiral shape. But they clearly have no common origin.

Leonardo da Vinci with his scientific interests has looked long and intently at water pouring out of a pipe to discover, by analytical means, the laws that underlie this natural phenomenon. He has found a static pictorial symbol for what in reality is constant motion – the spiral tendrils of line moving one upon the other, out from a centre of bubbling coiling shapes. His object has been to describe nature's workings and he has done this in a drawing of great beauty. Van Gogh in a state of acute mental tension and excitement has experienced the night sky as a conflagration of stars exploding and whirling like

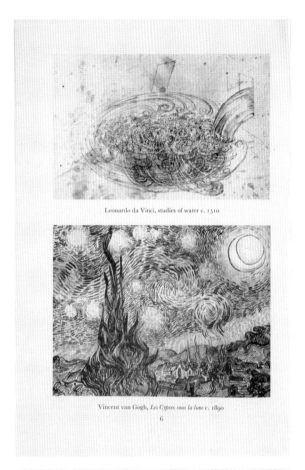

Leonardo da Vinci, studies of water c. 1510

Vincent van Gogh, *Les Cyprès sous la lune* c. 1890

6

VICTOR PASMORE
The coast of the inland sea 1950

Fig 5 *Leonardo, Van Gogh and Victor Pasmore* Page 6 and colour supplement from *Talks for Sixth Forms* booklet, Spring Term 1960

giant Catherine-wheel fireworks, and the whole landscape, trees and hills, rock and wave and pulsate in sympathetic response. He too has looked at Nature but what he has found there is the mirror of his own psychic convulsion, his own mental distress. In translating what he felt when looking at the sky he has arrived at the same coiling spiral form.

Now […] look at Victor Pasmore's painting – like an architect he has set out to build his picture from a number of given units, not describing landscape as the physical eye sees it but re-fashioning the idea of landscape and creating an equivalent for it. Using a unitary principle, again the coiled spiral, a strange interplay and interchange of sky and earth has resulted, a curious ambiguity that produces the quality of poetic experience. It is like a pictorial translation of a musical composition perhaps a fugue; certainly those of you who study music will call it 'contrapuntal'. This artist, in common with many other modern painters, has looked more concentratedly at the structures that emerge on his canvas than at the external world of Nature. The marks and patches of colour, as they are placed on his canvas, create their own interior world; they exert pulls and attractions, directional tendencies, centres of optical concentration, disturbances of balance – all of them, hidden structural factors and energies, like the forces in a magnetic field. Whereas the earlier artist took nature as his point of departure, many modern artists take the rectangle of the canvas and their palette of colours as their point of departure, and nature (if it plays a part at all) is more likely to be their point of arrival – and even then only in the form of very indirect reference.

But this is only one aspect of the total field of modern art, which is so richly varied that anyone who is at all interested in the visual arts will find some point of contact. Most people realise that one can only hope to understand and enjoy modern music by listening often and attentively to it; the same kind of close attention is needed to enjoy painting, sculpture and architecture.

The creative artist today makes demands on the imaginative powers and capacity for feeling of his public. Perhaps unconsciously and instinctively he is compensating for the excessive emphasis on rational scientific thought and the materialist values of contemporary society. Painting and sculpture, one could say, are there for our personal enjoyment, but

in the case of architecture it is a necessary part of our social responsibility. We cannot, we dare not, afford to be uninterested in the shapes that are being provided for living and working – they directly affect our lives and our future. Of one thing we can be certain; if our society becomes complacent about its mechanistic and scientific ideal and neglects the creative Arts, then the psychiatrists will be its angels.

1.7 *The Arts of Design* (1956)

Published in *The Universities Quarterly*, Vol.10 No.2, February 1956, pp.162–65.

It is frequently said that in answering the demands of the times the universities must still 'keep their standards' and stand for the right things. This, when it is discussed, usually centres round intellectual standards and one would hardly expect it to be otherwise. But there is a feeling that this injunction to preserve standards also applies to the peripheral questions of accommodation, physical well-being and general environment. In the past the standards that were discussed in these fields appear to have stopped at efficiency, comfort and utility; consideration of aesthetic standards has seldom featured strongly. Indeed, in the case of the modern universities it is still not so much a question of 'keeping the standard' but rather of establishing an aesthetic standard to keep.

It is clear that early in this century, in many cases, an attempt was made to manufacture a quick substitute for a long tradition by considerable play with leaded lights, heavy, dark, 'monastic' furniture, the silver-gilt mace, carved heraldic devices and the like. The challenge that they should be fully the universities of the modern world was never met, at least not in the creation of a truly contemporary environment for working and living. To take but one example: there is scarcely one of the younger universities that can look back at the general standard of its Calendar for 1935 in terms of typography, page arrangement, quality of printing and general design with any sense of pride. At a time when Eric Gill and Edward Johnston had reintroduced clear, disciplined beauties into English typographical work, debased Gothic founts and the hack type-setting of the jobbing printer were considered right for the new universities. Can it be said that the position is greatly changed today? Certainly the leaded lights

and the pseudo-monastic furniture have gone, but has the uncritical outlook that made them possible? No one expects the universities to embark on a wild chase of fashionable design idioms. The great Oxford and Cambridge presses show that a sound tradition of design and impeccable craftsmanship can preserve a balance between a rigid conservatism and an innovating experiment. The fine letterforms used throughout Senate House, London, remain in the mind the more strongly by contrast with the commercial sign-writer's sans serif in other university centres.

The adverse critics of educational standards in the schools of this country today must recognize one field at least where rapid advance can be recorded. At no other time has so much thought been given to the education of the eye, admittedly not so much by systematic instruction as by indirect methods. It would be unfair for the philistines to attribute any drop in intellectual standards to this very welcome advance. It is an introduction to art as an integral part of living, although it would be difficult to assess its effectiveness in sharpening the discriminative powers of the pupils since so little is done to develop a critical sense by direct instruction. In 1939 when the High School for Girls at Richmond, Yorkshire, was built it was, to most people, a remarkable and daring innovation. Today school building falling below this high standard of design is seldom found. The frank use of new materials, consideration of space relationships and emphasis, the vitalizing and integrating value of colour are everywhere respected. Not a few local authorities have their permanent art advisers whose influence spreads far beyond the province of art-education and has begun to affect every aspect of design in the schools, from school furniture to typography.

The transition from an environment in which these things had mattered to the, until very recently, clinical neutrality of many university precincts was in this respect a sadly retrogressive step. The argument that it was effectively countered by the new intellectual vitality that awaited the newcomer to the university was hard to sustain. Genius perhaps needs few external props, but that humbler talent which largely fills universities today will be the better for living and working in surroundings which refresh and revive its spirit. The modern civic universities, it is true, have inherited the buildings of a misguided nineteenth-century 'monastic' ideal; the earlier years of this century added grandiose pseudo-classicism and neo-Georgian, and between the wars a certain amount of cultural warehousing, but, whatever the legacy, the eye of an enterprising and skilled designer can transform it into a positive source of refreshment, if not inspiration. The many splendid new buildings that have been added since the war should not be allowed to deflect attention from the central problem of transforming the old, which constitute a very large proportion of university property. The imaginative treatment that the contemporary architect is anxious to sustain throughout his building, inside and outside, has made many of the recent additions to university buildings object lessons in the integrating and vitalizing power of the designer's hand. The lesson has not always been fully assimilated; all aspects of university environment should benefit in a similar way.

It is still not unlikely that the newcomer to some of our modern universities will make his enquiries at a Porter's lodge that reminds him of a suburban railway booking office. He will almost certainly walk through furlongs of cream-painted surgical tunnelling, passing on the way notice-boards which present varying degrees of typographical and calligraphic distress. The interior of the lecture room, though clean and bright, continues the desperate monotony of academic cream. In every direction the contemporary ideal of efficient function has taken the lead. There is no doubt that the highly organized routine of life satisfies in itself some of the human need for order and reliability, but once these demands of efficiency have been met, many people have been content with the situation. The machine is running smoothly enough, why bring in this aesthetic distraction? A justification could be attempted on the grounds of even greater efficiency, or by the fear that those who live and work in surroundings depleted of distinctive personal character may gradually assume the attributes of the machine. But really it needs no high-falutin' justification; the pleasure, the increased refreshment of spirit that this consideration of environment contributes is sufficient. To-day even the man of intelligence seems at times to need a reminder that art is an enrichment of life and living and not an enrichment of museums.

If the academic is sceptical of 'education' that trains the hand without training the mind,

he must also be prepared to acknowledge the impoverishment that results from training the mind without 'educating' the senses, though divisions of this kind are admittedly false. There are of course the dangers of 'preciosity' and 'dilettantism', but these are symptoms of a highly sophisticated stage in development that is, in many cases, still in its early period. They are symptoms that are more likely to come from attempts at imposing, in cerebral fashion, ideas of taste and standards of culture than by concentrating on arranging the conditions in which a natural response and intuitive judgment are fostered. A lecture, whether it be on the appreciation of painting, architecture or industrial design, may do no more than go in at one ear/eye and out at the other unless it is followed up and confirmed by visual experience and some continuity in methods of developing sensitivity and discrimination. University environment should help visually in this way.

It would be quite untrue to say that no moves have been made to improve the position and that no one is concerned about it. Much has been done, but it becomes increasingly clear that the situation can only be satisfactorily resolved by consulting the artist-designer. Society is prepared to consult the specialist in the solution of almost every other problem but hesitates in matters of aesthetic judgment. There is resistance to the intrusion of the specialist into fields where personal choice should operate. But a very different picture would have resulted from the operation of personal selection and judgment consistently applied; one would have been aware of the integrating factor of a personality giving a certain homogeneous character to an environment. But this has not often been the case in the recent past. Piecemeal development, accumulations of separate compromise decisions by committees, or limited decisions by a number of different individuals can only produce a neutral or visually unorganized situation. It is the growing recognition of the important contribution to be made to university life by the consultant-designer that is in large measure responsible for the improvements that can everywhere be seen.

With the rapid expansion of many of the universities, the task of establishing an aesthetic standard or preserving an existing high standard will demand continual consultation on matters of design and it would seem that an even wider use will be made of the artist-designer. Unless he is tarred by the brush of nineteenth-century romanticism, he is working as objectively as a structural engineer. He has a problem to solve and the solution of it need occasion no extravagant displays of temperament to disturb the clients for whom he works. If it is agreed that the universities have a responsibility, not for dictating standards of 'taste' but for providing the best material for the development of individual critical awareness and discrimination, then standards of design in every field are of importance.

It will not be surprising if, in a few years' time, the 'General Design Consultant' features in the list of the administrative staff of the majority of English universities.

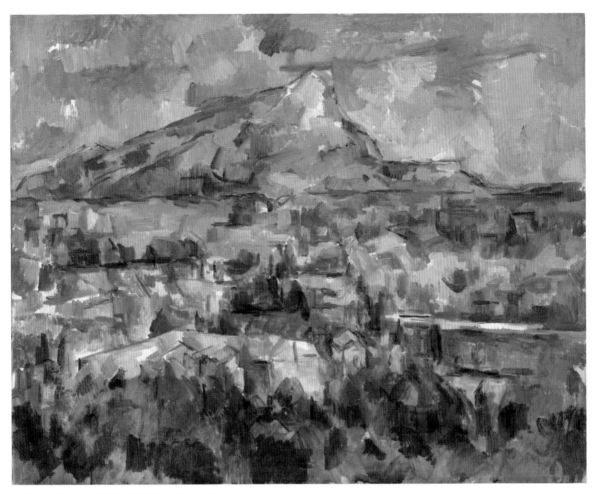

Fig 6 Paul Cézanne (1839–1906) *Mont Sainte-Victoire seen from Les Lauves* c.1902–4

... From the late nineties to his death the idea of creating a sort of visual music, unbroken sequences of colour modulation, of integrated lines and tensions, becomes more and more obsessive. All factors which hitherto tended to preserve the separate identity of each object or each volume are rejected in the interests of achieving a kind of abstract system of colour and planal development. His work has had a profound effect upon the generations which have followed. It offered them the idea of the picture as a construction, no longer as the statement of a momentary effect, the representation of anecdote, of literary subject matter or superficially descriptive record, but as an architecture of colour-form

From de Sausmarez's text on *Cézanne*, Part 4 of *Tradition and Experiment in Art*, a series of broadcasts provided by the BBC for the School Broadcasting Council in the United Kingdom as part of *Talks for Sixth Forms*. Published as *Notes for the Teacher*, Autumn 1965.

2 THE PAINTER'S EYE

It has often been said that Maurice de Sausmarez wrote on art as a painter and teacher rather than as a critic or historian, but he had a natural gift with words and a keen interest in his subject that enabled him to voice his critical perceptions with a fluent articulacy, informed by extensive reading and research. The texts brought together here offer a sample of his occasional writings on art and artists including reviews of books and exhibitions, introductions to exhibition catalogues and forewords to books, interspersed with notes and extracts from his manuscripts, and finishing with the in-depth monographs that were the last pieces he wrote.

Amongst de Sausmarez's earliest writing is a study of the art of Thomas Hennell which was produced for the short-lived *Alphabet and Image*. Edited by Robert Harding, it was one of several visual arts magazines founded by James Shand, the owner of the Shenval Press. In 1958, Shand started *Motif* magazine, essentially a typographic journal, but with an eclectic mix of subjects ranging across graphic arts, painting, sculpture and photography, as well as art education, edited by Ruari McLean. De Sausmarez became one of its regular contributors in the 1960s, as well as writing for the *Connoisseur*. His painter's eye could grasp the different ways in which another might achieve particular effects of colour, line and form. Ironically, it was de Sausmarez's acute observation of the individual singularities of facture amongst the Camden Town painters that prompted Wyndham Lewis to write a letter to *The Listener* criticizing him for 'singling out petty differences'. De Sausmarez responded: 'The fact that Mr. Lewis can see no differences worth noting but only a *distressing family likeness* is merely an admission of his own indifference. They are as clear as those between MacBryde and Colquhoun or Minton and Vaughan. His decision that family likenesses are distressing must be of astonishingly recent date'.[41]

While his own practice remained, by choice, within the classical tradition, de Sausmarez was always open to new experiments in art. Indeed, it was his training and the solid ground on which his own practice stood that enabled him to recognize when new territory was being explored, or rules were being broken with convincing effect. Hence his sympathetic, appreciative analysis of early work by new artists such as William Culbert and Margaret Benyon. William Culbert's work is well known today for its preoccupation with light and *bricolages* of found and recycled materials, which he uses in a wide array of scales, from wall-mounted sculptures to public space installations. Margaret Benyon is now internationally recognized as a creative holographic artist. Her interest in interference patterns led her towards holography, a medium previously the province of science.

One of the methods that de Sausmarez employed in his research on living artists was the interview. He was adept at drawing observations from them, and directing discussion towards pertinent aspects of their work. Three examples are included here. The first – a discussion with Peter Sedgley – was recorded in 1967, two years after his first one-man exhibitions in London and New York. The interviews with Naum Gabo and Henry Moore formed part of the *Studio International* special on *Ben Nicholson* published in 1969. Nicholson, somewhat withdrawn and resistant to publicity, had entrusted the task of editing this special to de Sausmarez on the evidence of his article on recent drawings by Nicholson, written for *The Connoisseur* in 1963. The correspondence arising from this partnership, based upon mutual respect and trust, is held in the de Sausmarez archive together with the material collected by de Sausmarez for the project, including the interviews with Gabo and Moore.

The study on Poussin's painting of *Orpheus and Eurydice* was commissioned to form part of the series, *Painters on Painting*, published by Cassell & Co. London in 1969. Published under the general editorship of Carel Weight, the series was made up of individual studies of single paintings, each analysed and explained by different professional artists or teachers. It had a simple standard format of thirty-two pages per volume, with a foldout colour reproduction of the particular painting at the end of the book. So

placed, the image could be kept continuously before the reader's eye and the text read in conjunction with the image. The individual studies were also published together as four companion volumes. A letter written by de Sausmarez to the publishers in September 1968 reveals that the book was almost complete.[42] The only difficulty lay with the fact that the Louvre had lent the painting to an exhibition in New York and so the work was temporarily unavailable to de Sausmarez for the purposes of writing the section on colour. This was particularly critical for de Sausmarez as he wished to refute 'the notion handed down from the 17th century that [Poussin] was not really concerned as a colourist'. Poussin's *Orpheus and Eurydice* had first made its impact on de Sausmarez when he was about 16, as his introductory remarks explain. After providing the historical context of Poussin's character and methods, his concern with pictorial geometry and the possibility that he may have been interested in experimental optics, de Sausmarez moves to the detailed analysis of *Landscape with Orpheus and Eurydice*. He unravels its geometrical construction and demonstrates the subtle way in which Poussin uses pictorial geometry as a means of achieving not only an 'interrelated organisation' of forms, but also 'of assisting the pervasive sentiment of the subject matter' through an orchestration of design, 'psychology of gesture' and, of course, colour.

The section closes with extracts from de Sausmarez's book on Bridget Riley. The two first met in 1959 when Riley attended a Summer School in Essex run by Harry and Diane Thubron with de Sausmarez. The following year, Riley and de Sausmarez spent the summer together painting in Italy. The book, which was published after de Sausmarez's death, is perhaps the best-known of his writings after *Basic Design*. The device of the interview was used again here, giving insight into Riley's thoughts and processes [43] and the book also includes de Sausmarez's own observations and analysis of optical painting.

H.D.

2.1 *Colour and Light in Painting* (no date)

Extracts taken from an undated manuscript for a lecture on nineteenth-century painting (Maurice de Sausmarez Archive).

In speaking of Colour and Light in Painting my remarks will be those of a painter.

You would be wrong in assuming that these two factors have always been considered together – in fact, only the realist movements of the 19th century linked them inseparably. Before that time and since that time colour has been concerned with symbolism, with effective pattern making, with dramatic pictorial effect, with the interpretation of structure, or purely with sensation. Only rarely has it been used for the factual statement of atmospheric light […]

To the simple painter Nature is infinitely extended, his canvas is circumscribed – he sees that as the microcosm is to the macrocosm so must his painting be to Nature. Although his picture must be a world in itself, complete in its organisation with a system of cause and effect satisfying to the mind and the senses, it clearly relies on a relationship to the world outside itself for its more profound values […] We painters distinguish between conceptual and perceptual colour – even in our approach to the world of things, to experienceable reality these two aspects of colour are present.

From childhood we are encouraged to generalise – we speak of green grass, a brown jug, blue sky – but however useful these labels may be for communication between people they are complete abstractions only remotely touching here and there on the substance of direct visual experience. Colour defined in this way is what we in the studio call 'local' colour – it is conceptual.

The true content of direct visual experience is of forms in space coloured by infinitely varied sequences of colour – the green grass is not green but a series of modulations of colour – greens, blues, yellows, violets and so on; the brown jug similarly is another series of fragmentary modulations. Colour defined in this way is what we call 'atmospheric' colour – it is perceptual.

Now quite clearly mechanical physiological vision is outside the province of Art – because the human eye is physiologically most intimately and elaborately connected with the brain it is virtually impossible for it to operate exclusively as a machine. The human mind is both a knowing and a living apparatus and in a person fully conscious it is impossible for it to be merely a mirror; the vision of any object calls up a world of associations and desires, moods and memories which augments or modifies the visual

experience […] The one thing it does not do naturally is to make a photographic statement.

Now in organising the colour of a painting an artist has many things to consider – although colours have symbolic significance (think of your immediate reactions to certain reds, or purple, clear blue or black) although we may in childhood have had 'favourite' colours, when we have to make a picture, a composition of colour, it is the total mood of the picture that guides our choice. It is the *relationship* of one colour to another, not the colours in themselves. But immediately we begin to consider relationships other problems intrude – colour is not constant in its effective quality, it changes with the alteration of its surroundings. Let us take an example – place a patch of red ochre (a brick-like red) on white canvas, and a patch of identically similar colour on a black background – the red on the white looks a totally different colour – it is much darker and much colder than the patch on the black which looks more like scarlet than brick-red and much lighter. We notice too that the neutral colour in each case is tinged with the complementary of the colour area next to it. The balance, distribution and proportion of colour areas have to be weighed up. We find for instance in practice that hues of equal tone and intensity do not enhance one another – there needs to be tonal variety. If we use red and blue each at its spectrum value they seldom look well, but if we make the red lighter or darker these colours will interact. The question of balance is of concern to a painter – a minute area of brilliant colour will balance fifty times its area of subdued colour (colour of a low degree of saturation). You will notice that I have been considering these properties of colour in a purely abstract way – when we add to these aesthetic equations the factor of realism other complications arise. In painting sunlit landscape the yellow will turn all the warm colours a little towards yellow and will eat some of the blue out of the cold colours where sunlight falls upon them.

There are essentially only two main values – the big mass of light and the big mass of shadow – if anything is done to break up these masses half of the effect of sun will have gone. The shadows although intense should be fairly high in value – if the complementary nature of shadow and light is emphasised it is more successful (colour in light towards yellow and in shadow towards blue).

In painting fantasy or purely imaginary pictures the painter has absolute freedom in the choice of his colours – they have no need to appear probable in a realistic sense, though they must always be meaningful and satisfactory in an aesthetic sense.

The realist painter has his own way of solving his problem aesthetically – by the process of colour transposition. Nature presents us with a sequence of tones and warm and cold colours – providing the painter preserves the logic of this sequence he can paint his picture in any colours he likes and the effect will have a convincing air of probability. This makes it possible for a scheme of colour aesthetically satisfying to be used – the collaboration of Nature and the Artist's sensibility.

2.2 *The Mechanics of Perception* (1962)

Review of Paul Klee's *The Thinking Eye* and Johannes Itten's *The Art of Colour* (both published in 1961) and F.A. Taylor's *Colour Technology* (1962). Published in *Motif* 9 (Summer 1962), pp.98–99.

It is fashionable to brush aside an artist's own writings about art on the score either that what is written is not necessarily what is practised, or that no consistent theory can be deduced from the statements of an individual who relies so heavily on the wayward impulses of inspiration. How many earlier enthusiasts cracked their heads on Cézanne's verbal ambiguities in an effort to knit them together into a new aesthetic comforter? But isn't this perhaps the crux of the problem? Expositors of Modern Art are so keen to find in the artist's words a coherent illuminating pattern that fits the image of the painter they have already formed that failure to discover it makes them impatient with all his statements, even those often revealing flashes that might help them to a deeper understanding. For years the popular image of Van Gogh and his way of working has been made less probable by a serious study of the 800 letters – the treasured symbol of passionate, untutored, uncontrol crumbles with each page turned. And now another popular image, Paul Klee, the shibboleth of whimsicality in paint, is in need of revision through the publication of the massive collection of his theoretical writings, as tough and as much rooted in the physical world and a belief in the relevance of its functional laws to artistic creation as anything since Leonardo and Dürer […]

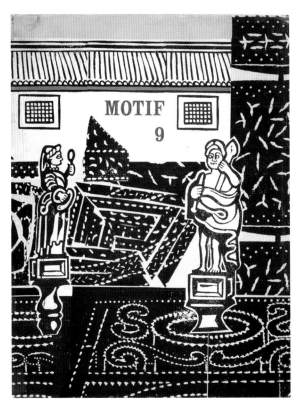

Fig 7 Cover of *Motif* 9

The Thinking Eye [...] is not an easy book for the layman, nor indeed for the experienced, since it is highly concentrated and in each section the fascination of extension into a variety of associated fields was irresistible to a mind as multidimensional as Klee's. But if the book is studied in the way that its content was intended to be assimilated, i.e. phase by phase with an appropriate interval allowed for digestion, it provides a fundamental education in creative thinking and analysis and a spur to formal invention [...] It is not a treatise on the traditional pattern of technical methods and aesthetic rules; in fact Klee is very contemptuous of what he calls the 'narrow-chested asthmatics who give us laws instead of works'.

The poetics of Klee arise out of a relentless penetration of experience, which moves from the astonishing attributes of the dot on the page in front of him to the concept of cosmic tensions. Like Leonardo, Klee is interested in form as structure and as function, but whereas Leonardo's main concern is the field of physical mechanics, Klee's is that of

the mechanics of perception. Leonardo's scientific detachment allows him to be the observer, Klee's aim no longer makes this possible since he is both observer and the observed. The distinctions so often drawn between objective and subjective here appear irrelevant. For Klee each physical manifestation is both clarity and paradox, empty and full, itself and something other. Metamorphosis underlies the whole of his conception of reality. The individual instance is evaluated not only for its own specific characteristics but also for its potentiality as a sign representative of many differing associations. The precise analysis of Leonardo yields laws relative to physical functioning and natural appearance; the intuitively felt deductions of Klee create equivalents for the processes of forming and growth that unite interior and exterior reality. In fact Klee is suspicious of form as a static realized phenomenon and is far more concerned with the process of formation – genesis, essence, growth, determinant forces – all those factors which create and sustain motion.

To the extent that science may be said to be an organized attempt to discover how things work as causal systems, we are justified in calling the bulk of this study scientific. Unlike Kandinsky who said 'There is no *must* in art because art is free', Klee is aware of the work of art as an organic system with its own principles of growth which in a sense are compulsive; although a strict definition of the laws which govern this system may not be possible, the artist is none the less aware of them pragmatically. The 'goal' may not be clearly defined at the outset but as the work grows the artist becomes more and more certain of when he has made a contradirectional move (he may then accept the new direction with the consequent change of 'goal' but much of what has already been done must be re-made, and what will follow will progressively obliterate the originally inferred structure) The artist cannot build without assuming a direction and Klee's main effort seems to be turned towards digging down to the uncovering of those factors that contribute to this sense of direction, in his words 'the pre-history of the visible'. In *Creative Credo*, he says 'actions may well be the start of everything but actions are governed by ideas' ... 'the visible realm is no more than a *special case* in relation to the cosmos and other truths have potentially greater weight ... We are striving for the essence that hides behind the fortuitous'.

[The] illustrations of completed works by Klee […] demonstrate conclusively how much the analytical framework of his teaching underlay his own creative work. In most cases the paintings illustrated were produced a considerable time after the period of the notebooks and yet they might well have been done as direct illustration of the theoretical propositions; no disparity here between statement and work. Against this background the element of whimsicality appears often merely as an associational adjunct to the basic formal structure, the fundamental abstract constructions are 'qualified' in terms of the associations they conjure up; with the simplest and most economical of 'signs' almost any geometrical shape is miraculously transformed into a head, a house, a being.

Considering Klee's renown as a colourist the section devoted to colour in his notebooks is relatively slender but provides a useful comparison with two other recent publications dealing exclusively with this topic […]

Where Mr Taylor enthusiastically speaks of Ostwald's deep concern for the psychological aspects of colour and goes on to claim the necessity of a four-colour theory for this purpose, Klee writes: 'It is customary in this country to limit the scientific aspect of the question to a mathematical-logical proof of correctness. Thus the psychological aspect is neglected by Ostwald for example. The psychology of the colourist demands the division of the (colour) circle into three or six parts'. Taylor it is true argues that the quadrichromatic theory is not a separate system but an extension of the trichromatic in order to obtain more exact mixtures from the start, but Klee, the practical colourist, sees aesthetic value and satisfaction in the process of first tuning the 'pure' red, yellow, blue, and the diametric contrasts, through subtle adjustments of mixing and by testing the effect on the eye. He goes even so far in his opposition to the quadrichromatic theory as to say that a slightly faulty establishing of the basic relationships between the primaries 'is less unfortunate than the division of the circle into four or eight. That really hurts!' And on this same point Johannes Itten, after explaining how the trichromatic opposites (e.g. blue-orange) mixed together give grey whereas in Ostwald's four-colour system yellow being opposite blue produces the mixture green, says 'this fundamental difference in construction means that Ostwald's colour circle is not serviceable to painting and the applied arts'.

Useful as Part 1 'The Science of Colour' of Mr Taylor's book may be to some, Part 2 'The Technique of Colour' will scarcely fail to disappoint the serious artist and designer. The introduction states that in this second part, having in mind the wide variety of arts and crafts where colour is used, 'the data have been made applicable to almost any subject'. This is surely courting disaster by attempting too much and yet, on examination, the utility of this Part 2 seems mainly to hang on 'pleasing colour schemes' and other well-worn shreds which would need a lot more airing than this to freshen them up. The evidence of well over fifty years of the Modern Movement's fascination with colour has hardly touched this section of an otherwise handy compendium of scientific facts (far more of these than in either Klee or Itten).

Johannes Itten was in charge of the Preliminary Course at the Bauhaus between 1919 and 1923, a colleague of Klee and Kandinsky precisely during the period when the main mass of Klee's theoretical writing was produced. [Itten's] book on colour, whatever reservations one may have about its heavy mannered format, is likely to be of greater value for the purposes of practical instruction than anything yet produced. The shortcomings of most works on the subject, apart from inadequate and inaccurate colour plates, are firstly that only a perfunctory reference is made to the field of subjective responses while objective principles are drummed out with thunderous primaries and secondaries; secondly, no real attempt is made to show how the enunciated principles are effectively translated into the subtler fields of pictorial expression – references to colour schemes for fashionable interiors, some brash poster art and a few generalizations about Gainsborough's 'Blue Boy' and 'The Laughing Cavalier' usually suffice. In this book by Itten immense trouble has been taken over the colour printing which is superlatively good […] The complementary and simultaneous contrasts here really have an optical 'Zizz', and the refusal to propound a 'law' of discord is refreshingly consistent with post-impressionist thinking. Itten's approach is based not on Ostwald but on Goethe, Chevreul and Adolf Hölzel, and an early chapter entitled 'Subjective Timbre' makes it clear that he is careful to encourage and make full allowance for the individual's private conception of colour harmony. A proper balance is maintained throughout between objective principle and subjective response culminating in important

chapters on 'The Spatial Effect of Colour', 'The Theory of Colour Impression and Colour Expression' and 'Composition'. The practising artist and student will find this stimulating because the subject is treated in a way that comprehends the achievements of the twentieth century. […] It is a work written by a painter and a distinguished teacher; it makes no pretentious claims. To the question 'In the realm of aesthetics, are there general rules and laws of colour for the artist, or is the aesthetic appreciation of colours governed solely by subjective opinion?' Johannes Itten replies 'If you, unknowing, are able to create masterpieces in colour, then unknowledge is your way. But if you are unable to create masterpieces in colour out of your unknowledge, then you ought to look for knowledge'. [Klee's and Itten's books] are a belated but superb addition to the line of great theoretical and didactic writings on art.

2.3 *The Value of Workbooks* (1969)

Extracts from a typed manuscript, dated May 1969, for the foreword to the book by Natalie d'Arbeloff (Maurice de Sausmarez Archive).

The art of the past furnishes countless instances of the extent to which the visual artist has been committed to the study of nature as the mainspring of his pictorial invention. The value of keeping sketchbooks and notebooks was never questioned; it was accepted as a necessary part not merely of the artist's training but as a continuing means of his retaining and replenishing his vocabulary of forms and notions of structure. It provided him with a storehouse of germinal ideas for later development […] There are very good reasons for believing that our response to abstract art, in so far as it has significance for us, is conditioned by association with the external world of tangible forms, sensuous experience of space, psycho-physical reaction to the laws of the real world; only an individual who is, or who has learnt to be, deeply concerned about physical substance and physical space of the external world can hope to produce meaningful non-figurative work. But the education of this response calls for an extension in the manner of using notebooks and many a young student is unclear about not only the value of this aspect of study but also, even when convinced, about the nature of the graphic note-taking activity itself.

Natalie d'Arbeloff has given in this book an admirable example [44] […] she offers it as *her* version […] emphatically, it is not offered as a stereotype, but as a provocation to more searching involvement in investigatory studies […] It is as a means of deepening not only our response to the external world and to the range and creative flexibility of the materials we use, but also of cultivating the power of invention, that a work-book has its full meaning and value. Gyorgy Kepes reminds us of this when he writes 'the difference between a mere expression, however intense and revealing, and an artistic image of that expression, lies in the range and structure of its form. This structure is specific … An artistic image, therefore, is more than a pleasant tickle of the senses and more than a graph of the emotions. It is meaning in depth, and, at each level, there is a corresponding level of human response to the world'.

Natalie d'Arbeloff clearly defines the nature of a work-book as a personal inventory of formal ideas, and she is well aware that it has its ultimate justification only in the development of works specifically related to the individual creative talent and temperament. It is, at one and the same time, a means of study and a spur to creative thinking.

2.4 *The Pen Drawings of Thomas Hennell* (1947)

First published in *Alphabet and Image* 4, Shenval Press, 1947.

Thomas Hennell, poet, painter and authority on husbandry and rural crafts, went to Java as an official war artist in the autumn of 1945. Soon after his arrival he was reported missing. He was a rare and accomplished artist. He had a deep understanding of the spirit of traditional craftsmanship. This understanding made him aware of the underlying convictions and the free and spirited imagination that were the birthright of the old craftsmen. It was from this understanding that he was able to write 'There is a mystery in what is simple, the mystery of the simplest longest lasting thing'. Only by appreciating the extent of Hennell's concern for the land and its traditions can one approach his work as a creative artist. His drawings are suffused with the spirit of the land; he was deeply interested in traditional husbandry because it stood for a mode of life and thought that was timeless and universal, a form of living in which natural laws were paramount.

Any technical method interested him, but he always spoke as if the most important consideration was the exact understanding, if not the literal representation, of the subject. Two records will suffice to show his determination to get to the heart of things. The following extract from a letter from one of his students gives a vivid picture of him about 1930, when he was teaching at a school in Bath. 'Most of his teaching was done by taking individual boys into a corner where he would talk to them with tremendous seriousness. He was a man who could express himself with great clearness but needed a more sympathetic and more developed mind in his listeners than he ever found with us. But he would never let his student go until he thought the lesson had been understood. This often took some time and we used to dread being taken over to the corner. The answer to an inquiry about a windmill once took him half a morning. Hennell at these times became totally absorbed in his subject. His descriptions were athletic. He became the sails of the windmill, he became the miller carrying sacks, he showed with his fingers the meshing of the cogs and gave lists of the hardwoods used for the different parts of the mechanism'. The following was a more recent account: 'It was winter and after supper round the fire he brought out bowls of apples and nuts. These were important because he had grown them himself and called them by their names and explained how they had to be cultivated and how long he had had the trees, whether bought or given, and how different was the fruit from similar trees on other soils in Essex, Somerset, Herefordshire, Wales, Scotland and Ireland. He had an intimate knowledge of his own neighbourhood and could quote all the crops and operations for the past twenty years or more'.

Many reliable authorities consider him to have been as fine a poet as he was a painter. He had a vein of powerful and unique imagery and he had studied widely and deeply. His book *The Witnesses*, in which he records his experiences as a temporary inmate of a mental asylum, has an undoubted importance to specialists in psycho-analysis, but also demonstrates how closely related was his poetic fantasy to the hallucinations of a mind 'possessed'.

With many painter-illustrators there is a clear difference between the two divisions of their work, and although there is almost invariably the imprint of identity, book illustration imposes a set of limitations that evokes a new manner or, as sometimes happens, a mannerism. The fact that Hennell only worked on books that were bound up with his own interests meant that he was never called on to compromise and his work demonstrates this integrity. There is an undisturbed and gradual maturing from the scrupulous care of the early drawings in *Change On The Farm* to the excited, free and masterly handling of the later illustrations to *The Natural Order* and the drawings for the *Architectural Review*. His keen rendering of the essential life of things is seen in his ability to give the character of man-fashioned things as distinct from natural growths. There is a different 'feel' about the pen-line that defines a garden gate and that which suggests the rustle of leaves. The act of drawing was for him not simply a polished technical accomplishment, consciously learned, but a spontaneous outpouring of the momentary pattern of his emotions.

There is a continuing conflict between those who would centre creative activity in the emotional sphere and those who would place it in the sphere of the intellect. The former has led in recent years to the worship of 'child art'; the latter too often leads to a self-conscious science of 'picture cookery'. To the artist both extremes are equally dangerous and yet both factors are equally important. Hennell's work at its best achieves a masterly interplay and tension of these forces. The seemingly effort-less tracing of lines, spontaneous and free, is controlled by a vision that has been disciplined to comprehend the total visual experience, each stroke contributing to a relationship that encompasses both the emotional content and the intellectual form.

In his watercolours, the broken washes of colour have all the vitality of the random splashes of the child, thrilled with the waywardness of the brush, and yet a longer and deeper scrutiny brings to light the tenuous line of the draughtsman in full control of the rendering of formal relationships.

Hennell was successful as an illustrator of books dealing with the countryside, largely because he allowed no aspect of his subject to go unstudied. Hob-nail boots, corduroys, a long flapping mackintosh with poachers' pockets in which he carried most of his equipment, and beneath his jacket pullovers and waistcoats, two to three deep, provided protection from the severest weather and enabled him to paint the countryside by lights and under conditions

Fig 8 Thomas Hennell (1903–1945) *Landscape: Flint Heap, Road-Making*, c.1937–41

Fig 9 Thomas Hennell (1903–1945) *The Tree*, c.1938–40

usually neglected by most landscape painters. His main means of transport was a huge upright bicycle laden like a pack-horse with paraphernalia, including long canisters in which he kept his stocks of precious water-colour papers amassed on his travels, rare varieties discovered in the most unexpected places. His sketchbooks were full of records of the progressive stages of changing landscapes, as of a copse being thinned and flax pulled, or the momentary actions of a plough-horse at work. The drawings for his book illustrations were generally executed half-imperial size, in a direct manner with little or no redrawing or alteration. The problems of the reduction in scale for process engraving were so thoroughly understood that there was no conscious limiting of the rhythmic flow of the pen or brush. Sickert used to say that the 'eye-catch' was the core of every drawing and that the drawing develops freely about this core until the concentration flags. Hennell's drawings have this unity and easy fluency. His art was founded on a deep study of the Old Masters, particularly Claude, Rembrandt, Blake and

Bewick, and he possessed an interesting collection of drawings.

He was deeply interested in methods of working; the conventional and unconventional figured, oddly assorted, in his outlook. A favourite tool of his was a pencil point dipped in ink, which gave an almost Chinese emphasis to the stroke which began with a blot of ink and trailed off to a line of pencil with no ink carried to its end. This was used under, in the middle of, and on top of watercolour washes, so that in the heat of painting he often had both his hands and his mouth full of implements. He could not work happily with oils, which he said behaved 'like toothpaste'.

Bicycling along country lanes, his eyes appear to have been gimlets piercing their way to the smallest object of interest, a dormouse to be gently coaxed out quivering on to his hand or a special kind of grass to be stored in the memory. There is a story of how, when drawing a threshing scene with a friend, he had said suddenly 'Did you see that dog eat the regimental stores?' On being questioned further by his nonplussed companion he had explained how the dog had eaten a man's lunch out of the pocket of his coat. 'But why didn't you stop him, Tom?' 'I was drawing the dog – the artist's job is to respond and to record'. His was an essentially contemplative attitude, an utter absorption into the life of the forms before him: there was no aggressive self-conscious attempt at the domination of Nature but a submission to its spell. Writing about appreciating the qualities in things, he says, 'to do so properly one should cultivate one's leisure; it's something like being able to relax completely and allow the beauty of the things to take effect'.

In an essay *In Praise Of Watercolour* written for the annual volume of the Old Watercolour Society's Club, Hennell says 'We look in a landscape painting not primarily for a rationalized statement nor for description of fact, but for the moment of vision. Rarely indeed is that supreme moment captured in an *important work* … The lyric is our forte, and today we come nearer to it in watercolour than in words'. Few contemporary watercolour and landscape draughtsmen today have captured this supreme moment more consistently than Thomas Hennell. The finest of his drawings are effortless and unselfconscious. There is an almost mystical element in many of his works – a mysticism of the earth, that is so much a part of the English genius.

2.5 *The Camden Town Group* (1950)

'The Camden Town Group – Pictures in the Leeds Collection', was published in the Leeds Arts Calendar, Vol.3 No.12, Spring 1950, pp.12–17, 20–24, 28.) De Sausmarez's introduction to the catalogue of the exhibition *Paintings by some Members of the Camden Town Group*, held at the Lefevre Gallery in November 1950, is a redacted version of the earlier essay. Text that appeared only in the Leeds essay is distinguished here by the use of *italics*.

English artists, unlike their French colleagues, seem reluctant to form groups or coteries. On the whole, they are suspicious of the sort of mental agility and capacity for dialectic so characteristic of French artist-circles. Since the beginning of this century French art has given rise to a perplexing number of movements, groups, and sectional interests. Over here scarcely half-a-dozen clearly articulate groups have emerged […] In each case the overcoming of insular reserve has resulted in a new dynamic power in English art. Of these groups the most important may prove to have been the Camden Town Group – important in its achievement and in its influence, which has lasted to the present time. […]

Apart from a certain agreement about the need for an association of painters that would give equal opportunity for exhibiting to artists of various tendencies whose views were in conflict with established societies, it is difficult to find any common factor. *Sickert, Gore, Gilman and Pissarro, with Manson, Bayes, Drummond, Lightfoot, Ratcliffe and Turner made one fairly closely related group; Innes, John and Lamb made another, while Bevan, Ginner, Wyndham Lewis and Grant were more or less outside both camps and themselves had little in common.* When the Camden Town Group is mentioned as signifying a particular technical handling, the reference is usually to the Sickert-Gore-Gilman faction and after a study of the paintings certain similarities in handling will be noted.

Gilman […] had been influenced by Sickert but later transferred his allegiance to Cézanne and Van Gogh. Spencer Gore, sensitive and poetic, developed from a form of pointillism associated with Camille Pissarro, and continued by his son Lucien, to extreme simplification of natural forms in a high-pitched key of colour. Sickert then at the height of his low-toned Dieppe period took on a higher-keyed palette and the use of small patches of colour juxtaposed on a groundwork of the chief masses of colour and

tone with occasionally the hint of impasto. He had come under the influence of Camille Pissarro (via Lucien and Gore) and had realised the value of the new prismatic chiaroscuro which obviated dark undecorative shadows [...] R. P. Bevan who had worked at Pont Aven was developing, in angular patterns of shape, his own variant of Gauguin's simplification of form and theory of synthesis [...] and Ginner too had lately arrived from France with Post-Impressionist theories to discuss.

To the circle Gilman contributed a capacity for dialectic and the forthrightness and conscience of an evangelist. At the time of the formation of the Group he had already begun to adopt a palette of prismatic colour and was loud in his denunciation of "dirty" painting. *Bitumen and all the "useful" mud of academicism was anathema. Even his previous mentor Sickert was occasionally decried for failing to adopt the Signac palette. From his days at the Slade School until his death in 1919 Gilman struggled continuously to extend the boundaries of his own art by intelligent experiment and enquiry* [...] Velasquez and Whistler were his early models until Sickert's influence prepared the way for Post-Impressionist ideas coming from Ginner and, finally, his love of Van Gogh.

In 1914 Gilman coined the term 'Neo-Realism' to describe the content of works he was then exhibiting at the Goupil Gallery. It stood for (1) personal research, (2) love of medium, (3) objective transposition of nature. Through 'this method of intimate research' results 'a decorative composition which is an unconscious creation produced by the collaboration of Nature and the Artist Mind'.

Sickert's House at Neuville is reminiscent of Vuillard, whom Gilman greatly admired. Again there is a simplicity and restraint about the whole work with its infinite subtleties in the relationships between variations of warm and cool greys. A complete lack of self-consciousness characterises the work. There is no element of illustration, no stressing of descriptive fragments. Here we have a piece of visual poetry of the quality of Proust's writing. [...]

Mrs. Mounter is a lovely low-toned work on a scheme of plum, dull khaki-greens with a note of

Fig 10 Harold Gilman (1876–1919) *In Sickert's House at Neuville,* 1907

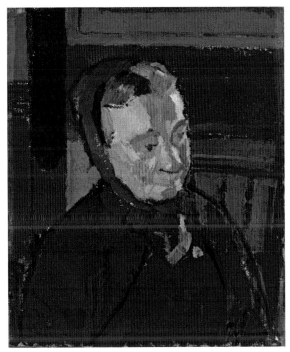

Fig 11 Harold Gilman (1876–1919) *Mrs Mounter,* 1916–17

vermilion. The transitions of form built in facets of colour retain the decorative intention while suggesting convincingly the plastic qualities. Again there is a creamy richness of paint and a delight in its substance. Gilman painted many versions of his old landlady and Frank Rutter has referred to them as 'the apotheosis of the charwomen, the transfiguration of homeliness, age and toil into a spiritual loveliness of colour that time cannot wither'.

To stand close up to [a painting by Gilman] and let one's eye move across its jewel-like surface of sumptuous colour is to experience a rich and sensual pleasure. Then to stand back and, through the logic of the relationships, to watch the mosaic of brilliant colour build the substance and density of the forms. This brings an intellectual satisfaction to complete the synthesis of reason and emotion, the dual basis of all great works.

In his later works [...] Gilman states the main 'colour-focus' in terms of the most brilliant colour that can reasonably be associated with the particular form or localised area, and from this pursues a logical transposition of colour, *preserving always the authentic sequence of colour tones* [...] Unless one is prepared to surrender to the delights of Gilman's sensuous use of paint and orchestration of colour, the significance and value of his mature works will never be fully appreciated.

In 1914 Spencer Gore died at the age of thirty-six and it is probable that the loss of this brilliant young artist was a contributory factor in the gradual disintegration of the Camden Town Group and its merging into the London Group [...] Endowed with a super-sensitive perception and a capacity for transforming the commonplace and familiar into visions of exquisite freshness, Gore is one of the most rare and personal artists of the last half century. [Lefevre introduction continues] Paintings of extreme tonal subtlety built up with small comma-like touches of broken muted colour characterise his early work. His later manner shows a broader and more vigorous handling and a dependence on simple schemes of colour. The essentials are stated with firm strokes relying entirely on the logic of tone and colour juxtaposition for their pictorial coherence. In the best of his final works there is a power and monumental quality added to his personal distinction of colour which give them a unique place in British painting.

Charles Ginner [...] remained faithful to his muse despite the vagaries of fashion and his work is as unique now as it was in 1911. A zest for construction, an unaffected delight in bricks, tiles and the wealth of detailed vision and a love of richly encrusted pigment. Every Ginner is a triumph of patience, loving care, unselfconscious delight in the visible world and persistent effort [...] Formalised pen strokes and scratches explain the differing qualities and textures in leaves, trees, brickwork and pavement producing the effect of fine embroidery [...] crystalline in its statement.

It can be claimed with ample justification that the Camden Town Group of painters has had an influence on English painting more potent than any since the beginning of the century in establishing a clear channel for the transfusion of Post-Impressionist principles and vitality into the central tradition.

2.6 *L.S. Lowry* (c.1959)

Extracts from manuscript notes for the opening address of an exhibition of works by Lowry, c.1959 (Maurice de Sausmarez Archive).

We have been offered on the one hand a picture of a naïve Sunday-painter and on the other the attempt to read into his early work a conventional academic grounding that he later renounced. Neither has seemed credible [...] Despite his attendance at Manchester School of Art Lowry never really came to terms with the conventions of academic training. The [early] works are gauche in the extreme, with surprisingly little idea of what the problems were that they were attempting to solve. They are struggling attempts to ape an acceptable style, but, thank God, Lowry has been consistently unable to play the ape. As an individual and as a talent he has been too genuine for that. It is only the subjects of these early works that are at all academic. It is also nonsensical to speak of his Impressionist period. There is nothing to support such a claim, unless it be the sketchy, separated brush strokes to be seen in one or two examples – certainly not sufficient to merit the term 'Impressionist' [...] The miracle occurred when his eyes were suddenly opened to subject matter so completely expressible with his particular technique that today we emerge from the exhibition to see everywhere around us the structure of a Lowry world. No longer did his technique seem at odds with the

forms in his pictures, it became the most perfect instrument for their expression.

I have said 'We see the structure of a Lowry world about us today', but it is quite false to salute him as a social commentator on the mid-twentieth century. His crowds wearing bowler hats and toques still debate the merits of Mary Pickford and Fatty Arbuckle, this is not the world of Bardot and Elvis; and a slick American car would seem almost as out of place in his whitened streets as it would be in the Sahara. The fact is, Lowry is an elegiac poet. His pictures, for all that they use the topography of Pendlebury, Salford and the Oldham Road, are recollections of a past, are personal reconstructions in the imagination, vehicles for that tenderness and love of the industrial environment of his youth which has consumed this artist throughout his entire working life […] He has an inborn sensitivity to dimension. The division of each canvas into its big, simple areas is captivating. This, even before one considers the subject, is an experience of the utmost rarity.

He has a fine sense of scale and his ability to organise complex crowd masses in movement is surprisingly free from repetitive conventions. He really loves the shapes of things. Again and again it is the loving concern for the silhouette and the shapes between forms that has absorbed his attention.

There is too, an enjoyment of paint, not perhaps an uninhibited sensuousness, but a pleasure in its variable texture as a means of expression and the qualities he can conjure from his simple palette of cobalt blue, black and white, vermilion and yellow ochre, giving rise to what we might justifiably call Lowry pinks, greens and lavenders.

2.7 *Georges Seurat* (1959)

Published in the *Leeds Arts Calendar*, Vol.42, 1959, pp.5–11.

This year marks the centenary of the birth of Georges Seurat, the only major figure of the end of the nineteenth century who has suffered serious neglect by critics, galleries and public alike. Less than a dozen monographs have appeared since his death in 1891 and most of these are lamentably inadequate. Only during the brief period of Cubism's ascendancy was Seurat's genius truly appreciated. Not merely is this neglect due to the fact that he represents the antithesis of all the assumptions on which most of the practice of today's painters is based, but his

reputation was damaged almost from the start by the host of 'followers' who at his early death seized upon the least important aspect of his work, the purely manipulative, and reduced it to banality. No method can transform mediocrity and Seurat remains the one and only genius of neo-impressionism. But even this statement is misleading since Seurat was closer to the Renaissance than to the Impressionists and in spite of his fanatical attention to the nineteenth-century theory of colour as expounded by Chevreul and Charles Blanc he remains true to the tradition of della Francesca, Raphael, Poussin and Ingres. He once defined painting as 'the art of hollowing a surface', an essentially Renaissance conception, and like the true Renaissance artist Seurat followed this up by emphasizing his conviction of the absolute need to base his theories on scientific truths. Again, like the true Renaissance artist, the sciences he principally consulted were mathematics and optics. Ambiguity he always shunned; his work and talent expressed themselves with impeccable logic and precision, and it was Seurat's uncompromising determination to develop his works on a scientific aesthetic that provoked and still provokes the hostility of critics. But it is precisely the detached objectivity of his pictorial geometry that brings into being, as it does with della Francesca, the unearthly and transcendent stillness, the poetic monumentality of his great works.

As so often happens in painting the critics and the public seized on the material factor of manipulative technique and lost sight of the deeper content of the work. Paul Signac, the most loyal and gifted of Seurat's colleagues, has said that 'the spot is merely a stroke, a method, which like all methods, is of no importance'. It is easy to understand why these painters have invariably repudiated the word 'pointillist' as a label almost as disagreeable to them as the still more insulting 'confettist'.

If paint is to be applied to a surface the painter is forced to use that method which suits best his purpose and in the case of the 'chromo-luminists' – to use the word adopted by Seurat – the spot offered maximum opportunities of control of colour division and of balance and proportion. It made a show of bravura impossible and allowed for that self-effacement of the painter in the interest of a greater concentration on the created work, which is one of the first principles of classicism.

Fig 12 Seurat *Hospice & Lighthouse, Honfleur*, 1886

Figs 13 & 14 Diagrams made by MdeS analysing the pictorial geometry of Seurat's *Hospice & Lighthouse, Honfleur*

Even this technique of divisionism has been widely misunderstood. The errors range from the naïve assumption that only three colours, red, yellow and blue, together with white, were used, to the idea that all prismatic effects were 'broken down' to the basic components and applied in separate dots. An examination of a Seurat reveals that the guiding principles were 'purity' and 'vibrancy'. A retinal fusion of blue and yellow dots does not produce a vibrant green in the same way that red and yellow dots produce a vibrant orange; it produces a dusty grey. In consequence we find Seurat achieving his green vibrancy by the association of warmer and cooler greens.

In addition, Seurat gave particular attention to the choice of a touch proportional to the size of the picture and, set beside his followers, in this he is exemplary. Where they are often heavy, laboured and banal, he is sensitive and delicate without weakness.

None of the hostility of the critics deflected him from his purpose. He never attempted to reply except by painting yet another picture, or, as he would have it, another experiment, since we know on the evidence of his friend Verhaeren that he only considered his works truly significant in so far as they proved a law or concept, only in so far as they furthered the identification of science and art. He worked prodigiously hard and prodigiously long

hours to produce the seven large paintings and some forty smaller paintings which, together with the preparatory sketches and drawings make up his entire legacy. He died at the early age of thirty-two and the major part of this output was packed into the last nine years. Measured against Van Gogh's frenzied outpouring in a working life of approximately the same length we can appreciate Seurat's patient and scrupulous approach. His masterpiece *La Grande Jatte* took nearly two years to construct with some forty preparatory oil sketches and some twenty-five drawings, and this is characteristic of each of the other major works.

Far too much attention has been paid to the technicalities of 'pointillism' or 'divisionism' in relation to Seurat and not enough to the aesthetic as a whole on which his work is based. In consequence his foreshadowing of Kandinsky, in his belief in a relation between the laws of optics and the laws of musical harmony, and his anticipation of Mondrian, in his compositional theory, have gone unnoticed. The link with Mondrian is too remarkable to be merely coincidental and would seem to be direct through the intermediary of Jan Toorop, who was a faithful follower of Seurat and a close friend and formative influence on Mondrian.

What Seurat attempted was a new classical Renaissance. The prevailing tendency was, however, in the direction of the rising Symbolists and Seurat's lack of interest in subject matter was an obstacle to the avant-garde of his day, as it remains an obstacle to the general public of today.

Before his death Seurat witnessed the gradual disintegration of the group that had so enthusiastically adopted systematic divisionism. The method had proved itself to be only of value to those whose temperament and creative talents made it consistent and flexibly expressive. Seurat continued to work unperturbed and seems deliberately to have made each of his large pictures an essay in a particular aspect of pictorial composition; groups of people out of doors in sunlight (*La Grande Jatte*), built on vertical struts and arcs; people under artificial light (*La Parade*) built on rectangulation; nudes in an interior (*Les Poseuses*), freer curvilinear organisation; movement of figures in artificial light (*Le Chahut*), diagonal emphases; and an attempted synthesis of all these compositional ideas in the final unfinished picture (*Le Cirque*).

One side of his work that deserves to be better known is his draughtsmanship. It is characteristic that he should have chosen a medium (black conté) that allows of no correction, that enforces unequivocal statement. Contour lines are never stated, never limiting, but implied by the subtle tonal gradations of masses working always from the centre of density outwards to the periphery creating roundness and volume.

2.8 *Recent Figurative Painting* (1960)

Introduction to the catalogue for the exhibition *Recent Figurative Painting*, held at the University of Nottingham Art Gallery, 13 January–7th February 1960. The exhibition featured the work of Craigie Aitchison, Michael Andrews and Frank Auerbach.

The naïve, critical attitude of some earlier writers on Modern Art saw in the invention of photography the death of the traditions of realism in painting. In the same way, the decline of individual patronage and the new enthusiasm for design related to the technology of mass production encouraged funeral orations for the art of easel painting. The scientific optimism of the nineteenth century had its counterpart in the commonly held notion, implied if not actually stated, of 'progress' in art, and it was not unusual to find figurative painting summarily dismissed on the grounds of its being out-dated and anachronistic. Today, we are better able to assess the fallacies in each of these attitudes.

Realist painting of the latter half of the nineteenth century was, in its final phase, completely

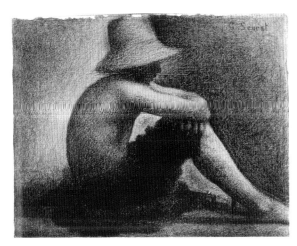

Fig 15 Seurat *Seated Boy with Straw Hat, study for Bathers at Asnières*, 1883–84, black conté crayon on Michallet paper

unconcerned with the factual, unselective, descriptive statements of photography. One has only to look at the last works of Monet to see this fact. Modern psychology has made it clear that sense-perception is essentially and subjectively selective and that 'pure' sensation or passive objectivity is an illusion, an impossible and, in any case, useless ideal for the creative artist. Courbet's value as an artist is solely dependent on his passionate, subjective and sensual response both to Nature and to the medium of oil paint and has very little to do with his objective realism.

Young painters in the mid-twentieth century have steadfastly, if not altogether confidently, refused to accept the demise of easel painting and, although the traditional tools and techniques of painting have often been rejected, there has still remained a solid core of young contemporary painters loyal to the medium of oil paint and to the scale of the cabinet picture.

The notion of 'progress' in art is one that cannot seriously be sustained. The art of painting is not concerned with a sequence of conceptual statements that can be proved true or false, giving rise to a development involving supercession; it is concerned wholly with qualitative experience and, to a large extent, with individual responses to experience. Under the pressure of ideological, technical, social and economic forces, of which the artist may or may not be conscious while working, it changes its idiom; but change is not synonymous with progress, and the epithets 'traditional', 'progressive', 'old art' and 'new art' are impossible to define without giving rise to dangerously false implications. Abstract painting is not necessarily more progressive than figurative painting. The example of Juan Gris and Nicolas de Staël is significant in this context. Gris arrived at a final, simple, synthetic, representational image, starting out from what he called 'a painter's mathematics'; and de Staël moved in his development from forms of abstraction comparable with Kandinsky and Magnelli to mirage-like figurative painting in images of extremely condensed simplicity.

It has to be admitted that the Renaissance tradition of humanist idealism has given place to a concentration on immediacy, subjectivity and a fundamentally 'existential' concept of Man in his relation to Nature. Figurative painting, which has too often been popularly identified with imitation, has gained a new dimension – almost invariably today it

has strong psychological inflections. The influences from Cézanne have changed to predominant expressionist enthusiasms.

In England, the great convulsions and revolutions of modern painting made singularly little impression until comparatively recently. From the year 1910, when the first Post-Impressionist exhibition was held in London, Fauvism, Cubism, Futurism, Expressionism and Surrealism seemed to pass by with little more than a nod from one or two English artists. The London Group, which was the first significant expression of post-impressionist sympathies, was initially dominated by Sickert and the English neo-realists (Harold Gilman, Robert Bevan, Spencer Gore and Charles Ginner), and a group of Cézannesque painters. Wyndham Lewis and the Vorticists, when they appeared, exerted little influence. Up to the outbreak of the Second World War, with the exception of a small surrealist group, figurative painting in England centred largely in the attitudes represented by Stanley Spencer, Augustus John, Paul Nash, and the short-lived Euston Road School. Painters like Matthew Smith, Ivon Hitchens and David Bomberg, who were closer to continental movements, worked in relative isolation from the main stream. Immediately following the War a broader interpretation of figurative painting could be detected, showing influences from Bonnard and Vuillard, Picasso, Matisse and German expressionism. Today the pre-war insularity has completely disappeared and younger painters are now intensely aware of the wider horizons of European and

Fig 16 Auerbach, Shell Building Site, 1959

transatlantic art. Figurative painting has gained a new stature through the realisation of the immense range of possible development represented by artists as widely differentiated as, for example. Utrillo, Munch, Ensor, Soutine, Kokoschka and Giacometti.

The painters represented in this exhibition demonstrate some of the variety to be found in figurative painting in this country today. For some, it is a situational interest; for others, it is the unrelenting and unevaluated battery of the visual impact of contemporary living, or the fierce rhythms of inevitable commitment; others, again, are compelled by the nightmare acceptance of the menacing images arising out of the horror-content of our time, or the self-identification with the felt organic pulse of existence. But common to all these attitudes is the rejection of a disengaged contemplative vision and the acceptance of complete involvement.

Figurative painting today is no longer a submission to the visible world in purely descriptive terms but is an interpretation of it. It is representative not only of a sympathy and confidence in the organic processes of life that characterise earlier periods, but also of melancholy, brutality, despair, psychological tension, social protest, the expression of Angst and fantasy. But whatever the reaction of the painter, he is able to say with Husserl that it is 'to this world, the world in which I find myself and which is also my world-about-me, that the complex forms of my manifold and shifting spontaneities of consciousness stand related'.[45]

Fig 17 Dubuffet, Corps de Dame-Château d'Étoupe, 1950

2.9 *Dubuffet in Paris* (1961)

Review of the retrospective exhibition, *Jean Dubuffet 1942–1960*, held at the Musée des Arts Décoratifs in Paris (December 1960–February 1961), published in *Motif* 6, (Spring 1961), pp.1–2.

Jean Dubuffet, who Alfred H. Barr as long ago as 1945 described as 'possibly the most original painter to have emerged in Paris since the war', has been officially honoured. Sometime wine merchant, sometime maker of theatrical masks, sometime meteorologist, occasional writer, Dubuffet is a man of exceptional intelligence with, to judge from his works, an undercurrent of truculent satirical incisiveness; the greatest representative of l'Art Brût.

After a colourful introductory gallery of early works, fresh with the affecting gaucheness of children's painting and a fine colour sense, one was projected into a world of aggressively disturbing images scratched and torn from grounds of coarse cement or textured paint or plaster. The vivid colours of the early works gave place to earthy greys and cold whites, a context in which sand can take on the brilliance of sunshine, and to a heavy surface matière of tar, pebbles, coal, broken glass and other extraneous substances. The child gave place to the maniac. After the initial shock of these brutal images, one managed to adjust oneself because there was such a degree of similarity in the simple images, that the mind and eye grew accustomed to the brutality in much the same way that the eye is soon conditioned to the 'spirituality' stereotyped in the hundreds of variants of the Sienese Madonna and Child pattern.

One's visit then threatened to become merely a tour of inspection of the astonishing virtuosity in the treatment of surfaces; skiddy varnished palette-knifed paint set in rough cement studded with pebbles, paint sludge built into the tumultuous landscape of a face and scored with a stick, cement sand and fibrous hair set with tiny fragments of mirror glass.

But a series of nude figures gouged into patiently fabricated wall surfaces shattered again any cultured poise. In these primitively erotic signs and images, these figures with their prominent genitalia, Dubuffet, like a Holman Hunt of the Urinoir, establishes a focal and tactile intensity in every part of the surface that ultimately becomes more affecting than the nominal subject. In fact throughout the exhibition there was the same obsessional concern with textural minutiae that one finds in Pre-Raphaelite painting.

The late landscapes, like large modelled physical relief maps, are some of the most important works; more painted, more deliberation shown in the changes of value within the monochromatic scale, more relationship between the separate units that make up the whole.

After moving through one complete gallery devoted to his graphic work and three-dimensional assemblages (objets trouvés deliberately placed to evoke figurative ideas) showing as powerfully varied an inventive textural exuberance as any early surrealist, a return was made to the nightmare horror of his main development.

The stained ectoplasmic figures of 1954 are terrifying; a form of scabrous rotting seems to attack the painted surfaces and as one looks one is aware of the process of decay taking place before one's eyes. The beautiful resolved decorative collages of 1956 bring relief with a new kind of affirmation of the structure and beauty of nature and one passes on to the neutral serenity of the texturologies and materiologies. And yet here another disturbing thought obtrudes. These texturologies are merely large continuous fields of texture with nothing to clearly set them apart from sections of a gravel path or a rough cement wall. The thought of a human being, compounded of sensibility and mentality, spending hours of work to achieve an identical painted image of 20 square feet of gravel path is a truly disturbing one.

On the final wall of this exhibition a guard of honour appeared to have been mounted to see one off the premises, a monolithic line-up of old bearded cynical idiot-sages, but the coup de grace was actually delivered by the mocking image entitled *L'Inconsistent*. It is hard to resist the thought that Dubuffet intends this to characterize humanity that he has laid bare with his scalpel, his gouge, his trowel and his corrosive wit.

This was an exhibition to challenge the premises of every sort of academic painting, figurative and non-figurative, to challenge the old guard and the avant-garde; Dubuffet's is an art perhaps even more socially realistic than the social realists.

2.10 *Paint and Matter* (no date)

Unpublished manuscript notes (Maurice de Sausmarez Archive).

[…] Dubuffet's texturologies are only a small part of his work and to me his significance is bound up with the creative exploitation of matter […] The principle of stratification means that the structure of matter holds within itself a chronology, a history, a process in time locked in a single substance. Rembrandt's impasto does not affect us merely by its contributing greater density to the painted flesh, its own density seems to be an equivalent for Nature's process of growth and maturity, we feel that the paint substance shares and contains something of the secret structure of life's own development. The phases in the development of the impasto are clearly felt and have deep symbolic significance – and this symbolic significance is all the more profound the more we are able to follow, in the buildup of the impasto, the phases of striving towards a definite end. Intention is an aspect of the future and it remains in the future as long as the present is unable to satisfy it. Yet the attempts at resolving the intention which are enacted in the present, immediately they take on material form belong to the past. Painting therefore has the possibility of being an activity in which future, present and past are held together and timelessly symbolized in the substance of paint, the structure of pigmentary strata.

2.11 *Contemporary Sculpture* (1960)

Introduction to de Sausmarez's study of 'Four Abstract Sculptors – Hubert Dalwood, John Warren Davis, Trevor Bates and John Hoskin', published in *Motif* 5 (Autumn 1960), pp.32–43.

In the sumptuously illustrated *Art Since 1945*, (published by Thames & Hudson), surveying the developments in art in the West since World War II, it should not go unnoticed that out of the 120 illustrations only five are concerned with sculpture and all of these accompany the essay by Sir Herbert Read on the contemporary scene in Britain. Admittedly the publishers have acknowledged on

the wrapper that 'the book deals primarily with painting', and in this it is admirably comprehensive. But the fact remains that in a work of 375 pages on art since 1945 barely twenty pages are devoted to sculpture, and there would seem to have been no pressure on the contributors to avoid this field. There is at the present time a natural inclination to look to painting as the source of new developments; it is characteristic of periods in which transience and the flux have been preferred to permanence and the static. A considerable amount of contemporary sculpture demonstrates close affinities, sometimes to the extent of sharing the same symbols and shapes, with aspects of painting. Today sculpture, which can boast greater talent than it has known for years, is suffering cruelly financially – costs of material, costs of transport, costs of studio-space, costs of casting and the cost of time place it at a considerable disadvantage with painting, which now often seems to require no more than a few tins of hard gloss, some hardboard and a spoon. The interested spectator who has assimilated the consequences of the revolutions in modern painting is not infrequently ill at ease with modern sculpture. There was, it is true, less of a break between Rodin and Michelangelo than between Monet and Raphael, but there has been no Cézanne of sculpture and the occasional sculpture of painters between 1900 and 1930 (Modigliani, Picasso, Boccioni, Matisse) has often been more widely disseminated than the work of the great source-figures of modern sculpture (Brancusi, Gonzalez, Lipchitz, Arp). The public is in consequence less well prepared in approaching recent developments in sculpture and even the lessons that it has learned from the widely shown works of Henry Moore are limited in value and application.

There is a continued belief that the human figure and the forms of landscape are the sole 'referents' in the appreciation of sculpture; that form is synonymous with material bulk; that there is an aesthetic sanctification of specifically sculptural material and it is still often assumed that, as Gaudier-Brzeska wrote, 'Sculptural feeling is the appreciation of masses in relation; sculptural ability is the defining of these masses by planes'. Perhaps nothing is more characteristic of the younger generation of artists than their desire, not necessarily consciously or deliberately expressed, to prove all constrictive definitions and aphorisms false.

The human figure and the forms of landscape are now only two among the many referents and generative sources of sculptural ideas. The world of technology, scientific data, science fiction, the 'banality' of everyday things, fragmented forms of the subconscious, magic hieroglyphs, vegetal structures and the intuited images arising from the basic material used, all are accepted as generative sources, but all are transmuted in the crucible of sculptural feeling […]

In sculpture today Man is not only related to the organic world through organic forms, he is directly related to modern consciousness through the creation of symbols that, ambiguous and esoteric as they often are, nevertheless seem to attempt the humanizing of technology, stimulate forebodings or purge despair. There is as it were a symbiosis of natural and technological structure that encourages a sympathetic revaluation of twentieth century environment. […]

The scientist's definition of form as 'a diagram of forces' is as true for much modern sculpture as it is for modern painting. The elements of a structure are considered in much the same way as the energies in an electromagnetic field. Interest is now not so much in the condition of 'being' as in the potentialities of 'becoming', the 'process' is preferred to the 'state' and is often left clearly evident in the final image. Again the authority of Nature is invoked. Form is often translated from mass into a pattern of lines by which the sculpture attains a 'transparency' and the void is as charged with sculptural significance as the solid. Space has become a key word in mid-twentieth century art and the sculptor as well as the painter accepts the definition of space as 'the relation between the position of bodies' (not necessarily static volumes where the limits of bodies can be measured but also dynamic fields of forces and energies which cannot be measured but are intuited or felt). In much the same way that Kandinsky has encouraged the painter 'to enter a painting, to move around in it and mingle with its very life' so the contemporary sculptor demands of his audience this imaginative act of self-identification with the interior nature of the made object or the organization of space. This body-felt reaction to an object, situation of forms, or activation of space gives rise to an association of ideas, many so deeply embedded in the human psyche as to resist conscious clarification. Here a reference to four

Constantin Brancusi New Born 1915 photo Giedion-Welcker: from
Contemporary Sculpture, George Wittenborn, Inc, New York

Barbara Hepworth Oval Sculpture 1943 16½" long plane wood,
concavities painted white *collection Margaret Gardiner*

William Turnbull Head 1955 9" long bronze

below Hubert Dalwood Large Object 1959 32" × 39" aluminium
collection Tate Gallery

Fig 18 Photo of original article in *Motif* 5 showing four instances
of the 'egg' form

instances in which the 'egg' form has been used to convey essentially different sculptural feeling will be helpful.

Brancusi's *Sculpture for the Blind* of 1924 […] is a form of essentially gentle meditative calm retaining a soft warmth – it is in marble – and demonstrating the superb control of the form's rhythm to activate the light-space. Although this is a carved form the sensation is of the form being conceived from within, not arrived at from without, and there is a compulsive identification of oneself with its tranquil centre.

Barbara Hepworth's *Oval Sculpture* of 1943 is again a carved form but here there is no feeling of the form having developed from inside but of its having been pared away. The cellular hollows have been arrived at by penetration from the outer surface. Like the pebble worn by the action of the sea it symbolizes vast impersonal forces and links us with concepts of space far beyond its actual physical dimensions.

William Turnbull's *Head* of 1955 is a modelled form but the sensation it produces is not of an expansive building up, and not of the steady erosive principle inherent in the Hepworth, but a corrosion in which the forces bite inwards to the centre and the vicious slashings of the surface are like self-inflicted wounds.

Hubert Dalwood's *Large Object*, 1959, is also a modelled form, cast in aluminium, and here the sculptural content is again different. An exuberant expansiveness characterizes this form with the energies moving outwards from the centre giving the surface the character of a ripe fruit. The indentations and scorings of the surface bear the mark of direct manual attention and pressures; they contribute to the vivacity of the play of light over the form.

The principle of 'truth to material' which was part of the sculptural catechism of the 'thirties has shown signs of crumbling. The Surrealists had, of course, never accepted it (one still shudders at the memory

Fig 19 (opposite) Poster designed and printed by William
Culbert for the lectures given by de Sausmarez at the RCA
(79.5 × 57.2 cm)

In the spring of 1960, de Sausmarez was invited to give a series of three lectures at the Royal College of Art to mark the fiftieth anniversary of the publication of the Futurist Manifesto on painting. The topics prompted by this gave de Sausmarez the opportunity not only to examine dynamism, Orphism and Futurist painting, but also to venture into interconnections between the development of artistic ideas and other changing aspects of contemporary thought, ranging across philosophy, psychology, physics, and mathematics. 'The development of science and the development of art since Cézanne has tended to shift our interest from things to patterns of structure, patterns of growth, development in time.'

FEB 11 1910

Three lectures on topics suggested by the fiftieth anniversary of the first manifesto on futurist painting february eleventh 1910
MAURICE de SAUSMAREZ
science museum lecture theatre feb. 8, 15, 22

of the cup and saucer made of fur) and had often appeared to work on a diametrically opposed notion that 'untruth to material' is a means of invoking new sensory and revelatory experiences. With the coming of synthetic materials (though not yet widely used in sculpture) the question of what is true to their nature is unanswerable since their synthetic character gives them potentialities in use covering completely opposed structural principles. Although it is still true to say that the good sculptor continues to respect the inner nature of his material there is a far less restrictive application of this general law; rather is it an exuberant response to the full potentialities of the material, a desire even to stretch it to its limits. A considerable number of young sculptors might be called 'abstract expressionists' deriving from a strange amalgam of surrealist, constructivist and expressionist influences. They would say with Louis Aragon 'Material has no sentimental importance, invention is everything', a dictum equally applicable to the traditions of Baroque sculpture.

The *objets trouvés* of surrealism were justified by Kurt Schwitters in his uncompromising phrase 'Everything the artist spits out is art'. Such a thesis is admittedly the most extreme form of romanticism's ego-centricity. By the same token anything the artist chooses to select from the material objects of environment can be expressive of his creative personality. As Sir Herbert Read has put it, 'Selection is also creation … Nothing is so expressive of a man as the fetishes he gathers round him … Art in its widest sense is an extension of the personality: a host of artificial limbs'. There is the danger of this becoming merely a new naturalism, more pointless than the old, to be justified in Courbet's terms, i.e. 'The beautiful is in nature, and it is encountered under the most diverse forms of reality. Once it is found it belongs to art, or rather to the artist who discovers it. … Beauty as given by nature is superior to all the conventions of the artist'.

The fashionable rejection of deliberation and the emphasis on automatism and purely inspirational techniques in contemporary art is an almost exact parallel. The configurations which many action painters achieve today with expenditure of considerable physical effort are not intrinsically so different from those achieved by nature's 'laws of chance' in millions of instances daily. Some contemporary sculptors pose this problem in an equally direct way. The forms

used are often made to look stratified and appear so arbitrary in shape as to suggest exhibits in a geological museum […] There is a poetic ambiguity in the interplay of landscape and human figure allusions, and an enforced retreat from the sophistications of cultured response to that primordial level of animistic experience that has given to many an outcrop of rock formation on a regional map names like 'Cow and Calf' or 'Devil's Seat'. The image follows the form; the making is an imageless act, the image arising as a consequence of what is made.

Susanne Langer has written 'Works of art are projections of *felt life*, as Henry James called it, into spatial, temporal, and poetic structures. They are images of feeling, that formulate it for our cognition'. Communication on such a basis must assume that despite the individual nature of our experiences and feelings there is a fundamental level on which experience of the vital issues of living are shared. As Sir Russell Brain has recently said in the course of his broadcasts on *Symbol and Image*, 'the richer the experience of the observer, and the more sensitive his receptiveness, the more likely it is that he will share, in part at least, the artist's feeling'.

Much contemporary sculpture seems to be intimating that only by a return to 'primitive' sources of response and the most fundamental forms can we hope for a new sculptural development to match the present efflorescence of talent.

2.12 *William [Bill] Culbert* (1965)

Introduction to the catalogue for the exhibition *Bill Culbert Paintings*, held at Nottingham University Art Gallery, 20 May – 13 June 1965.

William Culbert has moved a long way since [his first exhibition in 1961]. In that show, the culmination of his years of study at the Royal College of Art, he appears in retrospect to have been establishing for himself firm ground in known territory for the later developments, and already there were personal essays that broke through his sensitive and intelligent Futurist appropriations. But if the superficial influences of that early period of 20th century painting were being shed, something of its creative philosophy was to remain and provide a lasting and a deepening influence.

In the same way that the concepts of Bergson often seem to illuminate the work of Boccioni and

Fig 20 Bill Culbert, Transit, 1964

Severini, so they throw light on Culbert's second phase. Few extracts could more readily offer us help in approaching the works of 1962–63 than this quotation: 'No one image can replace the intuition of duration, but many diverse images borrowed from very different orders of things may, by the consequence of their action, direct the consciousness to the precise point where there is a certain intuition to be seized.' The elements in the paintings of that period function both as structure and symbol – the painter in his deux-chevaux experiencing the Provençal landscape, the fusion of human internal 'reality' and the kaleidoscopic transformations of external reality. But already the representational was giving way to the presentational – the saw blades, the grooved wood, the oil drum tops, the objets trouvés pointed to a changing concept of the relationship between creator and created. It was as though each work was already foreshadowed in the forces intuitively felt to exist within the elements employed, the painter himself being caught up in the process of resolving a matter-energy dichotomy to reveal, in the synthesis, meaningful relationship, meaningful in the sense of belonging both to the sensuous realm of subjectivity and to the disciplined order of objectivity. These energy-tensions operate in the visual pull of masses and colours and through the tendency of the eye to be seduced into pursuit of linear directions. The creative

process that is seen to be emerging in these works of 1963 is central to the developments from mid-1964 to the present time. Works like *Cognate* 1964 and *Supremes* 1965 present the idea of movement, which has been a continuing obsession with Culbert, in a 'positional' fashion […] Other works like *Involution* 1964 and *Ingress* 1965 produce the effect of motion through the superimposition of a sort of latticed surface operating at one vibrationary optical rhythm upon a ground moving at a strongly contrasted visual speed. There is a concentration on the deployment of the inner energies of colours, of shapes, of juxtaposition, to achieve rhythmical sequences that give a new meaning to the term 'pictorial dynamism'. These works are breaking fresh ground […]

But one characteristic of Culbert's work which sets it aside from much that operates only on the level of optical tensions is its sense of the 'documentary'. Each painting has a vivid sense of being grounded in something experienced, though it would be hard to trace the elusive symbolism: each work operates as structure and as symbol.

The special characteristic of creative activity in the arts lies in *enforming*, imposing form upon inchoate material, creating structural coherences. When a painter or sculptor says, 'That colour doesn't work, that shape doesn't work', he is intuitively aware of a break in the organic system which is the painting

or sculpture. There is no precise means of defining theoretically this structural coherence, and with much contemporary painting there is no way of preconceiving it, the canvas being the very field upon which the search for correspondences and contrasts takes place. But the faith that such coherences can be discovered and created has animated the efforts of generations of artists. William Culbert's work is amongst the latest and most vital manifestations of this quest.

2.13 *Carel Weight and Roger De Grey* (1966)

Introduction for the catalogue of the exhibition of work by Carel Weight and Roger de Grey held at Nottingham University Art Gallery 14 January – 8 February 1966.

As though to make amends for its failure to support new developments in painting in the last century, the intelligentsia has today developed so phrenetic a compulsion to give its attention to what is new that painting now faces an inverted crisis. The steady and lengthy maturation of talent with its concentration on a limited objective is everywhere in danger of being shrugged off as creative stagnation; references back in time, previously accepted as a frequent precondition to a step forward, are considered an invalidation of creative personality. Invariably in such a situation a great deal of fine painting (together with the prolonged struggle towards its achievement) gets far less attention than it deserves.

Over the past thirty years Carel Weight has been deepening a talent which, like that of Hogarth and Rowlandson, finds much of its effective stimulus in the daily routine of ordinary people. Through his eyes the unspectacular façades of Fulham and Battersea and the motley world of plumbers and pimps, of commercial travellers and congregationalists are invested with a fierce intensity that can range from menacing fiendishness to pathetic despair. Each painting is charged with an unmistakable mood, and the evolution of the design seems to follow effortlessly the flow of Weight's strongly developed sense of dramatic invention. Yet these are anything but *tableaux vivants*: they are the raw substance of real terror, real vice, real misery and real vacuity. Like the poet who transports us with words from our contemporary laminated armchair to the gate of Hades, Carel Weight takes us as effortlessly from Spencer Road to the epic of Lucretia or the vilification of Christ. But an over-concentration on subject-matter might very well fail to do justice to the originality and unexpectedness of the pictorial structures and the moving and intensely expressive character of the

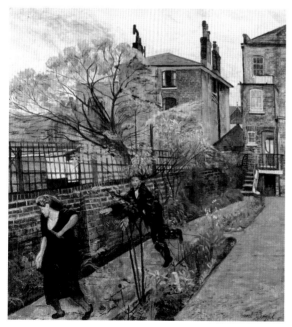

Fig 21 Carel Weight (1908–1997), *Death of Lucretia no 1*, c.1965

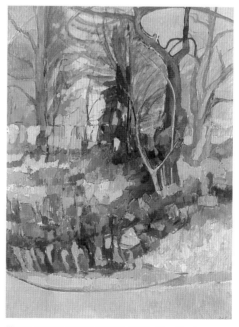

Fig 22 Roger de Grey (1918–1995), *The Garden Opposite*, c.1966

colour in these works. Our national propensity for undervaluing our native talent should give us cause to reflect that in Carel Weight we have a painter who can with ease stand his ground with Ben Shahn, Renato Guttuso, Francis Gruber and the Australian Sidney Nolan.

Roger de Grey's work and talent are of a very different kind. The visible world for him is not, as in the case of Carel Weight, the pool in which imagination discovers the images for its manifold dramatic inventions, but the initial starting-point and referent for constructions that offer us an ordered distillation of space. The brushmarks are not specifically descriptive of objective reality but act rather as markers in the exploration and control of the canvas area. Pervaded by a classical restraint in both colour and tonal range, these paintings are distinguished by a fastidiousness and a lucidity of structure that pay as much attention to the visual pleasures of dimension and interval, of colour modulation and relationship as any purely abstract work. The tight rein that de Grey kept in his earlier work on the geometrical scaffolding of his pictorial construction has been progressively relaxed and an easy yet authoritative fluency characterises his recent work. There are signs also of a growing tendency towards a loosening of the ties between the painting and its external referent, a move resulting in a greater emphasis on the painting's autonomy as a structural equivalent rather than a descriptive record of nature.

Referring to musical composition in one of his Harvard University lectures of 1939–40, Stravinsky says something that has great relevance to the works in this exhibition: 'The faculty of creating is never given to us all by itself. It always goes hand in hand with the gift of observation. And the true creator may be recognized by his ability always to find about him, in the commonest and humblest thing, items worthy of note. He does not have to concern himself with a beautiful landscape; he does not need to surround himself with rare and precious objects. He does not have to put forth in search of discoveries: they are always within his reach. He will have only to cast a glance about him'.

2.14 *1968 Royal Academy Summer Exhibition* (1968)

From ' London Commentaries', in *Studio International*, Vol.175, No.901 (June 1968), p.316.

It has to be conceded, by even its most inveterate critics, that there are changed features in this bicentenary year's Summer Exhibition of the Royal Academy. The central galleries which run the length of the exhibition are hung predominantly with large non-representational works; a gallery presided over by a kapok teddy-bear-valentine to John Betjeman has

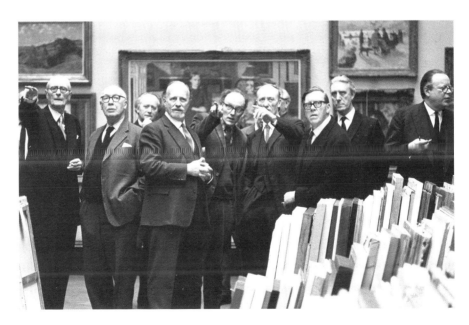

Fig 23 Selection Committee for the Royal Academy Summer exhibition 1968, in deliberation (MdeS centre, wearing glasses, pointing)

been devoted to what twenty years ago would have been called 'problem' works; the sculpture, instead of being concentrated to the point of indigestibility, has been dispersed throughout the show; and, overall, the works are hung less tightly with appreciable gain in the viewing of them. All these noticeable changes, which many have argued should have taken place long before this, have led inevitably to speculation about a rumoured change in the Royal Academy's policy. Such rumours and such speculation are built on the misconception that there is an established policy to change. In nothing is the Royal Academy more flexible, to the extent of vulnerability, than in its provision for selection and hanging: year by year the Selection Committee, and the sub-section of this which forms the Hanging Committee, changes and the exhibition each year reflects the new mixture, and represents the confluence of disparate criteria and opinions. It is hard to convince the confirmed sceptic of the fact that every work is put before the Selection Committee, and that the Hanging Committee is pre-eminently concerned with exhibiting the widest diversity of idioms consistent with a respectably high general standard. But this is so and would seem to me the only factor that might conceivably represent a 'policy'.

Another factor in the situation is of course the changing character of the submitted work, and the absurdity of attempting to determine the shape of an exhibition in advance of the receipt of works is self-evident. And equally self-evident is the fact that there can be selection only of what is submitted, and if the Royal Academy Summer exhibition does not yet include certain aspects of the contemporary situation in the arts this is not attributable to policies of exclusion but to the fact that no good representative submissions are yet available for inclusion.

The changes in the character of this year's exhibition have been made possible by an increase in support coming from serious younger artists. And what have they to lose? They will not easily find walls of comparable size to take the large works they habitually paint; they will not find a similar situation in which no commission is deducted from sales; a situation in the hands of fellow artists, many of them directly related to the younger generation through connection with art schools and colleges (until his election the new President himself was on the visiting staff of the Slade School); a perennial

situation in which fashion and commercial viability are wholly subsidiary to more fundamental criteria. It is this latter feature that is particularly appreciated by many artists of maturity who have ceased to enjoy the attentions of the critics but have not ceased to produce good things. And this is equally true of the considerable number of artist/teachers whose annual output may, through force of circumstance, be limited in amount but not necessarily in quality. Artists who have satisfactory opportunities for exhibiting with a dealer's gallery are understandably indifferent but they represent a comparatively small fraction of the total creative situation in this country. The Academy's increasing liberality may soon prove to be the main, perhaps the only, factor protecting the interests of a sizeable, and seemingly expanding, number of British artists.

2.15 *Margaret Benyon* (1969)

Introduction to the catalogue of the exhibition organised by Nottingham University Art Gallery 1 – 24 May 1969.

The difficulty of presenting his work to the public is one of the acutest problems faced by the 'experimental' artist of today, or indeed of any age, and even when a situation such as the present one presents itself, of a gallery and a ready-made audience, the problem is still considerable. The past to which reference might be made provides progressively less in the way of introduction as the truly experimental nature of the work is increased. [...] The problem is all the more acute as the work moves away from those traditions of art from which the historians of art have derived their criteria, for it then may seem that either the work is rootless and insubstantial or that it lies outside the bounds of artistic credibility. Well-intentioned writers on contemporary art have searched out psychoanalysis, metaphysics, semantics, Gestalt psychology, relativity, cybernetics and optical illusion, borrowing extensively from the new languages of science and technology in an effort to create a bridge to the public (frequently without knowledge of the language of these disciplines and thus the effect has more often been to create even greater mystification than enlightenment).

It would be no good service to Margaret Benyon to indulge in either fancifully philosophical or excessively technological language of this kind,

for her principal aim has been to exclude, as far as possible, vagueness and mystification in her efforts to extend her notion of reality by probing new aspects of it in visual terms. In her notebooks, to which I shall refer again, she has written, 'Any work of art that doesn't examine itself is poetical or metaphysical, undefinitive'; and the undefinitive is what she strives to eliminate.

In 1963–64, when I first knew her work, an unperceptive critic might have attributed to it the influences of 'op art' and a fascination with the phenomena of optical illusion, but if there was ever a connection it was a conditional one (perhaps a savouring of the possibilities of a different type of 'reality'). An optical illusion, by definition, deals with phenomena that are not easy to measure. In fact at that time she was less interested than now in the affective spectator-participation that 'op art' involves, and seeks by visual stimulation, and was more concerned with examining dynamic aspects of her own emerging creative ideas.

But however thoroughgoing one's rejection of vagueness, it seems inevitable that a painter will be forced to compromise, since any gradation of colour will tend to imply a third dimension, and colours will always be subject to descriptive or structural 'misreading'. And so, realising that one cannot avoid illusion, one of the earliest problems that Margaret Benyon set herself was to question the abstract expressionists' assumption that a painting must essentially be treated as a flat surface, and to resolve this problem without reverting to Renaissance space and spatial systems. The 'interference pattern'

Fig 25 Margaret Benyon, *Untitled*, c.1969

structures of 1965 were one way of opening up the picture plane, and other structured and 'programmed' means were found to explore the spatial proposition: their diversity and subtlety is one of the chief features of this exhibition.

Margaret Benyon confesses that one of her principal interests is in classification – classification of different sorts of reality. To quote again from the notebooks – 'To make the outside world more intelligible and *tangible*, the artist's job is with the presenting of an hypothesis, a point of departure for apprehending reality.'

It would be absurd to suggest that there have been no influences in her development [...] but all these have been fully digested and her work is now at a most crucial point of development. It is for this reason that the opportunities afforded by the Nottingham Fellowship could not have come at a better time and are likely to have such exceptional importance.

Margaret Benyon had already reached the point of questioning the value of continuing the tradition of two-dimensional signs for the expression of three-dimensional visual sensation, yet refusing the obvious alternative of constructions, when she made contact with holography, in which by utilizing the special properties of laser light it is possible to produce images that have the properties of both virtual and actual three-dimensionality. The properties of the hologram which appeal to Margaret Benyon are, firstly, that the image reconstructed in space is

Fig 24 Margaret Benyon, *Relief Interference*, 1965

truly a three-dimensional experience in which one can look at the various sides and aspects of the structure, and secondly that it measures time and space in its own terms and does not apply borrowed or artificial standards from outside. Her work in this very experimental field is amongst the first being attempted by artists in this country and her developments at Nottingham may be of the greatest significance – truly breaking new ground.

If this signifies a move towards technology Margaret Benyon may be relied on to exploit it from the basically existentialist position that she has come to occupy. She would agree with Gaston Bachelard that 'the value of an image can be measured by the extent of its imaginative aura'. And I cannot close this brief introduction without a final characteristic quotation from Margaret Benyon's notebooks – 'Making the invisible world visible may be what art's about – one could take this literally, e.g. demonstrating 3 + 3 = 7'.

Fig 26 Peter Sedgley, *Target Dive*, 1966

2.16 *A Conversation with Peter Sedgley* (1967)

Transcript of a recorded conversation between Maurice de Sausmarez and Peter Sedgley, February 1967 (Maurice de Sausmarez Archive). Afterwards published in *Leonardo*, Vol.4, No.2 (Spring 1971), 167–170, and in the catalogue for the exhibition *Peter Sedgley Paintings, Kinetics, Light Installations* (Prague, 1997).

Maurice de Sausmarez You came to painting in a quite unconventional way for this decade, I believe, in the sense that you didn't develop out of art school.
Peter Sedgley Yes. For something like ten years I was in building and architecture – and then in 1959 I completely broke with these activities and decided I wanted to concern myself with philosophy. I felt the need to get away and involve myself with the investigation of ideas, including fields other than architecture, and this led me to painting. I don't quite know why.
MdeS Well, in a sense painting has a philosophical undercurrent because when you decide to do this rather than that in a painting your decision is based on some concept of its rightness or goodness relative to the thing being made. I quite well see that you could become involved with painting through this interest in ideas, but it did mean that you came to painting free from accepted notions of what was

involved in painting or fixed notions about the creative process?
PS It's true that I had to find out things for myself, but one can never be wholly free of a concept of what painting should be. At that time, I was subject to a kind of decorative involvement. I had heard of Max Ernst and I had seen the work of people who had been influenced by him, in particular the decalcomania-frottage – a technical process that seemed to me to belong to the twentieth century.
MdeS So in a sense you made contact with your century not altogether through ideas but through a sort of technical break with tradition, while often retaining a suggestion of imagery that could be related back to past centuries – sky, Moon, land, water and so on.
PS Yes, and the next step for me was to try to free myself from that image content that related to the past. And this effort really involved one going into chaos and the next step was in fact chaotic. It had something of Surrealism about it and was extremely involved technically, with a textual content that presented opportunities for seeing through and beyond to hidden potentialities. I came to painting through Surrealism. The paintings from that period are evidence of my struggle.
MdeS How wrong assumptions could be that are based purely on the evidence of your recent work.

PS Yet, if I can't carry something of this with me into my present work I wouldn't paint a picture – that's my feeling – it's a question of retaining something of the mystery.

MdeS Could one put it that even in your present work the origination, the actual coming into being, still has to have for you an inherent magic – you can't contrive situations, you are still dependent on the element of surprise, the factor of chance?

PS Yes, the thing I fear most is that there may not be any element of discovery.

MdeS You'd be inclined to give up painting if it ever became merely a system?

PS Yes, that's exactly it – and yet I always insist on there being a system operative within each painting, a desire to see it work to a sort of logical rhythm.

MdeS And yet the control, the discipline and the element of decision that enters your work from about 1963 onwards might lead the average viewer to think that the whole thing was developed on an absolutely established narrow predictable basis. The element of chance is always there; do you ever really know whether the painting is going to work or not?

PS No, I simply give it the chance to prove itself.

MdeS And the great precision found in your paintings is the necessary means for allowing forces in the image actually to get working – any negligence or slovenliness in which the painting is carried out would result in failure.

PS That's the whole point – if the painting doesn't work technically, it isn't free to work at all.

MdeS But to go back to the period around 1960–1, you were, so to speak, a victim of chance. In spite or possibly because of the limitless possibilities of chance, you became trapped in the endless production of 'one-off' images lacking any point of development.

PS Yes – though, as I've already said, one is always to some extent subject to chance but one can lessen the odds.

MdeS But in 1961, you had no sense of an aim or a quest against which you could assess the character or developmental value of what you were doing – there couldn't be, because one can only have a true quest when one has some inkling of what one is trying to find.

PS Yes, these were moments in the wilderness. There was no real understanding of visual order and I didn't make use of architectural order I had previously known for the simple reason that I had renounced it.

MdeS But amongst the works of that period there are some that almost appear as pointers to a later stage – the circular image in strong colour that is almost 'optical' is like a talisman and there are others from the same year 1961.

PS Maybe, but it hasn't got the colour-structure to support it. Other aspects of my work at that time might have or could have developed into something not unlike, say, the works of Pollock – though at the time I hadn't even heard of him – and led on to a concern with optical illusions but, in fact, I went back to Klee-like preoccupations. I decided that I had to organise colour somehow. For about six months I played with coloured dots, identical units of eight different colours, making a kind of system of controlled modulation.

MdeS Did you experience a sense of release from the previous endless succession of chance images?

PS Yes. To a large extent that early work was like pieces of wood one might pick up on a beach because of their natural beauty. But the change involved me in a direct commitment to make things work through organisation and articulation of the units employed. Returning to England after a year in France, I produced work that represents a re-thinking of my outlook. I read Klee's *Thinking Eye* and was staggered by it – I started on a sort of self-analysis and organised courses of study for myself. Notes and drawings, masses of them.

MdeS I'm interested in your response to Klee's book – did you find it more valuable as a provocation to your own individual research and enquiry than as a dogmatic statement of clear principles by which you could work?

PS I think his actual writing at some points is very mystical but it is fantastic in what it can trigger off – you suddenly find yourself on a quest, almost wholly unconcerned with his argument, that may be productive for your own work.

MdeS Perhaps it is that he demonstrates a method of questioning highly productive creatively in terms of a visual art.

PS I produced books of studies, each containing about 50 sheets of drawn and written notes. Yes, books and books – the best part of the year 1963 was devoted to this.

MdeS I remember visiting you on one occasion in your Elsham Road studio and the excitement of seeing a little study on which you had just been working: a black and white linear vertical structure through which a full spectrum double-twist occurred horizontally. To our astonishment the centre of this image, in reality full spectral colour, became almost pure white light – it was fantastic, a total transformation of the material nature of the thing because what was there was not seen, it had become something else.

PS This was the result of striving to bring about maximum tensions – I didn't know it was going to happen, that it was going to work like that.

MdeS It's another talisman.

PS Yes, it was the use of a double structure – a tonal structure built up from dark to light working with the colour structure which produced this effect. It is one of those situations where everything acts towards one critical event – had any other tonal structure been used it might have been killed, reversed or negated.

MdeS If I remember rightly, it was a spiral movement going on in the colour structure while the black/white beat was constant.

PS Yes, I recognised the effects visually in black and white but what I wanted to find was a similar effect in terms of colour.

MdeS Did you find that the structures which had been of service to you in the case of black and white were equally useful in terms of colour, or did colour demand a new form of structure?

PS I found colour demanded fresh thinking about structure. For instance, I found that high contrast in a black/white range produced the same character or same effects – very differentiated colour of equal tonality. For instance, blue and green in the tonal register would cause this kind of optical effect whereas yellow and blue did something very different. With black and white the visual effects seem to me to be constants one can manipulate like clay or putty, and arrive at a composition. But with colour I realised, for example, that blue and red, blue and green gave differing and particular optical results. It was a question of handling qualitatives as well as formal factors.

MdeS Another thing, would you say that your growing interest in circular disc paintings came from the fact that in a circle, effects are produced equally around the circumference, at any point the effect is

operating at its maximum? An irregular shape would give these effects a bias this way or that.

PS I believe so now, but I didn't arrive at this as a result of a conscious decision. Out of my working with colour I had come to the conclusion that colour is not about shape. I know that Kandinsky tried to define the most characteristic shape for each colour. I believe it was yellow – a triangle, red – a square, and blue – a circle, but I can't find any justification for such correlations. Colour has no 'shape' because colour is a quality. It's like asking what shape is water. It depends on what container you put it into. I use the circle because it seems to be so completely anonymous. Albers perhaps used the square because it permitted him to observe more readily the effects he was studying. Some things must remain the same in order to observe truly how things differ and, in an enquiry about colour, it's the organizational form that must remain unchanged.

MdeS In one sense your work could be viewed as one big experiment to see how things work visually, but have you yourself got a larger view of it? Do you for example see your work up to now as being valid in terms of a wider philosophical or social context, or is it essentially an artistic preoccupation?

PS When I'm working, a painting looks right in terms of what I believe or feel to be right in my painterly way. I can only relate it philosophically by looking at it after it is made and seeing it in the context of the outside world. People have compared my work to music, science and poetry, and there may be similar aspects but they weren't intentionally put there during the actual process of making. Some of the connotations or connections suggested are quite disturbing – hallucinatory visions, psychedelic experiences and, of course, the use of a non-traditional illusion of space in terms of there being no 'up' and no 'down' has suggested interstellar space, movement and colours seen by the astronaut. This means that people have tended to push the associative content back into a figurative situation, something that they can understand. I think this is a pity because it tends to confuse the pure visual / emotive force that is the basic content of the work.

MdeS Would you say, on the whole, painters through the ages have seldom tended to think about a direct programme in their works and that it is rather more through their artistic commitment that they have made contact with the total intellectual atmosphere,

the philosophical and scientific thought of their age?

PS Yes, I believe conscious programming would be a very contrived approach and the pitfalls too numerous, because then it would become a question of trying to analyse from outside the processes going on in society, selecting from them rather than being subject to them. The work would become in fact a sort of collage. I think you really have to believe or disbelieve, if you wish, in your age and its image has to emanate from the artist acting as agent.

MdeS The painter won't, in fact, be conscious of how the image finds its way into the painting?

PS No. And where the image is consciously done, it remains, I believe, on the level of social comment rooted in its time, like Pop Art. For me the image must be the result much more of a hunch or intuitive process. Maybe one has to discard or overcome a great deal in order to get down to essentials.

MdeS You work a great deal with the circle, the target – are you ever tempted to reflect on the ancient symbolism of these circular forms?

PS I know of the Mandala, the early swastika, but that wasn't my reason for the use of the circle. It is the only form that allows me to investigate colour in a way that I feel to be right. It is limiting in a sense but, in order to see what is happening when you place this colour against that, the only formal organization I accept is that of concentric circles.

MdeS You are very concerned with what could be described as researches into the nature and behaviour of colour, but have you any sort of notion about its relevance to a wider context?

PS I think in a sense it has its equivalent value in the distillation of consciousness that is occurring now socially.

MdeS And just the degree of clarity that you can bring to a sphere of investigation adds its part to the total clarification of the consciousness of an age.

PS Yes, even though they may appear small contributions, the fact that people are involving themselves with particular problems is, I believe, important in the present situation. To clarify what you do and to commit yourself totally to whatever you do seems to me most important.

MdeS Do you see your paintings as inducements to meditation – is that the sort of affective power they might have?

PS Yes, they work in this way much more than by any form of symbolism, however oblique.

MdeS The wider and more general meaning they might have for society today then is perhaps connected with their effectiveness as a provocation to meditation. This after all is a profound and continuing human need.

2.17 *Poussin's Orpheus and Eurydice* (1969)

Extracts from *Maurice de Sausmarez ARA on Poussin's 'Orpheus and Eurydice'*, written for the series *Painters on Painting*, edited by Carel Weight (London: Cassell, 1969).

I was still a schoolboy when I first saw Poussin's *Orpheus and Eurydice* at the Royal Academy Exhibition of French Art in London in 1932 and I was overwhelmed by its beauty. I doubt whether I was then sufficiently articulate to have been able to indicate what it was that held me, but the marvellously ordered translucency of its colour was as potent a factor as its spaciousness of design and its dramatic intensity. Maybe I had fallen in love with Eurydice at first sight and identified myself with her fearful situation. During the seven years that followed I had the chance of seeing the painting on two occasions in the Louvre, and by this time I was a student of painting at the Royal College of Art, very self-assured in my assessment of artistic matters and only too ready to demolish what I then considered to be the *jejune* opinions and affections of my earlier inexperience. But this Poussin painting was invulnerable and I now had Cézanne, who had come to occupy a central place in my consciousness, to help me see even greater beauties and greater profundities than I had earlier been capable of comprehending. After the war, in the Arts Council Exhibition in the winter of 1949 'Landscape in French Art 1550–1900' there it was again, and I remember being half-afraid that it might no longer seem as beautiful in actuality as my memory of it. But it has survived every test and remains, for me, one of the abiding wonders of the world of painting.

[…]

Pictorial geometry and the concepts of proportion, of ratio, the Golden Section and the like, are concerned primarily with area-division, the rectangle of the painting being treated as a flat surface. The beauty of these geometrical procedures lies in the fact that the disposing of the principal elements of a composition is subject to a rhythmic

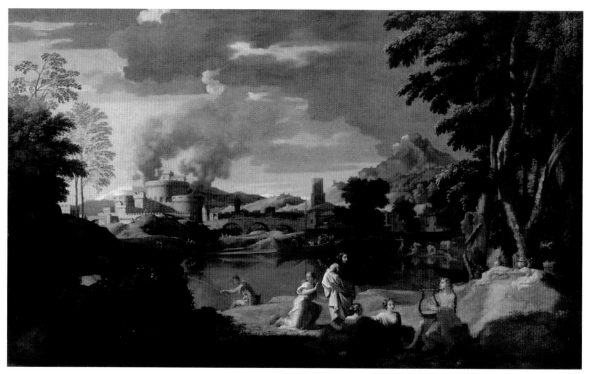

Fig 27 Poussin, *Orpheus and Eurydice*, 1650–53

interrelatedness over the picture's entire surface in perfect consonance with the original proportions of the canvas. It demands from the painter, in effect, an ability to review his spatial thinking in terms of two-dimensional relationships, and in achieving the marriage of these seemingly irreconcilable demands his work achieves a dynamic order.

[...]

In a self-portrait, of 1649, Poussin depicts himself holding a book, on the spine of which is written *De lumine et colore* (Of Light and Colour) and in his outline for a treatise on painting he writes 'form has to do with lines and colours'. It would hardly seem reasonable for a painter who confessed that 'My nature compels me to seek and love things that are well ordered, fleeing confusion which is as contrary and inimical to me as day to the deepest night' to neglect the ordering of colour in his works, an element most capable of creating utter confusion. Indeed he would seem to have been aware of this danger – 'Colours in painting are a snare to persuade the eye, like the charm of verse in poetry' and, for Poussin, colour as used by a Rubens or a Renoir was a seduction that had to be resisted, but conceived

as structure, colour provides no opportunities for seduction. Poussin, in fact, ordered his colour more like a post-impressionist than like a mid-seventeenth century painter. He rejected colour naturalism and chose instead to work in localities of colour – simple large flat units of colour that he could organise in an almost abstract way.

[...]

Landscape painting for Poussin was the imitation of nature according to reason, the representation of nature with the simplicity, clarity, and the interrelatedness that characterizes rational thinking itself. And Poussin's conception of Reason was closely bound up with mathematics and especially with geometry, symbol of clarity and order and demonstrably true. It was the principal means of reducing the *incoherence* or arbitrariness of the material world to order consonant with reason.

[...]

Diagram 1: The 'Landscape with Orpheus and Eurydice' has, as its basic geometry, the division of the picture surface on one of the Albertian ratios, 9/12/16. In addition the Golden Sections and the rotation of the shorter sides upon the longer establish

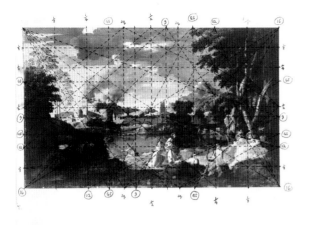

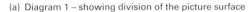

(a) Diagram 1 – showing division of the picture surface

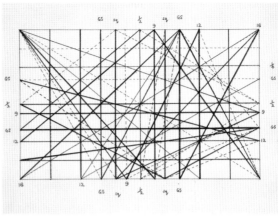

(b) Diagram 2 – showing abstract framework derived from Diagram 1

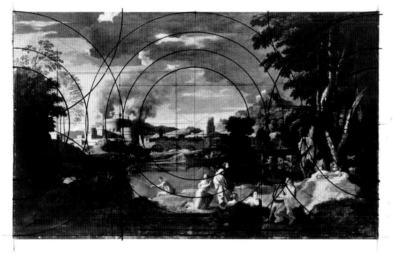

(c) Diagram 3 – showing system of related circles and half circles

Fig 28 MdeS's diagrams made for Orpheus & Eurydice book for the Painters on Painting series.

further controlling points. A powerful use is made of the vertical/horizontal grid and in particular the following points on the long side of the rectangle – the Golden Section and the divisions into 9 and 12 parts, and on the short side of the rectangle – the half, the Golden Section and again the divisions into 9 and 12 parts. Big inclusive triangles and diamond-shapes with lines radiating out from the four corners of the rectangle establish the principal shape locations and directions of movement in the composition.

Diagram 2 scrupulously employs only the abstract framework derived from Diagram 1, and comes as close to the design of the painting as any geometrical

resolution, disciplined by precise ratios, is ever likely to do.

Another geometrical substructure seems too clearly implied to be discounted – a system of related circles and half-circles [Diagram 3]. The first set of concentric circles has as centre the point of intersection of the diagonals of the rectangle, and as radii the Golden Sections, the quarter of the long side and the half of the short side of the rectangle. Finally, quarter-circles centred at the four corners and with half the short side as radii. It will be seen that many of the most significant thematic details and pictorial structures relate together or are contained within the perimeters of these half- and quarter- circles.

But let me state categorically that no claim is implied that this was Poussin's way of working. That he was interested in ratios is certain, that he worked with a reverence for geometry is also certain, that this painting is controlled by a discipline that involves more than an arbitrary division of the canvas area is certain, that the geometrical format derived from the ratio suggested here makes astonishing sense in relation to the major features of the painting I leave the reader to decide – but how these interests and controls were demonstrated in practice cannot be defined. In the same way that with great music the textbook principles of harmony are transcended to the point of making them appear absurdly irrelevant, so with a great painting like this one, the pictorial geometry is inseparable from the whole flow of the inspired creative process and indistinguishable from its compelling imagery. But that it is deeply and miraculously embedded is, I believe, unquestionable.

[…]

The pall of smoke rising from the castle with its strong diagonal movement, setting up tensions with the heavy cloud formations moving in opposition, and the small flashes of light breaking the cloud structure, create an ominous dramatic situation on the left to wreck the balanced calm on the right of the picture. The design, the relationship of the shapes and the shapes themselves carry superbly the fearful content of the story, the dramatic climax that will separate Eurydice from Orpheus. But no less inspired is the gestural relationship between Eurydice and the snake in the grass, and between Eurydice and the fisherman who is alerted but uncomprehending. Eurydice moving away to the right in terror, the fisherman bending over his rod and line to the left creates a dramatic split, while both heads turning inwards create a sense of relatedness. It is evident that Poussin was interested in psychological analysis of appearances, and that he gave the fullest demonstration of his belief that there is a correspondence between the movements of the soul and those of the body, that our emotions are visibly expressed in physical reactions and gestures. One of the haunting things about this painting is the fact that you, the spectator, are the only person to share Eurydice's full horror – the fisherman does not yet realise the cause of her startled movement, the presence of the snake, and Orpheus and his enraptured friends are too deeply immersed in

the beauty of his song. There is something heart-rendingly poignant about this fearful end to what has been a blissful warm summer's day. The fishermen and the bathers on the far bank of the river are bringing their various activities to a leisurely close, Orpheus is transported by the flow of his inspired song and his companions are caught in the web of its beauty. Nature can seldom have looked so lovely bathed in this golden light of late evening, and yet Poussin has managed to create the sense of a menacing presence merely by a long slanting cloud formation, two columns of smoke, an uplifted hand and a turned head.

[…]

Shifting one's full attention to the colour, the immediate impression is of the last mellow brilliance of the evening light (note the inspired way that the bright sunlight catches the very top of the tower in the centre of the painting and the topmost peaks of the mountain to the right, thereby keeping the landscape 'active' as subsidiary to the drama of the figures); the light of a dying sun is caught between the fast encroaching foreground shadow and the menacing heaviness of the extensive grey cloud formations. Does this not in itself symbolise Eurydice's predicament?

The controlled organisation of the light throughout the entire painting is of a masterly subtlety […] the relating of shadow to light on the left middle distance changes gradually and imperceptibly as one's eye moves through the landscape to the right registering the lessening of the light's intensity […] the warm lights, cool half-tones and warm shadows [are] superbly adjusted one to the other throughout […] the entire composition is painted on a fairly dark mid-brown ground which is used to great advantage, particularly in contributing to the complex interplay of warm and cool greys in the sky (the warm greys ranging from lavender-grey to pale yellow-grey; the cool greys from dark slate-grey through green-greys to the palest cobalt-blue-grey), and in the individual passages where bright opaque colour is 'scumbled' over (i.e. dragged across rather than precisely covering) to create a sort of shot-silk ambiguity (look for instance at Orpheus' lemony-green robe). This same warm dark ground makes its contribution to the astonishing diversity and beauty of the greens in the painting, their variety in colour. A similar diversity

of subtleties is to be seen in the changing colours of all the buildings in the middle distance – lemon-greys, orange-greys, green-greys, lavender-greys, salmon-pink-greys, pale warm blue-greys, etc.

The encroaching foreground shadow […] is not only constantly changing in colour and contour but is enlivened by flower-dappling, echoed again in the flowered chaplets worn by the figures in the sunlight, and in the urn of flowers at the base of the tree on the far right. This foreground shadow is designed to envelop the lower halves of the two recumbent figures so that one's eye moves straight from Eurydice's upheld arm to the figure of Orpheus, the right sleeve of the standing figure and the turned heads of the recumbent figures acting as 'stepping stones'. Had these two recumbent figures been fully lit one's eye would have been entirely deflected by inevitable complex colour, tone and shape contrasts.

In Eurydice's upheld arm and turned head we have the fulcrum of the design. Her white sleeve is the strongest warmest white in the entire painting; the white drapery carried by the standing figure next to her is very subtly 'tilted' towards a blue-grey and thus takes on a subsidiary colour-role. This standing figure and the recumbent figure immediately at his feet are dressed in pale crimsons only fractionally differentiated, which create optically a simple unity, allowing the dialogue between the fisherman and Eurydice to be dominant […] But this hub of the painting contains greater surprises. The fisherman's auburn hair and the 'auburn' shadows to his pink drapery are set against the greyed cobalt-blue of the water, and one notices that at the point where the lemon-yellow fishing rod crosses it, the colour of the water becomes darker and changes towards violet. Is it possible that these are isolated early instances of colour thinking of the kind one finds fully developed in Seurat's 'Bathers' or in a Cézanne landscape? This question seems progressively less far-fetched as one notes the lavender-violet shadows on the yellow-lit castle and in the half-shadows of Eurydice's lemon-yellow drapery; the violet halo round the contour of the dark tree on the far river bank; the pale blue shadows on the orangey-white drapery of the recumbent figure next to Orpheus; the lavender-violet of the bridge and the clothes of the shepherd piping to his flocks in front of the yellow castle; the changing relationship of the water and the greens surrounding it moving from cobalt blue-grey to dark pinky-slate

blue that registers as violet; and then the outcrops of earth along the foreground river bank that appear as yellow-ochre rhythmic *beats* against the blue river, brought to an end on the right by the yellow-pink drapery (on which lie two chaplets of green leaves) counterbalanced by a pale blue drapery of identical tone.

[…]

Perhaps the most remarkable evidence of Poussin's colour thinking is contained in the disposition of the brilliant reds on the right of the painting. Orpheus carries, over his left arm, drapery of the purest vermilion which is seen in the immediate context of cool fresh grass green of the river bank to the left, the light lemony-green of Orpheus' robe and to the right a bank of darker ochre green. Everything is calculated to give this vermilion the maximum power. Hanging on the tree above and to the right of Orpheus is a mass of drapery of a similar red but slightly reduced in power by the probable admixture of a touch of very pale ochre yellow. Just across the river on the riverbank near the bathing figures is a mound of clothing of this same type of red, this time reduced by slight admixture of white and yellow. And beyond that again, hanging from the window of the house, immediately above the group of bathers, is a strip of red. For me, this is the clearest evidence that Poussin was thinking and creating colour-space. What other explanation can there be for such calculated placing, for this fascination with the problem of making the same, or near similar, colour – red – function in differing spatial contexts? […] But look again at the area occupied by the vermilion draped over Orpheus' arm; across the river is a large tree to the right of the tower, the area covered by the dark green of this tree being exactly large enough to act as a counterbalance to the vermilion. Had it been any smaller, had the value of the green been any different, it would not, it could not, have functioned in this way. Look from one area to the other and see how dynamic the balanced tension is!

[…]

Everything that has here been discussed, the painting's design, its shapes, its lines, its intervals, its angular directions, its psychological inflections, its colour, its every descriptive detail moves towards the achievement of its monumental representation of this epic. 'Genius is the art of co ordinating relationships' (Delacroix).

If Orpheus singing to his cithara produced celestial sound, Poussin's canvas has matched its quality with visual beauty – *De lumine et colore*.

2.18 *Four drawings by Ben Nicholson (1963)*

Published in *The Connoisseur*, Vol.154, No.619 (September 1963), p.32–36. The four drawings: *Paros, Evening. September, 1961*; *Still Life, Malcontenta. June, 1962*; *Palladio. June, 1962*; and *Court of Honour, Urbino. May, 1962*; were reproduced again on pages 6l–64 of de Sausmarez's *Ben Nicholson*, a Studio International Special (1969).

A draughtsman has two allegiances; one to the object he draws, whether it be a fragment of the material world or a vision in the mind's eye, the other to the surface on which he draws the image. It sounds simple enough but the seeming simplicity is delusive. Seldom is the balance struck. When the first proves too demanding, the artist, tempted by the siren-like beauties of the object, plunges deeper and deeper into a sea of descriptive detail. When the second is uppermost, he traces his geometries with a cold perfection that leaves no place for the human pulse. The paper can so easily become the battleground between 'the window' and 'the square'.

These drawings by Ben Nicholson are superbly poised and answer the demands of both loyalties. The lines as they move over the picture-field cut the paper's initial ground into a sequence of rare intervals and pellucid shapes whose geometry holds distilled, the landscape, the pillared courts,

Fig 29 Ben Nicholson, Palladio. June, 1962

the jug-life. Relationships in space are suggested by a sequence of overlapped shapes, chiaroscuro is entirely eliminated, the purity of the line recalling the portrait drawings of Modigliani, but without their sensuous sentiment. Everywhere sensibility refines and re-forms. So tense and disciplined is the line that builds again the image of the artefacts in *Paros Evening Sept. '61* that the sudden intrusion of the rigorous scribble states at once the presence of the free and restless organic tree-form. In *Malcontena June '62*, to measure the palimpsest-like first statements against the final contours is in itself an object-lesson in sensitivity; the shapes of space are as tangible as the table-legs, their rhythmic intervals more telling than the turned wood. Yet these drawings have no preciosity, they are the free inventions of an artist who lives and breathes clarity and precision. There are no complexities of analytical deliberation, no parade of emotions, no philosophical disquisitions, but the sustained flow of visual poetry, the purest 'objectivity'.

In a statement of 1948 Nicholson has said 'the kind of painting which I find exciting is not necessarily representational or non-representational but is both musical and architectural, when the architectural construction is used to express a *musical* relationship between form, tone and colour; and whether this visual, *musical* relationship is slightly more or slightly less abstract is for me beside the point'. So it is that one discovers in these drawings, as in some of the paintings, passages that would knit together with the pure geometry of non-objective work, and specific delineations that fix a locality as surely as any topographer.

In a recent book Nicholson has been called 'England's most distinguished Cubist' but the early influences of the still-lifes of Picasso and Braque, and the *collages* of Juan Gris have long since been assimilated. The stronger and more lasting influence was that of Neo-Plasticism, Nicholson having met Mondrian first in Paris in 1934, and then a closer relationship from 1938 to 1940 when Mondrian lived and worked in a room above Nicholson's studio in Park Hill Road, Hampstead. But even during the time when the doctrinaire Mondrian stood as mentor, Nicholson's neo-plasticism was continuously threatened by internal heresy. Life, of which art is an extension, has increasingly made its claims to attention; the generalised statement has from time

to time been coaxed nearer to particularisation, the eye and the heart have been seduced. It is particularly in the drawings that this is best appreciated. In these, Nicholson has seldom moved away for long from sympathies that he shared with the friend of his youth, Christopher Wood, sympathies that led to the appreciation of the naïve intensity of the Cornish boat-painter Alfred Wallis. The love of the uncomplicated inscribed images on the surface, the flat graphs that are rescued from mere decoration by the empathetic pressure of the artist's 'seeing', these and the unique detachment of the resulting object are the things that have been valued.

In Nicholson's work abstraction and figurative work have achieved a rare identity. His integrity as an artist is now proverbial. The wholeness which this implies characterises his entire output and, what we now distinguish as his style, those inflexions of statement that are unmistakably his; purity, clarity, a geometrical order that yet reveals the inner essence of things. It is not surprising that Greece, heart of all classical aspiration, and Italy with its ever-present Renaissance past and the living spirit of Piero della Francesca, of Alberti and Palladio, should have inspired some of his finest drawings.

Since the war his reputation abroad has steadily increased and he has received distinguished awards in all the major international exhibitions. There can be few who will deny him his place, by the side of the internationally renowned Henry Moore, as the greatest painter England has produced this century.

2.19 *Ben Nicholson* (1969)

Extracts from de Sausmarez's preface to *Ben Nicholson*, a Studio International Special, edited by Maurice de Sausmarez (London and New York: Studio International, 1969).

Looking at one of Ben Nicholson's most recent works 1969 (snow monolith) in his studio high above Lake Maggiore, what appeared to me previously as a number of disparate factors in his life's work suddenly assumed a transparently clear sense of unity. The work is a painted relief, 6 feet 5 inches high and 2 feet 3½ inches wide, and of proverbially impeccable Nicholson craftsmanship. The crisp clarity of the shapes recall the discipline of the uncompromisingly severe abstractions of the 1934–40 period, and yet the colour has taken on a subtle shifting tenderness that characterized many of the early still lifes of the

twenties and works like *Porthmeor beach, St. Ives, 1928*. All Nicholson's feeling for nature and natural phenomena, continuously expressed in his vibrant drawings, is contained here in the colour and handling of paint, intensely expressive of falling and fallen snow. As if to underline this directness of experience, high in the painted relief is a suffused line where two painted areas come close to meeting, recalling for me the experience of the previous evening looking across the lake in moonlight when the dark powder blue of the undifferentiated terrestrial area was separated from the almost exactly similar powder blue expanse of the night sky by a white suffused line, the snow caps of the mountains. That every inch of his painting is scrutinized and savoured was made clear by Nicholson's pleasure at my noticing the extreme subtlety of two brushmark breaks in this white line, as meaningful as in a Chinese landscape painting. And then again, this relief – monolith – reminded me of Nicholson's essays in freestanding wall reliefs like the one at the 1964 Documenta III in Kassel, nearly 50 feet long and 13 feet high, and his long-standing relationship with architectural sensibilities and interests. Much of Nicholson's work since his seventieth birthday, while still exhibiting new and vital extensions to his talents, has seemed to draw together in a powerful way the strands in his earlier creative field.

[…]

To many younger contemporary critics, Nicholson's work in the thirties may be criticized for its lack of any sustained programme of the kind to be found for instance in the case of Mondrian or Malevich, and for the fact that its visible appearance of sustaining a constructivist dialectic is fictitious. But Nicholson's greatest talent is precisely his ability to escape the snares of a cause and effect rationalization of his creative processes – he considers that the greatest danger is for an artist to begin imitating his own work. He would approve of Kandinsky's statement that 'so long as artistry exists there is no need of theory or logic to direct the painter's action. The inner voice tells him what form he needs'. It was characteristic that Nicholson's particular brand of neo-plasticism should have been threatened by internal heresy from the start. As he says 'I could not be bothered to read Mondrian's theories. What I got from him – and it was a great deal – I got direct from his paintings', and certainly

Nicholson's passion as a painter could not have conceived of a Mondrian-like ideal so spiritually purged that painting would be wholly superseded. Above all, Nicholson is a sensuous and visual artist, his logic is sensuous and visual. In his total work he would find himself wholly in agreement with Cézanne who said 'the painter must always follow the logic of his eyes. If he feels accurately, he will think accurately. Painting is primarily a matter of optics. The matter of our art lies there, in what our eyes are thinking'.

[…]

As a dedicated maker of superbly structured objects rather than of easel paintings Nicholson's studio has more the character of a well-ordered craftsman's workshop, a long bench running the length of a solid wall which shuts out the seductively beautiful panorama across the lake, and storage racks along other walls carry the immense amount of work always in process of making. There, too, on shelves or tops of cabinets, are the collected mugs, jugs, bottles, carafes, compotiers, that one has known over so long a period in Nicholson's paintings. Like the simple objects still standing in Cézanne's

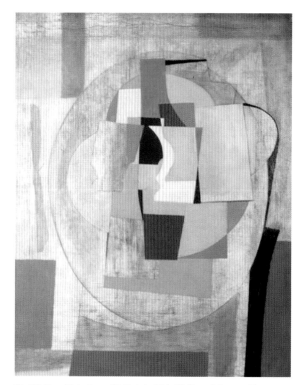

Fig 30 Ben Nicholson, 1947, July 22 (still life – Odyssey 1)

studio in Aix, these mugs and jugs have the sense of being hallowed by the continuous affectionate visual attention they have received over the years. There, for example, is the striped jug from the 1911 painting, and there, the compotier and big spotted jug from 'May 21–48 (cat not under table)' and many another painting. But it hardly needs saying that Nicholson is not concerned with recording resemblances to nature but with the process of transmutation into a related geometry of pictorial logic and structured articulations.

The comparative ease with which Nicholson moves a 6ft painted relief belies his seventy-five years, and his easy movements and the springiness in his walk bear evidence of the tennis player of earlier years. His quick bright eyes, that seem to miss nothing, fix you directly as he talks in a lively high-pitched, yet soft, voice. Within the briefest span of time one may find him shifting from recollections of Max Beerbohm and Christopher Wood to a spirited appreciation of Bridget Riley's prize-winning show at last summer's Venice Biennale, taking in an affectionate reference to Mark Tobey, and a tribute to Rothko's achievement on the way – no words are wasted, they are used like a craftsman's use of a hammer. And the abiding impression one has is of an individual possessing a flexibility of mind, generous enough to retain a sense of the creative urgency of the new generation and a truly synoptic view of experience over a life-time.

2.20 *Naum Gabo talking to Maurice de Sausmarez* (1969)

De Sausmarez's edited transcript of his interview with Naum Gabo, published in *Ben Nicholson*, a Studio International Special, pp.15–16, 21.

MdeS I believe you came to England in 1935 and I wonder whether you knew Ben Nicholson before you arrived here?

NG I can't really remember – maybe we had seen each other in Paris – we might have met each other in a casual way, but I remember when we really got to know each other and that was at the *Abstract and Concrete* exhibition organized by Nicolete Gray – but that was not my first visit to London, my first appearance in England was in 1934 when I came here to confer with the Diaghilev Ballet, which was at that time called the Ballets Russes – I had to confer with Massine about the possibility of a new ballet.

Fig 31 Naum Gabo at work in his studio, 1968

MdeS The ballet was appearing at the Old Alhambra Theatre I believe, wasn't it?

NG No, in Covent Garden I think – but in fact all this is so far back in time that I can't with exactitude give dates and so forth. But certainly it was at the Nicolete Gray exhibition that I met Leslie Martin, Ben Nicholson, and also Barbara Hepworth, Stephenson and John Piper. I did not meet at that time Henry Moore – that came later. But that is how it started – I came to London, I liked it very much, it was such a contrast with Paris which was violent, gossipy and full of intrigue and jealousies which I hated, and London to me was like coming to a place of peace from a place of war, although I knew afterwards it was not so peaceful!

MdeS So you met this group and you decided to stay?

NG Yes, I decided to stay in London because it appealed to me, it was just what I wanted. I saw what they were doing, what Ben was doing, and the young architects like Leslie Martin, and young men like Piper who at that time was on the very Left and a very good painter, and Stephenson who I met too – the atmosphere here was more germane to me, whereas in Paris artists like me were just like foreign bodies in the world of art. In Paris there were very few artists of our kind; the atmosphere there was not at all germane to my spirit and my state of mind.

MdeS Leslie Martin I suppose by this time had already got some ideas about the possibility of some kind of publication, the survey of constructive art *Circle* which you helped to edit, because it appeared the next year 1937 didn't it?

NG Yes very soon we were having talks, Ben, Leslie and I, and it was obvious that we needed to have some mouthpiece.

MdeS How did these editorial meetings happen, did they take place in Leslie Martin's rooms or did you have some sort of a central meeting place?

NG We divided the responsibilities, Ben had the responsibility for the painting, Leslie Martin had the architecture, and I looked after the sculpture and general constructive ideas. But there was no business of putting responsibility on individuals to meet a date-line, we wrote to certain artists throughout the world whom we knew were working in this direction and they sent photographs and articles, there were not all that many at the time and we knew every one of them; of course we subsequently discussed our propositions but we did not have what you might call editorial meetings. We all three of us were working together on it and we were united ideologically.

MdeS But you, in fact, were the most experienced constructivist (if one uses this term in that context) of the whole lot. Nicholson had come to the ideas of constructive art only some four years earlier, before that he had been painting in a highly personalized and rather romantic way. You at this time must have been the most experienced and longest committed constructivist of this group?

NG Well, I couldn't help it you know! Earlier I was engaged in a particular trend of ideas, and I had to leave my own country because there was reaction from the Government against my art, which incidentally is a very fertile thing particularly at the beginning, because it creates energy by giving you something to work against – I miss it in the situation now, it is too easy now to become an abstract

artist and be recognized. When I came to England I found in Ben and in the circle around him the seeds of what we had started in Russia – so obviously I was attracted to the situation and I could contribute something of what I had known before. We did not have arguments as far as the arts and the philosophy of art were concerned. When I met Ben I valued him for his quality as an artist and also felt that the spirit of that man is truly in his work – if you feel in a man's work something similar to your own spirit, that is the basis of proper friendship.

MdeS In fact you found that you had an identity of purpose and interest and attitude. Then two years later Mondrian arrived here in Parkhill Road.

NG Well that is characteristic too. We were living in Paris, Mondrian, myself and my brother, and a certain number of others, and young artists who were practising what we might call abstract or constructive art, but there was no real atmosphere there at that time, it was always very doubtful whether these one or two would not tomorrow be changing to something else – which they often did, in fact.

MdeS So you had known Mondrian before in Paris?

NG Oh yes. I lived near him, and we were part of quite a small circle. One of this circle was Vantongerloo who was fighting Mondrian all the time, saying that he was the first with the square; Mondrian of course laughed about the whole thing. The atmosphere in Paris was against constructive art. The few artists who were there had no contact with the country, or with the city, or with the field of art – they were isolated and very lonely, and actually meeting animosity.

MdeS You think that Mondrian felt this himself?

NG Oh yes, definitely – he liked Paris but he was working absolutely alone quietly in his studio, and so was I.

MdeS But what about you and Ben and Mondrian in London?

NG Well, Ben found Mondrian the room at 60 Parkhill Road and it was back to back with the Mall Studios, a back room overlooking the gardens, there was a tree in the garden which Mondrian didn't like. He came to us frequently, he enjoyed my wife Miriam's food. He was always on some funny diet and at this time he was on a Haye diet. He really needed looking after; the man was living on carrots! Somehow Miriam managed to get him to listen to her and he used to come for lunch.

He was the only one of the circle of my friends who was tolerant to an artist who was not abstract. I myself feel this way – for instance, I very much admire those works of Ben's which are sometimes outside the abstract field, because the abstract values can also be found in a work of art which is figurative, as distinct from non-objective. As a matter of fact I think that one should first see the work which an abstract artist did before he became abstract, then you know whether he is genuine or not.

MdeS Those four years before the war were years of intense activity and I wonder very much, if the war hadn't come when it did and put a stop to the gathering momentum of the new impulses, how much more might have been achieved ?

NG So much was already achieved in those four years. For myself I remember the importance of my meeting with all the artists at the Mall Studios, and with Herbert Read – it was an event for me. Although at that time Herbert Read was very much for the surrealistic philosophy, in my talks with him I found out that he was not at all that much committed to it – he adopted surrealist art because he felt there was something important in that movement, with which I agreed, but he was one of those critics who do not take anything for granted. He waited until he definitely could see the value of the whole movement. You know he did not write about me or my work for a very long time, until he saw work which convinced him.

MdeS Yes, he was a great man and an important factor in the situation.

NG It was a significant event in my life when I met that man, and he's a great loss. The mere presence of Herbert Read at that time meant that we could meet and talk within the terms of a philosophy. We did not necessarily agree on all details, but for me to meet a man of such great integrity and with that capacity of thinking, perceiving, and feeling, was of the greatest importance. He was one of those rare people who write on art (I could not call him a critic) who did love art. A great many people today are more concerned with the words about art than with the art itself, and this is unfortunate because it has no value at all really. It is in my opinion a very negative thing. You know the best critics at all times were the poets: Poe, Baudelaire, Apollinaire, and we were very lucky to have Herbert Read. He was exceptional.

MdeS He, as it were, kept you together by bringing ideas to a point?

NG No, he did not need to bring ideas, he was more like a magnet which brings together people and ideas, he was a sort of central point both as a person and as a critic. Who else could have transmitted us and our ideas as he has done? There was nobody – in Russia we did not have any great critics, it was we ourselves the artists who had to talk about our work with all sorts of manifestoes, in France there was nobody on whom we could rely – even later on, their words were of no value because their hearts were not in it – Herbert Read made England that central point from which our ideas spread. We were very active in Germany but we did not have active writers, we had many critics but they wrote and repeated what the artists said – they didn't bring so much of the philosophy of art to it as Herbert brought.

MdeS Yes, this was his great gift that as an artist himself, a distinguished poet, he had a real total sense of the philosophy of creation and art and could relate what he saw to this.

NG And he had the ability to bring this to people who might otherwise not understand what it is all about. In this respect I consider that the focal point England, and London in particular, and the group with Herbert Read in the centre was instrumental in spreading the idea.

MdeS I think this is what is so extraordinary. It's possibly something to do with England and the English – we are so restrained and reserved, we very often don't value sufficiently what occurs here. It seems to me that this period of four years that we are talking about is quite remarkable and much more important than it has been allowed to appear.

NG It is always that way. We are now thousands but it starts with one, two, three, a handful. It was a time which should be historically evaluated in a proper way.

MdeS I'm sure it will be. You spent some time in St. Ives didn't you?

NG We lived in London, from '35 to '39, September – the end of '39. Fully four years and at the beginning of the war we went to St. Ives – we had intended perhaps to go to the United States. We could not get a boat at once so we had to wait; we had actually got the tickets. A very important event in my life happened in London at that time – I met my wife, Miriam, and we got married, and Ben and Barbara were our witnesses.

MdeS Do you have any personal recollections of Nicholson?

NG Yes of course – we were very close friends and we are still near to each other in spirit. Off and on I get a letter – and I admire his letters – the last one which I sent him was a postcard of a cow from Switzerland when we were waiting in Zurich airport, he at the same time was sending me a postcard of a naïve painting of a tree and animals without realizing that my postcard of the big Swiss cow was already in the post. On it he had written 'Look on the other side. You think your name is short and to the point. How about E. Box?' which was the name of the painter of the picture he had sent.

I consider him a very sensitive artist, an artist of very great value and I like his work. But I must tell you something. You know in life you don't find too many real friends; if you find a friend with whom you share at least half of yourself you are lucky, the other half doesn't count. If you accept this then it becomes a matter of loyalty, it becomes friendship plus loyalty. Proper friendship in my opinion has to become so strong that the loyalty can be demanded from each other or expected from each other. Now this is a state which I reached with Ben. For Ben, I just wish him continued success in the work he is now doing.

2.21 *Henry Moore talking to Maurice de Sausmarez* (1969)

De Sausmarez's edited transcript of his interview with Henry Moore, published in *Ben Nicholson*, a Studio International Special, pp.23–24.

MdeS The years from 1933 to 1939 in the art of this country were a remarkable six years don't you think?

HM Yes, but I think it was only the development of what had been prepared some time before. If I were trying to explain it historically, I would begin with Roger Fry and Clive Bell importing Post Impressionism, with later the counter ideas of Wyndham Lewis, with BLAST and the Vorticist movement, and people like that, all leading up to the period of the thirties. A great deal of what was done then in England was a sort of 'catching-up' on what had been initiated mainly in Paris in the twenties and earlier. And for me Paris in the thirties, my meeting with Picasso, Giacometti, Paul Eluard and André Breton was far more important than Unit One and other episodes here. Unit One was really only a

Fig 32 Henry Moore working on a plaster maquette in his studio, Perry Green, 1963

gathering together of English talent which had got its chief sustenance, not from England but from outside.

MdeS And yet, in talking with Naum Gabo, he referred to the situation then in Paris as being hostile to constructivist artists and that, coming to England, he had found a group and a situation with which he could establish real links.

HM I'm sure that is true. There were so few artists in London in the early thirties that there were no deep jealousies. Someone like Gabo could come and contribute something, but in Paris there were the giants, Picasso, Matisse, Braque, Mondrian, Kandinsky and other big names, and an artist like Gabo might have been having a rather lonely time of it – I think this may be what made the English scene such a contrast and attractive to him.

Then in Paris there were individuals like Jean Hélion, (who was a close friend of both Mondrian and Léger); he provided a link with the English group. I liked him enormously. At that time he was someone who had to have a theory, a directional system to work on; he was perhaps more convinced in an intellectual way about abstract art than Nicholson or anybody else in England. Nicholson's conviction comes, not from theory and argument, but purely from what he feels he likes, and from an inner direction. He's very able to give justifications and

throw light on what he's doing, but he is not what one would call an intellectual, whereas Hélion had about him the stamp of the intellectual, and this I think is what led him, after the war and the experience of being a prisoner, to revalue his attitude to art and life in general and to reject abstract art.

MdeS I suppose you got to know Ben Nicholson in the Seven and Five Society didn't you?

HM Well it must have been then, but you know I can't remember ever exhibiting with that group, because, by that time, I'd begun to have my own exhibitions, and to have enough sculpture every two years for an exhibition at the Leicester Galleries, I needed to gather together and retain my work. I often found I didn't have work available for other shows. But I should say it was about 1930 that I got to know Ben, because I was married in 1929 and I remember that when someone had proposed me as a member of the Seven and Five my wife, Irina, took photographs of my work down to Chelsea for the meeting at which I was to be elected.

MdeS But I don't suppose you were ever a great one for attending meetings, so that you probably didn't see much of Ben at the meetings of the society?

HM No, I only began to meet him frequently after he came to know Barbara Hepworth well and came to live in Hampstead in one of the Mall Studios. I

had been living in a studio very near there, in Parkhill Road, since my marriage. The Seven and Five was being transformed at that time from what had been a rather mixed and muddled group of seven painters and five sculptors – though where they got five sculptors from in those days I don't know. I can't remember there being that many, unless one went to the Royal Academy. The few sculptors outside the R.A. – Epstein, Gill and Dobson – weren't members of the Seven and Five; John Skeaping might have been.

MdeS During this period in the thirties would a sculptor's keenest interests lie abroad?

HM Well, as far as I was concerned, mine didn't lie abroad so much as in the British Museum. If I had to say what things helped me most I would say, the British Museum, in learning what world tradition in sculpture was, my academic study of Life modelling and drawing and absolute obsession with the human figure, and my interest in natural forms.

But Paris, of course, did mean a lot to me – it was in those days the undisputed world capital of modern painting and sculpture. Starting from 1923 I made trips to Paris once or twice every year – and got to know what was going on there, from Cézanne and Cubism onwards. I think most of my contemporaries here had contact with Paris – many of them living there for long periods.

MdeS Do you recall any aspects of Nicholson's working situation at that time or anything that might throw light on his ways of working then?

HM 'Experimental' artists in England were having a terribly thin time. It was natural and necessary for those of us with like aims and sympathies to know each other and to be friends – you couldn't help it, it was like the situation of a foreigner in another land finding people he could talk to in his own language. And we sometimes went on holidays together – I remember there was a summer holiday, maybe the summer of 1930, when a group of us spent a fortnight at Happisburgh on the Norfolk coast – there's a photograph of the party reproduced somewhere, with Ben, Ivon Hitchens, Barbara Hepworth, Jack Skeaping and two friends of Skeaping's, and Irina and me. I remember it was very good weather, and it was there that we found ironstone pebbles which are hard enough and also soft enough to carve. Some were already beautifully simplified shapes.

So it was natural we all knew each other, but that didn't mean that we were not critical of each other's work, or divided in our directions – some surrealist, some abstract, and so forth. For example, in Unit One, in spite of its name, the people in it were so critical of each other's work that, after a year and a half, they decided to resolve the situation by a vote. Unless each member got more than half the total votes of the membership, he would automatically resign; when the voting was completed, I was the only one left in the group!

MdeS So, eventually, you alone were Unit One!

HM But to go back to Nicholson, I remember very clearly the architect Bobby Carter with his wife and children one Saturday morning coming away from 7 Mall studios with a small Nicholson work under his arm. I could see the whole family was very elated, and I'm sure Ben was very pleased that somebody was buying a picture, because it would be very interesting to know whether, up to the war, Ben could have lived on what he got from his paintings. I couldn't have lived only on selling my sculpture, I depended on my two days' teaching each week, and I don't believe that Ben and Barbara could have managed on sales of their work alone. Now this gave a common sympathy, because we were all in the same boat, in a philistine unappreciative world. In a sense I enjoyed it, because when people said there had never been any English sculpture and never would be, which is what was often said, it acted rather as a challenge, than otherwise.

MdeS Nicholson started to produce his white reliefs in 1934. Do you think this might have had some connection with his being then in closer touch with sculptors?

HM It may have been that having a few sculptors around indirectly prompted him to translate the Mondrian influence into carving, but he has always been a very good craftsman and to do that kind of thing would have been a quite natural direction.

MdeS And of course it does relate essentially to the idea of two-dimensional screens moving back in a controlled space.

HM Yes, it's a picture-plane progression – a relief idea allied to painting, a one-directional view.

MdeS What would you say you recall most vividly about Nicholson in those days, apart from his work?

HM In a way my biggest contact with Ben was really through his liking of games which I liked. Quite often he would ring up and say 'Henry, what about a game of tennis?' Well, he could make rings round me, despite my having won a competition in the tennis club at Castleford. I don't know whether he ever qualified for Wimbledon but he could well have done so. Ben is a natural ball player – he was an absolute wizard at ping-pong. He actually invented a variation of the game which he demonstrated at Gamage's or somewhere, hoping to patent it. Instead of a net one had a platform about 4 or 5 inches wide and used the top of this platform to bounce the ball on to and off. It gave hazards to the game rather like those in a game of fives, one never knew quite at what angle the ball would come off the platform.

MdeS Geoffrey Grigson reminded me of another game you used to play on a large sheet of paper.

HM Ah yes, shut-eye golf. That was introduced and I think invented by Eric Ravilious. On this large sheet of paper you drew an imaginary golf course with a variety of obstacles – e.g. a dog, a tree, a cow, a bandstand, a duck pond and so on – and then you'd put a few extra bunkers in; it was a golf course in plan. Then you put the point of your pencil in hole 1, had a good look at the course and where hole 2 was, and what obstacles lay between, then you had to close your eyes and attempt to draw a line to hole 2, without the line touching any drawn obstacle. Sometimes one did it in one, but more often at one's first shot one's line touched a tree, or a bunker, or ended up far away from the hole – one had to play a second, a third and so on until the pencil point rested plumb in the hole. You could play a nine-hole course, or eighteen holes, and as in real golf the least score was the winner.

MdeS Grigson recalls that Ben and you were absolutely prodigious at this game.

HM Well, it's a game that relies on visual memory, a judgement of distances and angles. Ben was an absolute 'natural'. This ability and skill was something that he enjoys enormously, and I'm sure that it comes out in his work – the actual technique, the way that it's done, the splendid craftsmanship, the unerring judgement – I'm sure all this is a great part of the pleasure that he has in working.

In 1930 Ben and I exchanged a work. I gave him a carving in white alabaster of 1929, and he gave me a very beautiful still-life oil, *Jug and playing cards*, also

of 1929. We still have Ben's picture hanging where we see it every day, and we continue to get just as great enjoyment from it as ever.

2.22 *Letters from Ben Nicholson to Maurice de Sausmarez* (1967, 1968)

Held in the Maurice de Sausmarez Archive. Extracts published in *Ben Nicholson*, a Studio International Special, pp.58–59.

Letter dated February 8 [1967]

'dear de Sausmarez,

Many thanks for your "basic design" just come – fundamentally I'd guess we agree on a great deal but I am a very very bad reader (especially if I have to *think* at all as this interferes with visual work already planned). First, because I have a lazy brain, what there is of it, second because if anything catches my eye while reading I stop and *look*. This last process I suppose ends in a painting or relief or drawing or in painting the garden gate or moving a book from one place on a table to another. There is no end to it! But I certainly will have a crack at reading your book.

To *teach* painting is a fantastic problem – in sculpture there is always the technique to be learnt but nine-tenths of painting technique can be "taught" (as I see it) in one lesson?

I like the idea of a painting extending on into daily life – if not to-day then in 2,000 or 200,000,000 years time, and think the general "breaking-up" of painting over recent years a very healthy sign – no longer is (it) a creative idea to be popped into a museum (mausoleum) but here it is, *here* and *now*. And I suppose teaching art is really a question of discovering the real artistry in a person (everyone has it but often deeply buried) and then liberating this – and what could be a more rewarding job – it is I suppose enabling someone (or indeed oneself) to become fully *alive*.

The outlet of so many art students may so easily be in some other direction. Even to watch a cat or a dog it is fascinating to see their particular artistry? or a bird … we have a

smallish very dark leaved prickly holly tree with red berries on it on our rather large terrace and there's a blackbird which flies in low over the terrace (especially in frosty weather when the berries must be pretty good food) and into the depths of the holly tree. I looked into the centre of this one day and there was the bird, same tone, same colour as the stem of the tree almost invisible and "looking" at me steadily with one eye. Now here is an "artist", no liberation is needed ... and if in a drawing say of Urbino Court of Honour I can achieve this *aliveness*, then there we are with another free bird?

I'm glad you liked the etching – it was one of the first two or three I made – since then I've made many others very different. The bite of the steel point into the metal is a terrific experience when all goes right and the necessity I am finding to reduce the idea to a series of lines is interesting. There is a point

also where I can cut into the metal in a line as straight as any ruler but with this difference, that the ruler will always rule straight whereas my hand line may at any moment decide to develop a curve – (*it* may decide) and if it does so then other lines must relate and may even develop a bigger curve or even straighter line than either I or the ruler themselves could make. It is the bird flying low into the dark prickly holly tree all over again – and with that eye.

I expect you'll say all this is too fancyfull for words and that I ought to stick to painting.

With all regards, Ben Nicholson

a very fine Tobey show now on at Basel – also behind the scenes one of the best of Mondrian's 1930 paintings that I've ever seen'.

Extracts from a letter dated February 11 1967 (In answer to a letter from M. de S. explaining the difficulty of getting a place in an art school today without academic achievement in one's earlier education)

'yes, indeed Turner would have had a job to earn his place – and so would I – but I did pass in to Gresham's and changing from Latin to German (of which I knew nil) I became bottom boy of the school – and at the same time as a scorned new boy got 9th place in the cricket eleven and the right to wear a scarlet blazer in place of the normal dark blue one. Probably ball games have more connection with painting than mere learning?

'On looking through your book I felt that you made painting sound a bit "difficult" – whereas of course it's the easiest thing in the world. I've had about 3 pupils in my time ... and made them get a room or studio nearby and said I'd look in occasionally – in fact all I found I could do was to *liberate* them and this I reckon takes a dozen – possibly two dozen lessons and the rest is up to them – either they have it or they haven't? *I wouldn't know how to deal with a class* – too difficult for words.'

Fig 33 Ben Nicholson in his studio

Fig 34 Letter from Ben Nicholson to MdeS, 1967

Extracts from a letter dated October 8 [1968]

'*a propos* "etching". I think I am not an "etcher" as I understand the medium at all – really to be this (an etcher) one should know and have the whole paraphernalia – prepare and print the plates oneself? … Off-hand I can only think of a couple of very small Verona and Pisa "etchings" which seem to me to have the true quality of etching. I suppose mine are really drawings on prepared copper (and I like very much the clear line and resistancy of the material and the smooth run of the implement.)'

'I don't feel that I know a painting until I've sat with my back to it for some months'.

2.23 *Bridget Riley* (1962)

Introduction to the catalogue for the exhibition held at Gallery One, 16 North Audley Street, London W1, April–May 1962.

Dynamism has been a central interest in much of the art of this century and it is the theme of Bridget Riley's work.

The forms she uses are strictly geometrical and static in themselves, though subtleties of dimensional variation are everywhere to be found; her manner of painting too has a meticulous precision which scrupulously avoids the dynamics of personal gesture, yet not without a warmth and richness. Dynamism here is neither the description of movement nor the record of actual physical movement, it is poetic and arises from the pure relationships of the pictorial elements used. The marks and shapes on the canvas are the essential agents and the sole agents of a primarily visual sensation. The paintings act like electrical discharges of energy making immediate contact with our neural mechanism. Bridget Riley treats what has been termed *optical illusion* as a 'real' system of visual dynamics. No painter can afford to deny that what we actually experience in sensation is any less real than what is postulated theoretically or what can be specifically measured. But these works are not to be explained as demonstrations of a theory of perception; in addition to their teasing ambiguities, they have a lyricism, a structural strength, an immaculate and vibrating freshness that is the clearest evidence of a creative sensibility, an acutely refined judgment.

Fig 35 Bridget Riley in her studio, London 1964

Bridget Riley's development has been consistently in terms of an enthusiasm about the dynamic properties of optical experience. From her student days an attachment to Ingres, Matisse and late Bonnard moved to Seurat. It was at this stage that she came across the statement of Charles Blanc 'Straight or curved, horizontal or vertical, parallel or divergent, all lines have a secret relation to emotion'. The resulting shift of interests has brought her work close to that of Vasarely.

This is Bridget Riley's first exhibition and it would be a disservice to make any but modest claims about her achievement to date, but it is abundantly clear [...] that she possesses a rich store of creative vitality, sensibility and invention.

2.24 *Bridget Riley's Working Drawings (1969)*

Introduction to the catalogue for the exhibition held at Bear Lane Gallery, Oxford 26 April – 17 May 1969; the Midland Group Gallery, Nottingham 24 May – 14 June, and the Arnolfini Gallery, Bristol, 8 July – 7 August, 1969. The essay was reprinted in *Art and Artists*, Vol.4, No.2 (May 1969), p.29.

Bridget Riley's studies can do more to instruct an interested public in the principles underlying the dynamics of her art than pages of verbal explanation. Not only are they works of rare distinction in themselves but close inspection reveals clues to the source of their dynamic subtlety, their pellucidity. It is a truism to say that the drawings and preparatory studies of all artists provide a special insight into the manner of their creative thinking, but there are some whose completed works present so immaculate a cover to their creative machinations (for example, Leonardo, Poussin, Degas and Seurat) that only a knowledge of their preparatory material for paintings

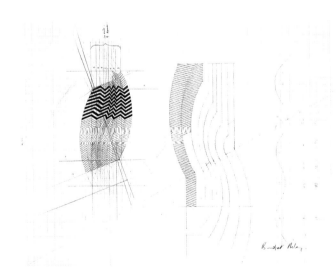

Fig 36 Bridget Riley, untitled study, 1963

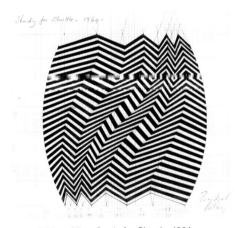

Fig 37 Bridget Riley, Study for Shuttle, 1964

reveals their true stature and the full nature of their creative talent. Bridget Riley is an artist of this kind and in this foreword I would briefly draw attention to factors that are revealed and, at the outset, to an ill-founded notion about her work that is demolished by a careful examination of these studies.

In the early phase of her development, the character of the optical tensions and energies with which she was concerned led to the assumption by many, critics included, that this was an art almost wholly dependent on the exploitation of phenomena classified as *optical illusion*. But her work from the first was primarily concerned with factors of modulation, progression, rhythmic range, changes in tempi, intervallic relationship – concepts that are often more usually associated with music – and out of this concern has emerged a visual dynamism that has inevitably included in its territory a wide field of optical 'energies'. In Riley's drawings and studies we witness a structural fascination with consonance, dissonance and overtones in optical responses and experience. But the appropriateness of a musical parallel does not end there. Although it would clearly be absurd to press the relationship in terms of any precise transferability between the two fields, some of the studies exhibited here might helpfully be likened to the musical form of the 'Invention in Two, Three or Four Parts' – the two parts, or 'voices' that structurally interweave to create the particular optical experience are derived from the measured intervals along the vertical and horizontal boundaries of the picture surface, the third 'voice' is often the addition of the diagonal intervals and directions, and the fourth 'voice' might be ascribed to the scale of intervals in greys, or of the measured coloured sequences.

Stravinsky in an interview with Robert Craft speaks of musical form being close to 'something like mathematical thinking and mathematical relationships. (How misleading are all literary descriptions of musical form!) I am not saying that composers think in equations or charts of numbers, nor are those things more able to symbolise music. But the way composers think, the way I think, is, it seems to me, not very different from mathematical thinking … But though it may be mathematical, the composer must not seek mathematical formulae. Seurat said, "Certain critics have done me the honour to see poetry in what I do, but I paint by my method with no other thought in mind".' All this might equally

well have been said by, or of, Bridget Riley – it certainly relates to her visual 'music'.

The studies from 1961–2 period reveal the interest at the time in the dense field of regularly repeated units which is subjected either to subtle inflexions in the shape of the unit over parts of the field permitting hidden structures to make a sort of 'hallucinatory' appearance, or to dynamic pressures progressively flattening or extending the unit to produce inner movements of contraction and expansion, changes in flow and speed. Studies of 1963–5 often seem to change attention to the figure/ground phenomenon (the ambiguous reading of black forms on white and white forms on black) and new subtleties of induced structure from two interpenetrative systems of progression. Factors of disruption and displacement, acceleration and deceleration, modulation, progressions, directional tilting, expansion and contraction, the interaction of two scales of warm and cold greys, and most recently, the increase and decrease of colour intensities in a dialogue of red and turquoise – these, amongst others, have been the formal means of change and movement employed by Bridget Riley to conjure subtlety induced structures and colour, to evoke and control the dynamism in her work.

2.25 *Introductory Observations on Optical Painting* (1969)

Extracts from one of the essays by de Sausmarez in his monograph on *Bridget Riley* (London and New York: Studio Vista and New York Graphic Society Ltd., 1970)

Few aspects of contemporary art have caused more misunderstanding among critics and public alike than what goes by the name of Op art. It is not that the elements of its artistic language are difficult to comprehend, in point of fact bald geometric abstraction, the keen incisiveness of 'hard-edge' painting and the eye-averting techniques of the graphic arts of advertising and display have long been assimilated. It is more in its creative philosophy and the lack of ease with which it fits into any of the accepted frameworks of either present or past traditions, that it raises special problems. On one level, its decorative potential, through the frequent convergence of dynamic pattern in its manifestations, has been seized upon and widely exploited commercially in 'Op' dresses, 'Op'

Fig 38 Bridget Riley *Cataract 3*, 1967

advertising, and 'Op' packaging, but this has as much intrinsic relevance to the work as the exploitation by a smart interior decorator of *The night watch*'s light and shadow for novelty effects, would have to Rembrandt's initial purpose in using chiaroscuro. Nor have the more serious efforts to place it in the same creative stable as Constructivism been particularly successful, despite the obvious points of contact and reference; nor again can its achievement be shrugged

off by shackling it to the field of the experimental psychology of perception, though here again the connection is significant and revealing. And there is little doubt that optical painting can be forced into the category of kinetic art only by falsification of the definition of terms. As a recent book on kinetic art concedes 'Of these three groups (of works concerned with movement) it is the one which is concerned with virtual movement that poses the

most difficult problems of classification'.[46] And this difficulty, I suggest, springs from the fact that in the case of optical painting it is not the art that is kinetic but the response to it: the optical 'zizz' occurs in the spectator's receptive sensibility, not in the object. In fact optical painting does not fall within the territory of kinetic art at all; it is an art essentially dependent on sustained meditative visual concentration, and not in any way connected with the mechanisms of physicality.

The most extreme arguments of Constructivism always pointed towards the death of painting. A latter-day Constructivist announced in capital letters that 'The empty canvas symbolizes the fact that this medium can have no more to offer in our times' and in another place he writes 'This medium reached its abyss before Mondrian predicted it'.[47] No-one will deny the Constructivist-realists their right to finish with two-dimensional equivalence in favour of actual form in actual space, but what cannot be sustained is the implication that painting was an art striving always to achieve real space, but which, through its limitations, was forced to make do with illusions of space and solids, and that the only valid statements to-day must be made in real entities, the manipulations of real elements. Some of the essentially non-material space concepts of modern science, or modern ideas of psychological space, would still seem to demand statement in plastic equivalents, where the creative imaginative capacity of the artist and spectator is encouraged to construct psychic and sensational relationships, references implied but not made concrete. For this task, painting would seem to be a valid medium because of, rather than in spite of, its very ambiguities. Real space and actual tangible form satisfy only part of human consciousness; the poet and the musician still appeal to other levels of mental and emotional experience, other notions of space, and the painted surface, developed and organized in purely visual terms, has an evocative potentiality no less extensive. There is very considerable evidence to support the claim that one important aspect of the profundity and the beauty of the art of painting resides in the implicit dynamism of this sensation of its elements being structured 'spatially' through relationship. The fact that this has been utilized in certain limited periods in the history of art to deliberately trick the eye into experiencing a naturalistic counterfeit of the effects

of the visible world has no relevance to the paintings under discussion, just as it has no relevance to the art of Cézanne, or for that matter to the art of Piero della Francesca.

Bridget Riley writes '… the fact that some elements in sequential relationship (e.g. the use of greys or ovals) can be interpreted in terms of perspective or *trompe l'oeil* is purely fortuitous and is no more relevant to my intentions than the blueness of the sky is relevant to a blue mark in an Abstract-expressionist painting'.[48] Criticism of her painting based on the failure to see a distinction between *trompe l'oeil* and the integral and implied 'spatial' dynamism of relationship in this two-dimensional art is characteristic of a banal materialism too stuffily doctrinaire and tendentious to be worth serious attention.

[…]

For Bridget Riley there is no such thing as optical illusion since this would imply the censorship of visual experience by factual measurement. Cobalt blue on a white ground is not the same colour as cobalt on a black ground despite the fact that in both instances the pigment may have been squeezed from the same tube labelled 'cobalt blue'. For Riley what is visually experienced is the optical reality, just as in daily life what is physically experienced is the physical reality (because of recent work in theoretical and nuclear physics we do not refer to the world of objects as physical illusion). It becomes abundantly clear that a substantial part of the victory won by modern painting is connected with the vindication of intuitive judgment based on direct sensory experience, and the defeat of the academism that had censored and disciplined sensory responses by reference to purely intellectual theories based on dead, factual, arithmetic measurement, pre-ordained systems and dimensional concepts of balance and symmetry.

[…]

In the 1880s Seurat was being faced with the same criticisms that have at times been levelled against Bridget Riley. Julien Leclerc objected to the 'pernicious confusion of art and science' and another writer stated that 'aesthetics has its own laws, which it must derive from observation, and not predict on the basis of physical experiments'. Arsene Alexandre warned that 'a little bit of science does not do any harm to art; too much science leads away from it' while another critic likened Seurat's paintings to

'coloured rug patterns which housekeepers use for slippers'.

Bridget Riley has written: 'I have never studied optics and my use of mathematics is rudimentary and confined to such things as equalizing, halving, quartering and simple progressions … I have never made use of scientific theory or scientific data, though I am well aware that the contemporary psyche can manifest startling parallels on the frontier between the arts and the sciences'.[49] Nevertheless, the relationship between science and art is particularly thrown into relief by Riley's form of painting, which reduces the material evidences of personal involvement to a minimum in the interests of an objective evaluation of the interaction of the energies inherent in the related lines, colours and shapes, and utilizes calculated intervals, frequencies and elements, in such a way that there might at times appear to be a resemblance to scientific diagrams. Further, it is frequently demonstrating principles which, though they may not be defined, are nevertheless as evident as the physical laws that underlie scientific enquiry and deduction. But it is not so much the apparently scientific detachment that worries the average spectator, as the apparent remoteness of the artist from the process of materialization, the feeling that the works might be produced by machines.

[…]

Riley believes that through relationship contact is made with extra-personal forces and energies, universal factors, while the element of subjectivity is retained on the level of individual-formative decision. Her painting is committed to the thesis that calculated relationships brought to a precise point of tension bring into being, or liberate, a field of energies that reveal a new dimension of experience and beauty.

[…]

The inquisitiveness that accompanies speculative thinking must seek out the terms for the demonstration of its suppositions, and not infrequently this demands a rigorous paring down to fundamentals. And it is in the precision of the sustained enquiry that Riley's painting seems to parallel scientific analytical procedure. But is it a sustained form of enquiry, and, if so, what is the nature of its enquiry?

There is a fundamental difference between the scientist's concern with things as agents producing effects, the imperative allegiance to causal systems, and the artist's concern with things for their own sakes. 'The artist is not committed to an inexorable rule of logic imposed from without on the matter in hand, he has to discover afresh in each work the logic peculiar to it. Only to a limited extent does the completion of a work provide him with a general hypothesis applicable to future problems … The problem during the process of making is always "how can this thing be made perfectly as a thing expressive in itself and in conformity with its own nature?"'[50] A clear distinction can be drawn between the scientist's desire to find answers to what happens and how things happen and the artist's satisfaction with the simple demonstration that they do happen and that they can extend the range of man's consciousness and aspirations. Bridget Riley says of her work 'I work from something rather than towards something. It is a process of discovery …'

Would this form of painting's pursuit of optical responses (its concern with the physiological mechanism of the eye) alone, be sufficient to justify the claim to its being art? No more than the pursuit merely of naturalistic verisimilitude qualifies as art. The justification lies in the fact that this enquiry into the field of optical dynamism is placed at the service of a faculty of informing that seeks to create totally structured coherences that minister both to our human need for controlled experience and expression, and to the deeper level of unverbalizable responses that are rooted in the psycho-physiological nature of our being. Charles Blanc wrote: 'If there is a great affinity between light and dark and emotion, there is even more between emotion and colour; straight or curved, horizontal or vertical, parallel or divergent, all lines have a secret relation to emotion'.[51] And Paul Sérusier has stated 'Thoughts and moral qualities can only be represented by formal equivalents. It is the faculty of perceiving these correspondences which makes the artist'.[52]

3 THE ART OF MAURICE DE SAUSMAREZ

Early paintings by de Sausmarez reflect the figurative legacy of both Stanley Spencer and the Euston Road painters. They include portraits, interiors, landscape and still life. He kept to these traditional genres throughout his career. He undertook portrait commissions, but his most penetrating works in this field are those of his close friends – and indeed his own self-portraits, which are acutely sharp in their close visual examination.

In the introduction for the catalogue of de Sausmarez's first one-man exhibition in 1949, his former teacher Percy Horton (by then Ruskin Master of Drawing at Oxford) wrote:

One of the characteristics of the art of our time is a feverish striving after originality which has led to extreme subjectivism and an exaltation of the ego in the work of some contemporary artists. The quiet delight which can be found in the appearance of the world outside ourselves is not however to be denied. There are still to be found good painters for whom an objective approach to nature provides a satisfying stimulus to creation.

Maurice de Sausmarez is such a painter. He is content to find the material for his paintings in the surroundings of his everyday life, but he does not consider it necessary to give this private world any particular angle or slant. For him it is not a subject for whimsical comment or amusing storytelling. Neither is it a point of departure for distortion or abstraction. He paints his breakfast-table or the fish for his dinner as he sees them, and in the same manner he likes to paint himself against a background of his studio or living-room. When he wishes to paint a human being he asks one of his friends to sit for him, and when he takes brushes and canvas out-of-doors it is usually to a countryside he knows and appreciates.

In fact de Sausmarez paints what he loves, and he does this with the modesty of an artist who realises the difficulty of capturing even a small part of the subtlety of the visual appearance of things. This realisation has grown with his practice as a painter, and with its growth has developed a greater sense of the richness, power and complexity of nature [...] .

De Sausmarez is not a rapid worker. He does not 'knock things off'. He approaches his work with deliberation. Everything has to be carefully considered [with] a scrupulous regard for construction in terms of truth of tone and colour.[53]

In the following decades, the increasing level of commitment that de Sausmarez was to give to teaching and its related responsibilities meant that the time left for him to paint was limited to vacations. In the latter part of his life these were spent in southern France, where he worked directly from the motif. Colour studies and drawings, as well as photographs, provided the base for larger canvases that could be worked on back in England – landscape compositions of fragmented forms and faceted shapes built from a controlled duality of colour and structure.

In 1971, when his own works were included in the posthumous exhibition staged in his honour, Marina Vaizey commented: 'he was a sensitive interpreter of landscape in a naturalistic tradition which also incorporated the structural qualities of post-Cézanne painting. His paintings are relaxed, elegant and elegiac'.[54]

De Sausmarez maintained a lifelong admiration for Poussin and Cézanne, and there is something of their classic geometries in his own painting, but his later work is closer in conception to that of Jacques Villon, who took the motif purely as the starting point of a visual idea and allowed the proportions of the picture to govern the buildup of a planar construction, creating a complex and energetic network of diagonals, intersected by verticals and horizontals of varying intensity of light and colour.

H.D.

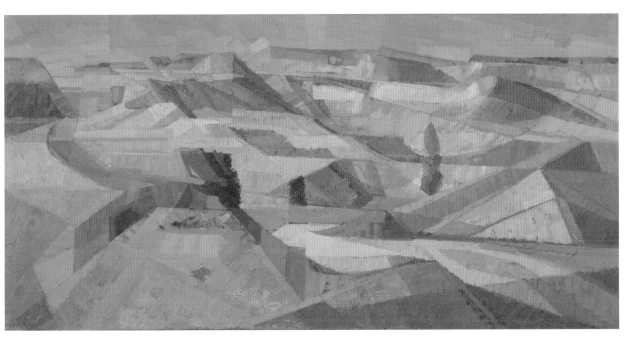

Fig 39 *Near Pienza*, c.1964, oil on canvas, 59.6 × 120.4 cm
Exhibited at the Café Royal Centenary Exhibition and the Royal Academy Summer Exhibitions of 1966 and 1970

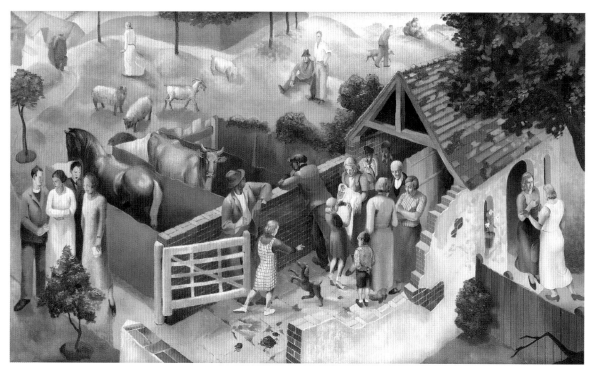

Fig 40 *Allegory*, 1938, oil on canvas, 78 × 128 cm
Painted when MdeS was a final year student at RCA

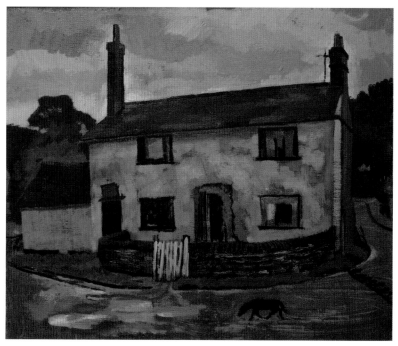

Fig 41 *Cole's Cottage*, c.1938, oil on panel, 49 × 59 cm
First exhibited at the Royal College of Art Students' Group Exhibition in 1938 and the Artists'
International Association Exhibition at the Whitechapel Art Gallery in 1939.

Fig 42 Photographs of Whitelock's bar taken by MdeS

Whitelock's is the oldest alehouse in Leeds. Opened in 1715 as the Turks Head, the poet John Betjeman once described it as "the Leeds equivalent of Fleet Street's Old Cheshire Cheese and far less self-conscious, and does a roaring trade. It is the very heart of Leeds."

Fig 43 *Whitelocks Bar*, Leeds, c.1954–5, oil on canvas, 69 × 100 cm

Possibly the work exhibited in the Royal Academy Summer Exhibition 1955, as no.588 *Bar-tenders*, although there is another painting of the same subject but from a different viewpoint (see photograph in chronology section page 16)

Fig 44 *West Hartlepool, Tees Valley*, 1953,
oil on board, 19.1 × 29.2 cm

Exhibited in *Modern Art in Yorkshire*, Wakefield City Art Gallery 1953, and purchased by Wakefield Council Picture Sub-Committee for the School Loans service.

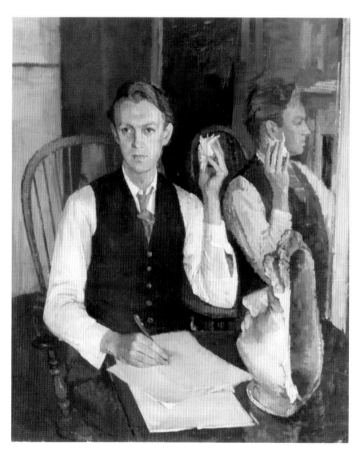

Fig 45 *Portrait of James Kirkup* (1918–2009), Gregory Fellow in Poetry at the University of Leeds (1950–1952), c.1951, oil on canvas, 76.2 × 63.5 cm

Fig 46 Squared-up preparatory drawing for the Portrait of James Kirkup, c.1951, ballpoint and pencil on paper, 38 × 27.5 cm

Fig 47 *Winter*, c.1955,
oil on canvas,
50.8 × 60.9 cm

Fig 48 *Kate Reclining*,
1949, oil on canvas,
45.5 × 60.8 cm

Exhibited at the RA
Summer Exhibition 1950,
afterwards purchased by
the Contemporary Art
Society and presented
to the Ferens Art Gallery
in 1952

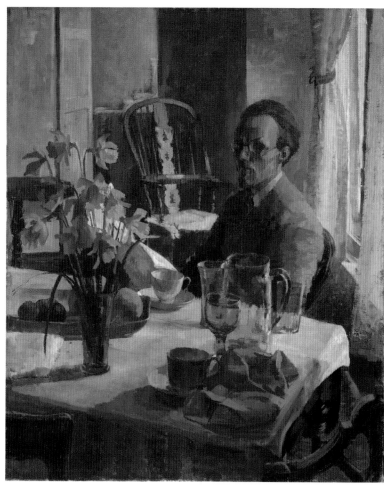

Fig 49 *Self Portrait at Table*, 1949,
oil on canvas, 60.8 × 50.8 cm

Exhibited at first one man show at Paul
Alexander Gallery, London, 1949

Fig 50 Self-portrait, c.1938/39, etching,
plate size 13 × 11 cm

Fig 51 Self portrait drawing,
c.1940s, pencil on paper,
29.5 × 22 cm

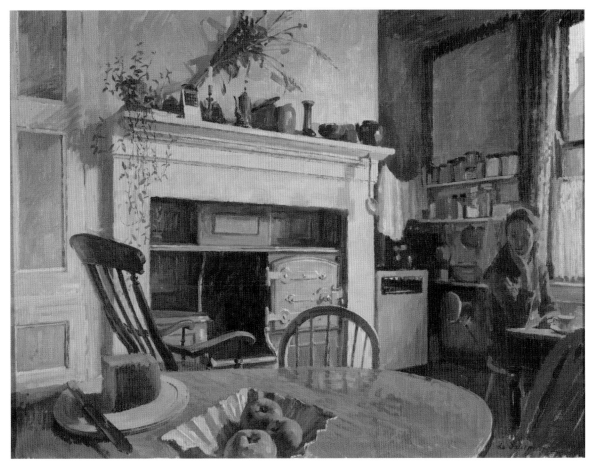

Fig 52 *Morning Interior*, 1954,
oil on canvas, 75 × 100 cm

Exhibited at the Royal Academy Summer
Exhibition 1954

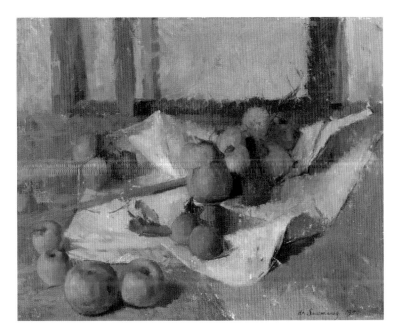

Fig 53 *Apples and Tomatoes*, 1950,
oil on canvas, 40.5 × 50.8 cm

Fig 54 *Still Life with Apples*, 1961, oil on canvas, 40 × 30 cm

Fig 55 Drawing for *Still Life with Apples*, 1961, pencil on paper, 30 × 23 cm

Fig 56 Colour study for *Still Life with Apples*, 1961, oil on canvas, 35 × 25.5 cm

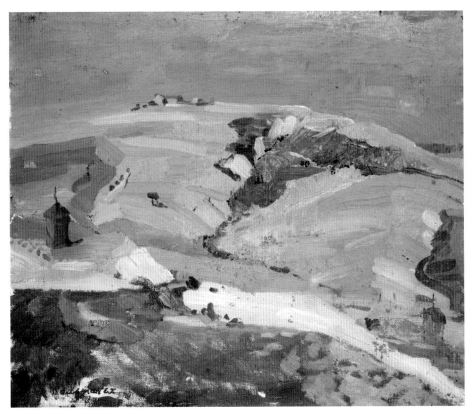
Fig 57 *Near San Quirico, Tuscany*, 1960, oil on canvas, 30 × 35 cm

Fig 58 Drawing for *Saltmines*, 1960, conté crayon on paper, 50.5 × 40 cm

Fig 59 Colour study: *Saltmines*, 1960, oil on textured oil painting paper, 38 × 52 cm

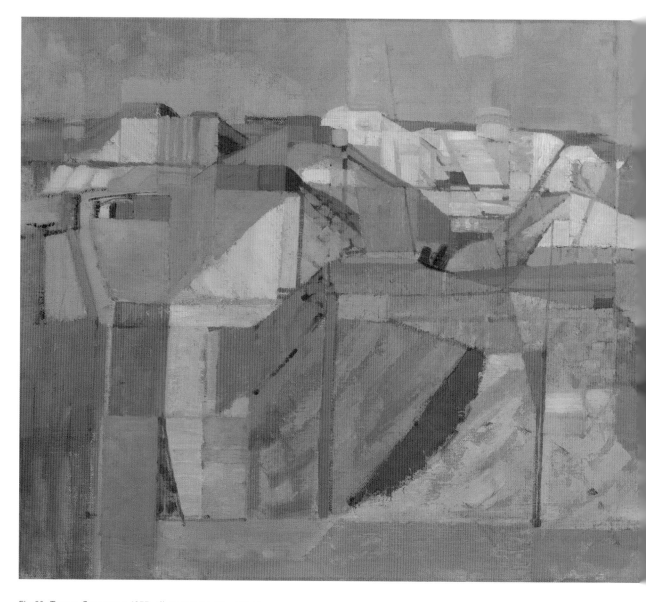

Fig 60 *Tuscan Summer*, c.1955, oil on canvas, 56 × 109 cm

Exhibited in *The Seasons*, the second of the Contemporary
Art Society's exhibitions of invited work, held at the Tate
Gallery London in 1956. Writing in the *Spectator*, Basil Taylor
commented:

> Maurice de Sausmarez is showing a meticulously careful
> *Tuscan landscape more abstract than his previous work. It*
> *is not an easy picture to decipher because the painter has*
> *attempted subtleties of space and structure within a very*
> *narrow range of tone, but this is a very serious and interesting*
> *departure.*

Basil Taylor, 'The Seasons', *Spectator*
(9 March 1956), p.316.

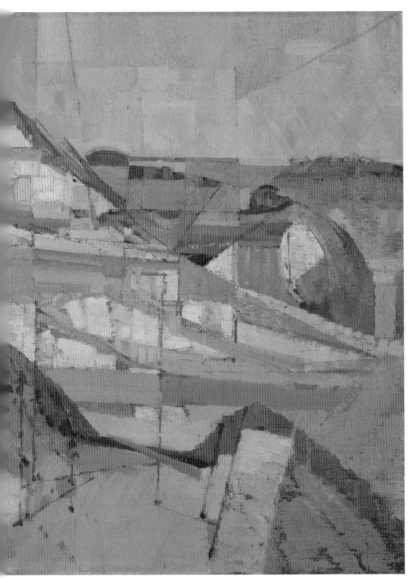

Fig 61 Landscape drawing, Italy,
pencil on paper, 28.3 × 43.5 cm

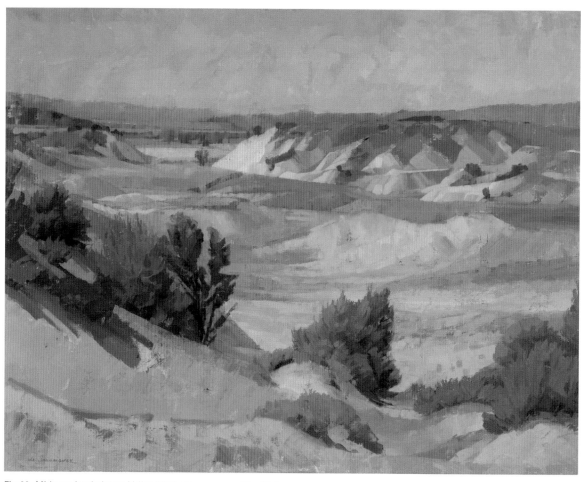

Fig 62 *Midmorning Luberon Valley*, 1965, oil on canvas, 71 × 91.4 cm

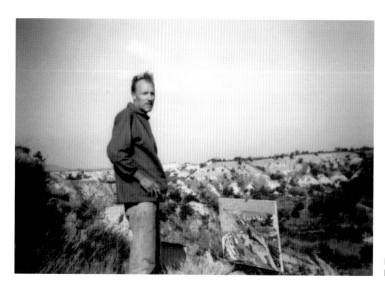

Fig 63 MdeS painting near Prades, near
Perpignan, 1961

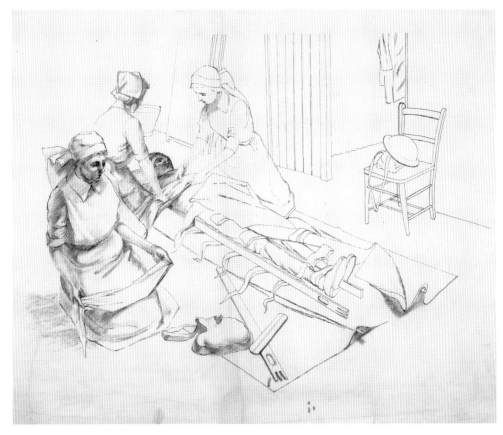

Fig 64 *Nurses bandaging*, ink and conté crayon on paper, 46 × 64 cm

Study for a painting exhibited in the AIA Exhibition For Liberty 1943, in the section This is What We Are Fighting For

Fig 65 *A Garden – God Wot!*, 1939, lithograph (zinc) on paper, 34.7 × 22.6 cm

Published in the series Everyman Prints by the Artists' International Association, 1939

Fig 66 *River Gunpost*, 1941, watercolour on paper, 28 × 37.7 cm

Fig 67 Study (landscape with a pig on the hill), no date, ink on paper, 28 × 38 cm

Fig 68 Colour notes, pastel on paper, 16 × 25 cm

Fig 69 Study for a composition, no date, conté crayon on paper, 24 × 38 cm

Fig 70 Drawing of house and trees, no date, pencil on paper, 23 × 29 cm

111

Fig 71 Two studies of buildings with gate and walls, no date, conté crayon on paper, 38 × 56 cm

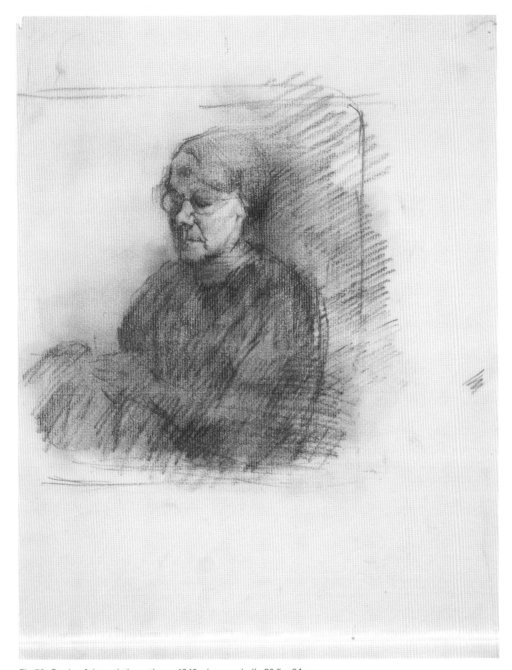

Fig 72 *Study of the artist's mother*, c.1940s, brown chalk, 30.5 × 24 cm

4 FOSTERING THE CREATIVE IMPULSE

Maurice de Sausmarez's enduring preoccupation was a deep concern with the theory and practice of educating the artist. Yet at a fundamental level his engagement with art education might be better understood as a clarion call for a creative education for everyone and for the artist in particular.

From his first published writing on the subject in 1944 until his death in 1969, de Sausmarez's resolve never waivered. With sincere commitment, he taught, reflected on and wrote about art education at every stage of human development from that of children and adolescents at secondary school to that of adults at art school. And while he undertook managerial roles, such as Principal, and actively participated in committees and organisations working for educational reform at local, national and international level, he did so as something of a belligerent, a critical voice that acted as a corrective, when needed, to the administrative and bureaucratic strictures at play.

There is everywhere in his writing a tension, a fine balance, between intellectual and intuitive approaches to teaching and learning about art. This is most keenly observed in his discussions of the work of the so-called Coldstream and Summerson councils whose changes swept through British art education in the 1960s. Here his observations on the purpose and value of art history in the art school curriculum are particularly pertinent, especially when we consider his own intellectual formation as an artist.

De Sausmarez's book *Basic Design: The Dynamics of Visual Form* of 1964 is his best-known legacy. In the 1950s and 1960s the Basic Design movement, if it can be called such, represented a fragmented field in Britain. There was no unified approach and its key protagonists adopted differing strategies to the teaching of a basic grammar of art. De Sausmarez's contribution seems to bridge the gaps between those various positions, synthesizing them in a fresh and productive way.

A creative education

Making their first appearance in print in the little-known *Club News* in 1944, it can hardly be said that de Sausmarez's fledgling ideas on adolescent art education made a significant impact upon publication. Fifteen years later, however, *Dissipated Octopuses* stood as his manifesto on adolescent art education and reached a much wider audience, first through its broadcast on the BBC's Third Programme in March 1959 then in *The Listener*, a widely read magazine, the following month. With art education under scrutiny at a national level, and the Coldstream Council newly established in January that year, it was an opportune moment for de Sausmarez's excoriating reflections. His timing was surely no accident and it might reasonably be assumed that he hoped to sway the Council's deliberations with such critical public appraisal. Here the failure of art education in secondary schools is seen first as a failure to free adolescents from the straightjacket of self-consciousness in their work and second, a failure to create the conditions for a more complete experience of the creative process untrammelled by curriculum and examination. The only way to suitably prepare adolescents for art school was, in de Sausmarez's estimation, for secondary school art education to somehow unshackle itself from the limiting factors of rote learning and exercises that, if anything, acted to dull the creative sensibilities of young people. He was not, however, suggesting that adolescent art education should be a mindless free for all. Rather, teachers should be equipped to facilitate learning in a more open and productive fashion that would encourage a holistic approach and precipitate a more fulfilling experience for students. The focus should be on a responsive process of making that allowed more autonomy for both the maker and the object made. What is required here is 'a constant give and take between the maker and the thing he makes, so that one cannot conceive of the artist as impressing *his* completely pre-determined mental image upon the object. He acts rather as a super-sensitive instrument for detecting and responding to the needs and demands of the evolving form.'[55]

At the heart of *Dissipated Octopuses* is a call for a creative education that will enable young artists to arrive at art school already equipped to take on the

challenges and opportunities that lie ahead of them. Further, such a creative education will not only pave the way for artists to develop in new and productive ways but also engineers, architects and any number of other occupations. A creative education for all is good for the economy and conditions of trade although that is certainly not the point. The point is to encourage teachers and students to consider their work afresh and to experience a degree of fulfillment previously unrealised.

In 1969, just months before his death, de Sausmarez presented his ideas on the subject once again. Although he had delivered a string of articles and talks in the intervening years, it is perhaps the scope of this 1969 talk that marks it out as significant and therefore worthy of further consideration. In the formal setting of a Conference for Art Advisers at Dartington College of Arts, convened by the Department of Education and Science, de Sausmarez's exegesis addresses interlacing themes that wind circuitously through his talk. First, there is the need, as he sees it, to situate art education, as all education, in the wider world. Whilst recognising the good work being done by some teachers, especially in primary education, he highlights the dangers of those teachers who teach in isolation from the realities of the outside world. Still, he cautions that an excessive concern with the surrounding environment, the wider world, as it were, might detract from a necessary focus on the individual driven by personal motivations. The implication is that social and environmental concerns might override everything else and act to stunt individual creative growth.

Second, he expresses concern with a split between the arts and science at too early an age, suggesting that the emphasis on education in one field or the other in early adolescence means that intellectual and creative faculties do not develop as fully as they might otherwise do. Delaying the requirement to specialise by several years would enable a wider understanding of the world and of humanity, so providing an opportunity for more creative minds to develop.

The final thread in de Sausmarez's address is one that might be summed up as the importance of looking back in order to move forwards. He acknowledges the significance of an awareness of artists such as Paul Cézanne (1839–1906) and Nicolas Poussin (1594–1665) for his own work as a practicing artist. In the same way, he emphasises the importance of an historical knowledge for art students. However, the only way for historical perspectives to be valuable in the present is for contemporary relevance to be shown. This means a focus on the sorts of problems artists of all ages face, rather than a focus on the form and content of the work produced. If this can be achieved then any anxieties students might harbour about influence and originality in their work can be set aside, enabling them to move forward more confidently as they tackle any difficulties they encounter more creatively.

The overarching message of the Dartington talk is a call for a liberal holistic education for the artist. With government policy on art education floundering at this time, the cumulative effect of de Sausmarez's attacks leave policy-proscribed curriculum and pedagogy hanging like flayed corpses, as he calls vociferously for new conditions in which creativity might flourish.

Intellect and Intuition

When it comes to teaching de Sausmarez's thinking repeatedly betrays a double bind at its core. This pervades all his writing as intellectual and intuitive approaches to teaching, learning and making, ideas fundamentally at odds with one another, are held in a productive tension. What this amounts to is a concern with the purpose and value of different approaches to teaching art and nowhere is this felt so acutely as in his discussions of the work of the Coldstream and Summerson councils.

In 1959 the Ministry of Education appointed the National Advisory Council on Art Education (NACAE) – known as the Coldstream Council after its chair, Sir William Coldstream (1908–87) – which devised the new Diploma in Art and Design. The Council first reported in 1960, then again in 1962 and 1964.[56] While its proposals offered improved status for art schools, it also called for inspection and validation of courses by a central controlling body. The Summerson Council, chaired by Sir John Summerson (1904–92) and set up to implement the Coldstream recommendations, sent its team around the country to validate the bulk of art and design courses at degree-equivalent level in the UK. Most inspections took place between February 1962 and March 1963. Of the eighty-seven colleges (and 201 courses) that applied for recognition, twenty-nine colleges (and

sixty-one courses) were finally approved. Following the first Coldstream Report in 1960, the Diploma in Art and Design (DipAD) gradually replaced the National Diploma in Design (NDD).[57] Now students were required to study art history and liberal studies intended to broaden their general education as well as raising it to degree-equivalent standard. The twin objectives of raising standards and liberalizing the institutions were, in themselves, a remarkable combination. Later, and following Europe-wide student unrest in 1968, in London, particularly at Hornsey College of Art, the Coldstream and Summerson Councils joined forces, under the chairmanship of Coldstream, to review tertiary level art education and reported jointly in 1970.[58] The Coldstream Council was clear that DipAD students should spend fifteen percent of their time studying art history and complementary studies and that these studies should account for twenty percent of the final assessment. The idea was, partly, to make the course more academic than the old NDD and to give it the status of a degree-equivalent level qualification.

Such significant shifts in approach and their impact upon how art schools operated attracted an array of responses as teachers, such as de Sausmarez, worked to provide students with the kind of art education they felt they needed, that is, the kind of art education that they believed would best equip students to continue developing as artists once they left art school.

In 1963–4, and in the wake of the initial Coldstream and Summerson reforms, de Sausmarez reflected on the purpose and value of the Byam Shaw School of Drawing and Painting, the independent art school where he had taken up a post as Principal in 1962. And while he laments the recent educational reform, he also seizes upon it as an opportunity to mark out the Byam Shaw's unique position to meet the needs of those talented but less-academically able students. Operating largely outside of the new structures, Byam Shaw was able to place the quality of portfolio submissions above any academic achievements and, in so doing, place intuitive modes of teaching and learning above the intellectual requirements of the DipAD. The radical nature of this approach was perhaps mitigated by the School's examination success rate, as well as the increasing numbers of students going on to further study in publicly approved institutions and into distinguished careers. These successes were vindication, if it were needed, of the

Byam Shaw's commitment, at that time, to remaining independent and keeping the requirements of the local education authorities at arms length.

His observations on the purpose and value of art history in the art school curriculum are pertinent too, especially when we consider his own intellectual formation. Trained first at Willesden School of Art and later at the Royal College of Art in London, de Sausmarez's art school education was fairly typical of the era. His earlier experience at Christ's Hospital School in rural Sussex, a school with a long history of high achieving pupils, is perhaps less typical and provided an environment that would have nurtured an intelligent curiosity that allowed him to develop artistic and academic faculties in tandem. Still he berates the DipAD requirement for intellectual enrichment through art history and complementary studies. His argument is not that these subjects should be laid aside entirely. Rather, they should come into play much later in the student's education.

De Sausmarez's exchanges with the artist Quentin Bell (1910–96) are emblematic of a commitment to identifying a workable solution to the practical training of the artist and the art historical content of that training. Writing to Bell around 1959, de Sausmarez sets out proposals for four alternative course structures at the University of Leeds where he had been employed as Head of Fine Art since 1950. What distinguishes the possible approaches from one another is how the teaching of art history is related to the teaching of art practice. His favoured option is the third one he outlines to Bell and marked as 'Alternative (c)' in the document. The crucial point here is that rather than placing responsibility for teaching history and practice in different quarters, de Sausmarez advocates quite the opposite, calling for the employment of practitioners who were also consummate art writers and critics. The purpose and value of art history in the fine art curriculum could only be assured, it would seem, if taught by someone who had the necessary skills and knowledge to bridge both disciplines.

In 1966 E.H. Gombrich reflected that art history is intellectual, academic and authoritarian.[59] Yet what de Sausmarez recognises in his deliberations on the subject is that this sort of view is not an undisputed matter of fact. Instead it is a risk that can be attenuated through the sensitive handling of course design for fine art training and the employment of

teachers with dual expertise who can also tease out the contemporary relevance of historical models of making.

Basic Design

Basic Design: The Dynamics of Visual Form of 1964 is de Sausmarez's best-known publication. In the art schools of the 1950s in Britain, Basic Design emerged as a radical new form of artistic training. It emerged in response to existing teaching methods embodied within the skills-based National Diploma in Design (NDD) and was an attempt to create a formalized system of knowledge based on an anti-Romanticist, intuitive approach to teaching art. Ultimately, Basic Design was grounded in the Bauhaus and its Vorkurs course, begun by Johannes Itten (1888–1967) in the 1920s, a preliminary or foundation course that turned the art student's attention to the manipulation and understanding of materials. In mid-20th-century Britain, Basic Design was taken up and taught by art teachers in different ways. The origins of Basic Design training in Britain were rooted in the influential thinking of the artist and educator William Johnstone (1897–1981). While earlier beginnings for Basic Design might be identified in the 1930s in Britain, it was from 1947 whilst Principal at the Central School of Arts and Crafts (1947–60) in London, that Johnstone led the way in radical pedagogical reforms. William Turnbull (1922–2012), Alan Davie (1920–2013), Richard Hamilton (1922–2011) and Victor Pasmore (1908–98) were among those whom Johnstone recruited to teach at the Central School. Classes provided training in understanding the qualities of line, pattern and form and their interaction when freed of representational content. Tasks ranged from exercises in drawing in a relatively free manner to others calling for order and precision, with exercises acting simply as a starting point from which students could develop their work and ideas.

Further, exchanges between innovative art teachers, including de Sausmarez, at conferences and short courses, were central to the development of Basic Design teaching. In Winter and Summer Schools across England and Wales, these teachers worked closely together to share their ideas towards the development of a course that aimed to provide a basic training in keeping with the demands of modern visual art.

Three themes common to Basic Design teaching might be identified: Rational Process, Science and Technology, and Intuition. These themes touch on key sentiments embodied in particular teaching programmes at particular schools. Basic Design teaching associated with the notion of an intuitive approach to making underpinned courses run by William Johnstone at the Central School and Harry Thubron (1915–85) at Leeds College of Art, for instance. De Sausmarez's approach to Basic Design teaching at Leeds was focused on developing an inquisitive attitude within the artist. The idea of a Rational Process was taken up by Hamilton and Pasmore in the Basic Course they devised together at King's College, Newcastle, then part of the University of Durham. A final theme common to a number of Basic Design courses relates to Science and Technology. Tom Hudson (1922–97) took up those ideas at Leicester College of Art when he encouraged students to explore new material such as resins and plastics. Meanwhile at Newcastle, Hamilton also looked to the microscopic scientific world for his teaching exercises and his own work.

What is clear is that Basic Design represented a fragmented field in Britain. There was no unified approach and its key protagonists adopted differing strategies to the teaching of a basic grammar of art. De Sausmarez's contribution acts to bridge the gaps between those various positions, synthesizing them afresh. He complained that '[d]ebased attenuations of traditional academic teaching placed too little value on looking in order to see and experience, and too much on looking merely to verify the 'facts' of intellectual preconceptions – anatomical, perspectival, botanical; technical method became more important than the power of invention; cultivated solutions of problems more important than personal experiment and free enquiry.'[60] De Sausmarez's sentiments here are no different to Basic Design's other major protagonists. Indeed, he aligns himself with those other key figures, such as Thubron, when he précises their common thesis on art education: 'Our idea of fundamental training needs to develop personal enquiry on the basis of practice, not theory, always the individual solution to each problem. It needs to place emphasis on intuitive and analytic work with materials and formative principles.'[61]

As we have seen, although there was a degree of overlap in the pedagogical imperatives underpinning the

different courses across Britain, different teachers did tend to place emphasis on one imperative or the other. For de Sausmarez, however, these differing imperatives held almost equal sway and he called for an art education that would allow the student to develop emotionally and intellectually as well as intuitively. This is what marks de Sausmarez's position out as unique. This somewhat measured approach to Basic Design might be seen as a counterpoint to the more radical tone of his criticism. As an art writer and critic de Sausmarez invited controversy and freely expressed his views and this applied to his writing on art education as much as anything else. Yet while Basic Design itself was a radical departure for British art education, de Sausmarez seems to have charted a middle ground within that field. Rather than rejecting any of the myriad strategies adopted by Basic Design teachers, he acted as a unifying force. Despite a sustained and impassioned belief in a creative education for the artist, de Sausmarez retained the ability to step back and view Basic Design with a hyperopic eye.

Central to this desire for a balanced approach to art education is perhaps his recognition of the individual student at the heart of it all. How we engage with something such as a simple mark upon a page is unique for each of us: 'there is a different "pulse-rate" in each, an inner dynamic which acts upon the surrounding space. This "pulse-rate" differs with each individual and arises as a consequence of factors too diffuse and deeply embedded psychologically to be susceptible to analysis.'[62] Each student is different and a degree of balance, or range of approaches, gives every student the greatest chance of engaging productively in one way or another. In this way de Sausmarez, perhaps, acted as a fulcrum, a complex pivot that held myriad approaches in equilibrium. His hope was that, 'out of it all might ultimately come a new art academy pre-eminently fitted to educate and express the consciousness of the age.'[63]

Beth Williamson

4.1 *Dissipated Octopuses: On the Teaching of Art to Adolescents* (1959)

Published in *The Listener*, Vol. LXL, No.1567 (April 9 1959), pp.629–63.

The Times Educational Supplement recently published a number of photographs showing boys and girls at Little Lake School in California making their own solar cooker. Children of about ten were constructing a large dish-shaped cooker from scrap timber. Some were cutting cardboard and aluminium with shears, others were glueing the shapes to the timber structure, others were carefully covering the surface with metal foil; some again were fixing the metal rods, welded to make the spit. The excitement was obvious; everybody was intent on the job. The finished object looked beautiful, and it obviously worked – the sausages were cooked.

The caption did not say whether this was a lesson in elementary science or a lesson in the art room, but for me these photographs reinforced and clarified ideas I have had for some time about the failure of art education in the later stages of school life.

For some years I have been a visiting art examiner in training colleges for teachers. Year by year this has meant looking at the student-teachers' own paintings and sculpture and considering their approach to art in schools – in the infant, junior, or secondary schools in which they will one day work. It has seemed to me that the principles and general shape of art teaching in infant schools and junior schools in England are exemplary. Each year the exhibitions of children's work between five and ten years show beyond question how right the direction has been – the direction that in this country was largely set by the superb work of Marion Richardson.[64]

But these exhibitions also show, and most people know by now, what heavy weather is made in the years beyond eleven. Something goes wrong. In place of the supremely confident out-pouring of the early years we get a tangled self-consciousness. Psychologists will say 'that's what one should expect'. I would reply that whereas the educational psychologists have done some really hard thinking and have found the best way of encouraging the young child, no one has as yet given anything like the same basic attention to adolescent art. So it is very much left to the teachers.

Some of the more intellectual ones may be busy studying the products of adolescent art, sorting out the pigeon-holes – 'introvert', 'extravert', 'haptic', and the rest – into which the work falls or can be pushed, but few question the educational ideas on which most of it is done. I am sure that in the hands of a trained psycho-analyst this pigeon-holing could be of importance, but practiced by art teachers untrained in psycho-analytical method it is likely to do harm.

Fig 73 Page from *The Listener*, April 9th 1959

But anyway most teachers in their day-to-day practice work empirically and try to extend the range of their fourteen-year-olds in various ways, introducing 'folksy' craftwork or misguided little essays in conventional applied arts like wallpaper design. And though it is hard to believe this, there are even numbers of schools where the bastard activity of hand-painted repeat-pattern-making is still practiced; one unit produced again and again in a geometric grid by laboriously copying or tracing it – an idea that can only have real meaning in terms of a mechanical process – such as block printing or screen printing. Why do they do it? What is it for? No one in those schools has thought of asking the question.

Other art teachers go in for some sort of would-be commercial design – posters, imitative book-jackets – not infrequently with ghastly lettering. To my mind, all this is inappropriate to children and evades the real problem. And in painting there is the almost invariable tendency to encourage spectacular and violently dramatic subjects: one finds an unending series of pictures called 'Fire', 'The Explosion', 'The Raiders', 'Smash and Grab', 'Bonfire Night', 'Ecstasy', 'Depression'. The fallacy is to assume that this sort of exciting subject will necessarily produce an equally exciting picture.

Another false trail is the so-called 'abstract'. Have you ever seen a number of these things by fourteen- or fifteen-year-olds? It would surprise you how alike they are. They are said to be abstract but in most cases they are a curious misunderstanding of the idea of abstraction. They are usually based on a known object – 'Buttons and Bows', 'Seaweed', 'Treble Clefs and Notes of Music', and so on. No attempt is made to understand the form or nature of the object: what the children tend to do is a jazzy arrangement of geometric shapes or amorphous waves of colour with these realistic or at any rate identifiable objects floating about in them, the whole thing looking like a dissipated octopus.

It is clear that they do not really come to terms with the true principles of abstract structures at all. I believe that the children do them in a way dictated by their own bone structure – the wrist and the elbow for instance act as fulcrums of a particular kind; it is easy to wheel your hand and arm round from left to right and to produce circular and zigzag motions. And it is precisely these easy, mindless, undirected rhythms, shapes, loops, zigzags and coils that appear again and again in these pictures. The same swirls and tentacles are now beginning to throttle even pottery and modelling. This is something entirely impersonal; faced with numbers of these one simply would not know which kind of child had done them. They are stereotypes – records of purely physical activity. You may say that surely this is what Jackson Pollock did, but in actual fact it is not, because he was already critically conscious, already an adult artistic intelligence.

Art teachers, when challenged on all these points I have been making, largely blame the present pattern of examinations for the General Certificate of Education, and I must say that reading through some of the recent examination papers I can well see how many of these questionable activities have been encouraged.

But behind it all, both the teaching itself and the examinations pattern, you can dimly perceive the line of thinking. The free and spontaneous work of the early years almost invariably diminishes and

sometimes stops altogether, and ways of countering this must be found. These excursions into applied art, or imitative posters, or attempts to whip up another phase of so-called 'self-expression' are all means to this end. I say 'whip up' because I do believe this is not true self-expression. The pupil soon realizes that the words 'free' or 'lively' or 'exciting' – all words beloved of art teachers – are synonymous with the recording of purely physical rhythm, the excited swinging about of the arm, impulsive gesture and spontaneous stroke. Whatever the subject, he realizes that he is expected to make a certain kind of picture.

I came across a blatant example recently – two illustrations in a book by a distinguished American professor of art education. Both are drawings done by the same youth – one a profile done with a sharp pointed pencil, as lucid and strange as an Indian line drawing or a Pisanello; the other, on the opposite page, a physically vigorous chalk drawing in the manner of a German expressionist, and the caption under this one reads 'Free representation made by the same student, Frank Stewart, after applying correct stimulation'. 'Free' and 'correct' – is this not an instance of making children slaves of an adult conception of 'freedom', diverting them from clarifying in their own terms their observations of reality and their desire to create order?

I am not arguing a case against 'action' painting: how could one in the face of the astonishingly rare achievements of a Jackson Pollock? Nor am I trying to open the door for dreary reactionaries who would like to teach perspective again. What I am questioning is the notion that expressive freedom is necessarily associated with certain specifically physical characteristics – making large and thick brushstrokes all over the paper or swinging the arm about in vigorous movement – or that it must necessarily mean releasing the latent melodramatic fantasies which we know exist in thirteen- or fourteen-year-olds.

One thing characteristic of children between eleven and sixteen is their widening horizon, their passion for the real objects and situations encountered in the grown-up world. Today, of course, children are relating themselves not only to the world of nature but also to science. Even the way in which they tend to look at nature is changed by, say, the new conceptions of space in the universe, or new insights into the structure of the atom. In fact many children now have a reciprocal and related interest in man-made constructions (how things work, how they are put together) and the constructions of nature. It is precisely this dissecting analytical interest and this interest in building, in constructing, that I want to take up, because I believe it offers something positive to art teaching that at present is almost ignored.

I do not at all believe that a child's aesthetic expression disappears at eleven-plus – I think it takes different forms. Just as in botany or biology children dissect and make diagrammatic records of the functional systems they find, so they should be encouraged to dissect and analyse forms in the art-room and make their own analytical drawings of the structural principles and systems they discover. These in turn should become the suggestive ideas for building equivalent systems and structures out of all sorts of materials – clay, cardboard, glass, plastic, sheet-metal, wire, and the techniques that go with them, cutting and welding and so on.

Some art teachers will tell me that they already do this kind of thing in making *collages*. This is just not so: it is true these *collages* are pictures built up from random materials, but because they are based on no real structural idea or discipline they simply turn out to be the same old dissipated octopus, only this time done in bits of old velvet, paper doilies and sequins. The important thing in what I have described is the connexion between all the phases in the evolution of the idea: the initial observation of the object, the process of analysing or dissecting it, the preparation of drawn analyses, then the turning of the structural system discovered into a new independent structure, equivalent to that of the object itself. There might even be a limitation in the materials to be used. You could set a group of children the task of making a new structure from only straight rods and flat planes, or from a series of elliptical shapes. I do not think it helps either a child or an artist to have unlimited freedom. After all, the architect and the engineer are not absolutely free – and it is the child with a potential talent in those directions who would benefit most from all this.

Because of the technological slant that we are now giving to education, secondary schools must give a great deal of attention to such children, and yet they do so painfully little to develop their sort of talent aesthetically. In all probability a boy who plans

to become an engineer will already have his mass-produced model aeroplane kit under the desk. But the excitement and the 'education' in actually designing the object, working out the materials to be used, seeing what was in the mind's eye become materially real – all this has been denied him. What is more, the workshop practice he may get at school does nothing to train his aesthetic sense. It is a sad fact that when schools have a vacancy for a metalwork or woodwork teacher they invariably advertise for a technical expert only, without inquiring about the candidate's qualities as an artist, a designer.

But this is a side issue. I am not really arguing for this kind of art teaching because it might do good to engineers or to the export trade. I want to see it introduced for all kinds of teenage children. The importance to me of the Little Lake School's solar cooker lies in the fact that it was an experience that was complete, even to the final stage when the children had to find the right position and tilt for the sun's light and heat to converge and do their cooking. If it is maintained that art is exclusively self-expression, then what these children have experienced is not art; but is it really true that it has no relation to artistic creative experience?

There is a constant give and take between the maker and the thing he makes, so that one cannot conceive of the artist as impressing his completely pre-determined mental image upon the object. He acts rather as a super-sensitive instrument for detecting and responding to the needs and demands of the evolving form. He is caught up in a creative rhythm in which one move, one colour, one structural element calls into being the next. I feel sure that this must also be so in the case of music, and there are certainly many instances of writers suggesting that this sort of situation occurs.

I believe we should begin to introduce the adolescent to this idea that he does not dominate the object he makes but that he should respond to *its* evolving nature, to the inner principle of its growth. In doing this we shall have helped him to break through the egocentricity that reaches its most intense form at this stage of development. We shall have helped him to see and respect the nature of things.

Thus what I have in mind is not something exclusively geared to the talented pupil, or to the child with a technical gift. It could and should be equally valuable to every pupil in the class. This sort of artistic

experience, because it is based on constructive factors and techniques, would help to get over that stage in adolescence when children become dissatisfied and bored with their own painting and drawing because their critical faculties have developed faster than their powers of execution.

But what I have been describing is no easy option. This sort of teaching would make great demands on the teacher. He himself would need to be creatively alive, inventive, resourceful, and intelligent. It would be both unfair and misleading not to mention the fact that something along these lines is now being done in one or two of the better secondary schools, but we really have not begun to tackle the problem. What I am pleading for is a development of individual sensibility and not the imposition of a system; at no point does it involve a mechanical application of theory. A pupil will have to face afresh each new configuration he makes as a form with a life and structure of its own. Sometimes it will be an abstract thing of pure geometry; sometimes a practical thing like that life-size solar cooker – which I confess I do consider to be a work of art.

4.2 *Innovation and Continuity in Art Education* (1969)

Script for the talk delivered to the Department of Education and Science Conference for Art Advisers, Dartington, June 1969 (Maurice de Sausmarez Archive).

I would like to say at the outset that although this discourse will perhaps appear to be one of criticism, I fully realise that excellent work is going on here and there throughout the country. I think it is important to say this, because otherwise it would appear that one is considering too much the generality of the situation and not paying tribute to some of the good work that is being done. If one criticizes teachers at all, one suddenly finds them getting up on their hind legs and saying, 'But in our school, or down the road or round the corner, of course, exactly what you praise is going on', but these isolated instances surely do not cancel out critical observation.

I think when one reflects on the extreme diversity of current attitudes in art education – the fact that contemporary art itself shows unparalleled diversity of aim, and in addition that contemporary society is subject to pressures which call in question many established values – one begins to realise the

immensity of the problems facing our profession and, difficult as it may be to keep alert to the nature of this sort of interpenetrative situation, it is an absolute necessity. Nothing is more dangerous than the attitude of the teacher who conceives of school as an island of ideals opposed to society's values – a sort of dialogue between teachers and taught, which leaves out of account the realities of the outside world and concentrates on highly personalised development in isolation. But I have reservations equally about the proposition that the teacher's job is, to quote a recent statement, 'that of turning children into educated citizens of the 21st century, and that it is essential that educationalists should have some conception of a future which is radically different from the present'. Having recently assimilated the notion that 'the medium is the message', we are now asked to swallow the proposition that 'Man is the product for the environment'. In the thirties this would have been branded as Fascism; now it's a viable statement of progressive educational policy in certain quarters. It only needs a central agency to define for teachers what the 21st century is to be and what it needs and, to continue the quotation, 'because Britain will be far more dependent in the future on sophisticated skills and knowledge, the educational system (will not fail) to provide people of the right quality'. Perhaps there is a good deal of sense in it, but I am alarmed. An effective part of the educational system, thank God, seems to be geared to no such programme – our primary and junior schools are laying the foundations of individuality and inquisitiveness as never before – there is some marvellous work going on in that area of education. But, almost because of this, I foresee a long period of tension within institutions of further education unless more attention is paid to the links through from general education to contemporary society as a functioning organism dependent upon cohesive responsibility. As in art, so also in education, the innovatory enthusiasm for concentration on the unique creative personality development, encouraged by the new science of psychology, has overwhelmed earlier emphasis on factors like social behaviour, good neighbourliness, social virtues (the very words now seem only fit for a satirical review, and yet they do mean something). It seems as though the agencies of continuity may be in danger of breaking down or of being disregarded, and those agencies are not external authorities, police

and the law and all that, those agencies need to be the educated consciousness of individuals to their responsibilities, accepted through conviction what is more – responsibilities not only to their own set or their own generation, but to society as a whole and to civilisation itself. Now, I believe that at the base of a good deal of the morass of student protest and rebellion there is an idealism and concern for social values. I think it has been very apparent – the only sadness is that it has, in so many cases, been wide open to exploitation because education, while having fostered it in the first place, has not effectively armed it with adequate dialectical weapons.

Similarly, at the base of the escalating drug situation among adolescents, one sees pathetic evidence of the new educational principles of experimentation and self-determination indirectly involved, and utterly defenceless because of a similar lack. These weapons of logical analysis, the means of investigating the truth of opinions, these really should be forged and sharpened in education, and one feels too often that they are not there; somehow this very essential factor in education has been by-passed.

Now if we believe that Man is the product for the environment or of the environment, then studies like environmental studies, social psychology, social anthropology, civics and in the arts, new materials, new processes, extension of media and the like, will dominate our field of thinking and activity. But the danger is that, though we may gain an impressive knowledge of the context of our activities and the media of our creative endeavour, and the effects upon individuals in society maybe, we are not really helped much in understanding why we do what we do, or why we should do this rather than that. If, on the other hand, we believe that despite the astonishing transformations of environment and social structures over the years, Man himself has not changed so fundamentally and is still subject to the same inner conflicts, doubts, impulses, then we are likely to feel that historical instances, the beliefs and counter-beliefs in earlier social contests, the accounts of the development of individuals and institutions that have contributed to the degree of civilisation we have, are of prime importance, and in the arts, the principles and practices that have helped to create great works and great monuments. But here again we have not done our job if this remains in the limbo of academic history – its relevance is to the perennial

problems of human responsibility for decision-making – the personal and social responsibilities implicit in choosing to do this rather than that. Now, I'm not saying that the teacher's role is in deducing and enunciating moral and ethical precepts – God forbid, emphatically not – but I am saying that the young person should be encouraged in education to assess the profound importance of issues involved in the making of things just as much as in actual self-knowledge that comes through text books or whatever, of a decision taken and its probable or possible consequences.

One of the greatest evils, I think, is the continuation of the split in education at about 14 or 15, a split that still demands emphasis if not specialisation in either the field of the arts or of sciences at an absurdly early age. It's idle to deny that this does happen, it's encouraged to happen really by our examination system, which derives its structure from universities; it's also idle to plead that the pathetically feeble provision for some experience in the one field to be still available in the other is adequate. The fact of the matter is that only a continued serious inquisitive commitment across the educational field will provide both the cutting edge of rationality and logical methodology to the arts man, and the selective sensibility and qualitative experience to the scientist and technologist. From far too early an age we separate the pursuit of the arts, with their contemporary tendencies to highly subjective development, from the sciences with their contemporary tendencies to tough, impersonal objectivity. There ought really to be a coming together of these things, a sort of spread across a whole field, to possibly the age of 17 or 18, where the young person can be really involved in a total sense of the field of human endeavour and the interlocking and the interweaving of these factors in human-intellectual achievement. At the age of 18 we give further opportunity for this disastrous split. At the age of 18 we have the specialisation in education for those hundreds of young people who are too often themselves still in desperate need of a further period of time in which to become educated beings capable of coping with problems of decision, sifting this from that. The false shibboleth of 'O' levels and 'A' levels is powerless to convince me that this is not so. Now, I'm emphatically not challenging the status of education as a field of necessary specialised studies,

it just seems to me to come at a stage of virtual immaturity in so many cases. The split I've spoken of was not so disastrous say one hundred years ago, because the arts retained a core of discipline not unlike the analytical and dissective processes of science (however misplaced some may now consider that to have been) and the sciences at that time were largely those directly involved in not only quantitative but qualitative experience.

We have made the disastrous mistake of thinking that the only meaning the young person accepts as being valuable is the emotional one – desperately starved, I think, of one half of the whole experience that will truly make continuing sense. I am sometimes distressed when I visit art departments in colleges of education to see the flabby rag-bag please-yourself atmosphere that often exists, the senseless and purposeless innovations, and at the same time, in their efforts to increase their academic status, too many of them have taken over the worst aspects of the universities of twenty years ago. It may even prove to have been a great mistake to attach the colleges of education to the universities – education is a practical art as well as a theoretical one, and university faculties of art traditionally have been incapable, utterly incapable, in any of the practical arts. There is the added complication of the universities and their examining boards being largely, if not wholly, responsible for the early specialisation I have just referred to. It is from the colleges of education that the bulk of the teaching profession is recruited, and in my view they are the sector of higher education in greatest need of drastic and immediate overhaul.

But to return to the problem created by specialisation at too early an age, the Master of Pembroke, Sir George Pickering has written: 'The function of an ideal educational system is to preserve and enhance the potential of the human child; to increase its range of awareness; to preserve and enhance its curiosity; to increase the precision of its thought; and, above all, to give it freedom to develop', over-specialisation promotes the converse, because 'it does less than nothing to solve the dilemma of ends and means; by denying to the young either the arts or the sciences, it renders almost impossible the synthesis of the past and present achievements of the human mind'.

Cézanne and Poussin are as real to me as the man next door. I don't thank any art historian for his

taxidermic activities, stuffing the past with dates, but only for his efforts to make more real for me the context and ethos in which the decision-taking of these artists was enacted. In the same way I believe that history at school needs to be presented in this way, with abundant opportunity for speculative thinking and critical argument. What might have happened had Napoleon succeeded in Europe is only a little less important for us than what did happen. How important really was it that he didn't triumph? The historian, Michael Oakeshott, writes: 'If the historical past be knowable, it must belong to the present world of experience; if it be unknowable, history is worse than futile, it is impossible. The past varies with the present, rests upon the present, is the present'. And accepting this, one can say that to reject an interest in the past is to impose the most serious limitations on our conceptions of the present. It is only by the realisation that Napoleons are with us still, that the abolition of slavery still leaves us with the insidious dangers of mental slavery, that Blake's creative anarchy and Mondrian's monastic universality are still vivid illuminations of possible directions into the future, that history can offer anything to our development; it is only when we realise this that it becomes close to us. To have shared something of the constructive visions of the past, and equally to have reviewed its sinister and corrupt forces, helps us in determining ourselves. The American painter Larry Rivers, speaking about studying with Hans Hoffman, the distinguished New York painter and teacher, said 'he made art glamorous by including in the same sentence with the names Michelangelo, Rubens, Courbet and Matisse, the name Rivers and his own, of course. It wasn't that you were a Michelangelo or a Matisse, but that you faced somewhat similar problems. What he really did by talking this way was to inspire you to work. He had his finger on the most important thing in an artist's life, which is the conviction that art has an existence and a glamorous one at that. He puts you on the path with the desire to go somewhere. What you find along the way is your own problem'. Now it seems to me that my generation has been guilty of either under-estimating or concealing the amount of support that we derived from the past and from traditional disciplines of thought and practice. But we alone are not guilty – it is shared by all of those who have made the most sacred of obligations that of being 'original'.

The injunction to be original involves the principle of rejection, rejection of all that might constitute an influence, beneficial or otherwise. Fifty years ago the most extreme statement of this doctrine was made by Giorgio de Chirico, who wrote: 'There is the artist of the future; someone who renounces something everyday, whose personality daily becomes purer and more innocent. For even without following in someone else's footsteps, as long as one is subject to the direct influence of something someone else also knows, something one might read in a book or come upon in a museum, one is not a creative artist, as I understand the term'. We can find this expressed today – listen to a critic writing about a sculptor's work: 'It looks like nothing, refers to nothing, arouses no emotion, expresses no temperament or stress … By shedding so many of the qualities which cling around sculpture, X too has found a genuine and contemporary style'. The creative arts today have become for many the exemplar of attitudes to experience, and when this extreme doctrine is translated into those activities most closely affecting social cohesion, the result can only be progressive disintegration. Yet, who would wish to deny the importance of originality? The fault lies in a fallacious concept of originality.

Since we are all of us compounded of genes so complex in their influential origins, there is no possibility of the emergence of a man unaffected by genealogical influence. To build upon a theory that totally rejects influences from the past is to build upon a theory that is untrue to the very nature of Man's being, and places a wrong evaluation on the relationship of past, present and future. Robert Simpson, an English composer now in his forties, with two symphonies and many other major works to his credit, said a few years ago in a broadcast on the subject of composing: 'They say it's lucky to find a four-leafed clover, but I have rarely heard of anybody finding one by actually looking for it. Your chances of coming across one are slightly improved if you happen to be an observant person, and you can become observant by training your faculties … It is curiously revealing to notice that … we nowadays are all geniuses … groping after four-leafed clovers … some of us with our eyes shut and with thick gloves on. I don't care a damn whether a composer is a serialist, an atonalist or whatever he cares to call himself … I am interested in the

validity of what a composer is actually saying and the skill and judgment with which he controls what arises spontaneously from his mind's ear. If the basic attitude of its creator is undazzled and farsighted, it (the work) will fulfill what seems to me a fundamental purpose of great art, to create confidence in the fact of living, growing, developing … confidence in our human potentialities is what really keeps us going, and it is always regenerated by great music. These values have nothing to do with being up-to-date'.

One of the shabbiest pieces of deception of which too many contemporary writers on modern art are guilty is the suppression or ignoring of the growing pains suffered by their heroes in reaching their maturity of expression. The meticulous realism of Guston's early efforts, the academic life drawings of Alan Davie, the early struggles with a severely disciplined training of almost every one of the major figures. We are encouraged to believe that at best it was totally irrelevant, at worst it was precious time lost in work of no consequence. Nothing, I believe, is further from the truth – their judgment and artistic intelligence were, in part, formed by these struggles – struggles with things very often unoriginal. To continue the extract from Larry Rivers, already quoted: 'My problem back then in 1947 was that when I started drawing in the presence of a nude female model, all that found its way on to my pages were three peculiar rectangles. At the end of the year I became frantic to draw the figure, and in a way that is no more advanced than Corot. If I didn't do this, I'd never be able to convince myself of my genius. To want to draw like Corot or, for that matter, any master, was more related to identification than to the creation of an original work'. I think this business of identification is terribly important, and I think it is something that perhaps doesn't get sufficient attention; one has to discover the situation that creates confidence in one's own essential talents, one's own essential creative ability. I have visited art colleges where after merely one patchwork year of foundation studies, students are under pressure to isolate some experimental area that will project them swiftly into one or other of the contemporary 'grooves', a band of creative endeavour and experience so narrow as to parody the term 'liberal education in the arts'. In such situations I doubt whether there has ever been so aggressive a policy of exclusiveness in what is taught and what is

permitted to be done. The justification, so I am told, is that science has set for this century the terms of all our work – scientific examination and the processes of analysis work towards ever-diminishing areas of intensive concentration. We have witnessed the pursuit of 'knowing about knowing', of wrestling with 'the meaning of meaning', three years in the pursuit of 'the redness of red' would seem not unjustifiable. Concentration, it is said, is also intensification. I think we have to admit that art recently has been invaded by concerns that more properly belong to the field of semantics. When the philosopher Schelling wrote 'to represent an infinite content, therefore, a content that really resists form, which seems to destroy any form … that is the highest task of art', he was operating as pure intellect, divorced from sensuous experience, he was inviting art's self-destruction. This sort of philosophical extrapolation which in terms of cerebration minimalises to the point of intellectual essence is of very limited value to the young creative artist; he may well find that his development has ended before it has begun. I fear this may be happening all too frequently today. But how much experience and, to go back to what I said before, how much dialectical equipment has the young art student for fighting his way through the jungle of falsehoods, irrelevances, half-truths? Somewhere Nietzsche says: 'only he who knows where he is sailing knows which is fair wind and which is foul'. But, where can the young person look for help? A little while ago I sat through one hour and fifty minutes of a rambling mishmash of scientific fact, philosophical half-truths, science-fiction prognostication, diversions into unprepared territory of protons, neutrons and quanta, sweeping realignments of society and education, delivered to an audience of young people. Well, it was greeted with tremendous applause, but the majority, I am sure, would have been unable to recall, let alone dissect, what they had heard. It was a sort of Svengali act and replaced the responsibility for thought by the acceptance of generalised slogans.

Now what am I saying? Not that a healthy situation is one that is undisturbed by radical innovation, that we would all be better off with a situation of cosy conformity, – of course not. I'm trying to make the point that the value of innovation is measured by the degree of critical acumen acquired from the study of forms and principles in continuity, from techniques of rational thinking and intellectual dissection developed

from long ago and, in addition, in the case of the artist, from the trained arbiter of the senses. I just do not think that we are paying enough attention to these stabilising elements of continuity. It is no good pointing to the development of, say, complementary studies programmes recently built into art education as the answer – the majority of these are themselves innovatory in character. It is nonsense to think that what I'm talking about is something that can be spread like butter on the top. We have to look more deeply for it, and I'm not at all sure how one makes provision for it to develop, other than through what I described earlier as a total involvement across a wide range of experience at school, to a much later stage than seems to be the case at the moment. Certainly one is unlikely to find this preparation going on in the colleges of education. To attend some conferences and teachers' discussions one would think that activity alone, extended activity, new activity, mixed activity, teenage-pop activity, inter-disciplinary activity, technological activity, any and every sort of activity holds the key to the transformation. Well, I just don't believe it. I think there's something more fundamental concerned in promoting an integrated individual who can bring a capacity for lucid, clear, objective detachment, an ability to stand back and say 'this, not this', with developed senses and responses and the emotional life of an integrated individual. I think we need to give our attention to the manner in which this sort of integration may be fostered and strengthened. In many cases it's not a question of extended activity so much as a question of stepping back and thinking harder and, in many cases, just thinking. It would be unnatural if our answers to this problem of the relationship of innovation to the total situation and to continuity were not extremely varied, but for myself I consider that as a start it might help to encourage firstly a reconsideration of the term *originality*, what we imply by this, and to what extent really we can or should demand it or expect it in the creative situation.

Secondly, a refusal to support specialised channeling which severs the sciences and technology from the arts. This I think is absolutely essential, and I think that in time to come it will be even more necessary for us to see that this split is avoided.

Thirdly, a realisation on the part of teachers that they are called on to struggle constantly with ideas, and to dissect and evaluate these ideas, not simply to swallow them. A good science teacher is alert to new things going on in his field, but he also has to put this to the test of his intelligence, he has to assimilate this and cope with it. The art teacher too has this obligation to think, to evaluate, to assess values in terms of creative development of an individual and to have the courage to make his own position clear. This might actually present the young with something firm to kick against, rather than the perpetual rubber man now facing them who takes on any shape they care to punch him into. No one says anything today, no one stands up and says 'take it or leave it, this is what I believe'. Evasiveness helps no one, least of all the young who are desperately in need of those who will accept the responsibility of stating their beliefs or their standpoints. It is the wobbling rubber men who are terrifying.

Then fourthly, remembering that art is poised somewhere between reason and absurdity, it seems to me that you can't really prepare for the absurd; the best preparation for the creative use of the absurd is the demonstration of the nature and limits of rationality. Opportunity, I think, must be there for exploring the absurd, but I think that it has its real intense meaning, its creative meaning, when it is valued against processes of rationality.

And fifthly, the obligation of the student occasionally to defend what he is doing, to defend his work not by recourse to cloudy circumlocution but rigorously – in the manner of a mediaeval disputation or a scientific thesis – not necessarily with words, but with drawings, diagrams, notes, and so forth, so that he has a sense of being put on his metal, having a sense of confidence in his ability to stand his ground, put his point of view. I see nothing wrong in demanding occasionally this sort of response from the student.

Finally, any innovation needs to be assessed in terms of its potential contribution to the development of the individual human being, a being with an historical past and we hope an historical future.

4.3 Adolescent Art Education

4.3 (i) *The Condition of Arts and Crafts among Adolescents* (1944)

Published in *Club News*, October 1944, pp. 2–3, 7.

The problem is the widespread lack or frustration of the creative impulse in the majority of adolescents today and the necessity of dealing with it […] It is

valueless to confine our attention to the problem within Youth Clubs or to attempt a renaissance there. We know that by the time people reach the Youth Clubs they are creatively barren, and in most cases lacking in initiative and too often distressingly apathetic […]

General education to-day is certainly better than it has been if we judge by material scholastic standards, but if we judge it by a typical product we find that it has been achieved by a neglect of living values as opposed to scholastic values, by a submerging of personal initiative, by killing spontaneous enthusiasm, by the ruthless imposition of a stock type. This applies particularly to Elementary and Central Schools from which Youth Clubs are mainly recruited … The fundamental object of education should surely be the creation, development and sustaining of enthusiasms in children – enthusiasms for knowledge, for creative expression, for true living values so that a thoroughly integrated personality may emerge […]

At the School of Art where I am an instructor the standard of work of the students when they arrive from Elementary and Central Schools is unbelievably low and their general outlook, culturally, is nil. In an experiment which I think warrants wider recognition, these children are taken through a course which seeks to incorporate as many sides of creative expression as possible – Fine Arts, Music, Dancing and Mime. In every case the teachers are starting from utter vulgarity and in many cases, strange as it may seem, creative apathy, but through encouragement, experience and enthusiastic direction the students quite naturally develop a relatively high sense of value. This has been particularly striking in music. The values and enthusiasms established by the time they are ready to leave cannot fail to influence their whole lives.

4.3 (ii) Art Education in Adolescence (1957)

Based on a paper 'The Next Phase' read at the Easter Conference of the Society for Education in Art held at Bretton Hall, 1956. Published in *Researches and Studies*, No. 15, January 1957, pp.33–38.

In considering adolescent art and its development we are committed to considering the development from the sure and unshakeable roots that were struck in this country in the great work of Marion Richardson. It can be said that the most important aspect of the revolution she initiated is the shift of emphasis from the work done to the child doing it. The primary interest is not in evaluating aesthetically or clinically what the child does, but in appreciating what the act of making has done to the child as a developing individual. The interest is not in techniques, not in dexterity, but in the individual's growth through personal experience and discovery. It is because the field of that experience has been limited (because of a limited conception of the nature of art) and because the child's potentialities have also been limited (because of a pre-determined conception of the child-artist) that there has been so far a failure to make satisfactory provision for development at adolescence and to bridge the gap between adolescence and adulthood. The art teacher has been encouraged to think of art as essentially a relieving cathartic activity, a private and personal purgation, ministering almost exclusively to the emotional life of the individual. But, as Walter Gropius wrote in *The New Architecture and the Bauhaus*: 'The quality of man's creative work depends upon the proper balance of his faculties. It is not enough to train one or other of these, since all alike need to be developed'. Art education must make provision for educating the emotions, the capacity for feeling; for the promptings of intuition, the inspirational; for the desire to know and understand, the intelligence.

This might all be platitudinous were it not for the fact that there is in art theory to-day a conspiracy against the intelligence; it is often thinly disguised but it is there. It is the result of a quite unreal and arbitrary splitting of consciousness into thought and feeling, intuition and intellect, as though they were mutually exclusive layers of experience instead of being utterly and inseparably interwoven. Neither the artist nor anyone else can estimate how the forces of emotion and thought, intuition and intellect are disposed in the creation of any work of art; there is a continual circulation between conscious and unconscious processes. But this fashionable denigration of the conscious intelligence has serious consequences when it is accepted in art education and it is precisely at adolescence that the full effect is unmistakably shown.

With the approach of adolescence there is a development of the logical and critical faculties which make it often difficult for the child to accept factors in his work which do not conform to rational standards […] Ways need to be found in which the intellectual

aspirations can be satisfied, while yet assisting and supporting the qualities of feeling, leading to a new confidence […]

Paul Klee […] realised that development in art calls for an acceptance of the two-fold nature of the thing made. Firstly, the idea it embodies or the purpose it serves; secondly, its own life and structure as an independent form. It is through the deepening and enriching of our understanding of these two aspects that development is made possible.

In the first place, if we believe that the child throughout the whole of his development is exploring his environment in increasingly complex ways, always trying not only to understand it but also himself in relation to it, we must also remember that this environment itself is expanding in every dimension […] To-day the general public is already attuned to seeing Nature in the same terms as man-made constructions. There is in fact a whole sphere of the visible world and the world of ideas that the adolescent seeks to adjust himself to in a creative way that can only be approached by extending the range of materials used and by welcoming the constructive intelligence […]

Reference was made earlier to the created object as an independent form with a life and structure of its own. A constant factor in children's work is the feeling for pattern, for qualities of colour and form that might reasonably be termed abstract. Stripped of associational or descriptive properties, forms and colours and shapes are experienced in a new and heightened way and a greater conscious appreciation of this abstract element in the created work should be possible at adolescence. Developed three-dimensionally in adolescence in the form of 'constructions', it opens the door to architectural thought and feeling and a new range of experience related immediately to the contemporary world, quite apart from its value as the basis for a deeper and richer experience in art generally. This level of 'abstract construction' has deeper significance for the individual and for society to-day than merely aesthetic significance. It is the point at which the individual can make contact with the extra-personal field of universal psycho-physical forces: – balance, motion, rest, stability, etc. […]

If we are to survive in this world of the twentieth century, of atomic development in power and speed and potential destruction, we can no longer afford to base our education on the anarchy of nineteenth century romanticism. Contemporary art educational theory is rightly insistent on freedoms, but true freedom can only come from a development which includes disciplining of the intellect and the emotions; a discipline which comes from the purposeful ordering of materials (and materials which may not have had any prior connection with 'Art'). […] Unless we succeed in teaching children to see that Art and Science are parallel and interdependent and to accept the scientific element in Art, then the very art that we cherish will appear as anachronistic to the next generation as Morris dancing does to this one […]

Adolescence should be the real age of experiment but the whole concept of experiment in the field of art education is in danger of being debased by the aimless mindless activities that too often masquerade in its place […] The infant in the perambulator gives the true example of experiment when it clutches a new shape, looks at it, bites it, tries to put it in its mouth, bangs it on the side, drops it, in some strange unknowing way appearing to test its properties and potentialities. It is what should be going on in art at adolescence; not a concern for skills but a concern for the inventive powers and aesthetic judgement – the meeting ground of science and art […]

The paucity of good work produced at adolescence which has been revealed in national exhibitions of children's art is related to the fact that the adolescent is not receiving the right encouragement to reach his true and full stature as a creature of feeling and thought, vitally attuned to the spiritual and intellectual climate of his Age.

4.4 Art in Higher Education
4.4 (i) *Playing it Safe?* (1960)
Published in *Motif*, a journal of the visual arts edited by Ruari McLean, Shenval Press, No.4 (March 1960), pp.2–3.

'It is because the general level of education, whatever its source, is undeniably so low that we do not insist on pre-entry qualifications …'

'… those who have spent most years in previous training before coming to the College do noticeably less well in the final examinations than those who have only spent three years or less.' These salutary remarks are taken from the Royal College of Art Annual Report 1958. (The Lion and Unicorn Press, June 1959)

Let's face it. The artistic and intellectual development of students entering art schools in this country is abysmally low, and, apart from acquiring a limited 'know-how' in a specialized field of practice, four years in the art school adds little to their mental horizons. Even the 'know-how' has too often the aroma of mothballs and the glossies.

[…] With very few exceptions the work is 'hermetic'; a special sort of art without connection either with the great traditions of the past, the origins of modern art, or the present time. It is an art that has its own tradition, and has in point of fact remained virtually static over the past twenty years. It is true that the basic factors in any education are not likely to alter so very much from one period to the next but the particular tragedy of this spectacle is that there is so little evidence of anything basic or fundamental, and so much evidence of clichés of 'examination style'; even the academic work is ineffectual through not being academic enough. Everywhere there is half-baked compromise, the quality most valued; in some sections of the examination it is becoming a commonplace for students of exceptional talent and promise to fail […]

The tradition of examination work has established an unbroken chain of artistic and spiritual incest that has too long characterized English art education. Even if one agrees that Art cannot be taught, one must accept the possibility of being able to create the conditions in which it might perhaps grow if the seed is there. But the institutionalized atmosphere of art education is destructive to anything but bindweed.

It may be argued that the appointment of the National Advisory Council for Art Education signals the end of the present examination system and structure of courses, and that the golden age is within sight, but let us not be blinded beforehand.

Teachers who are awake and alive to what has been going on in art during the past fifty years find themselves discouraged by the overwhelmingly administrative interests of the administrators. 'You'll be back on Monday' was the one remark made by a Principal to a young teacher having a first one-man exhibition in a Bond Street gallery recently. The young teacher – painter or sculptor – is suffocated by the ceaseless examination phobia. He knows that with a few significant exceptions the examiners appointed by the Ministry of Education are representative of the most conservative outlook, and in some cases are so obviously hostile to signs of modern developments appearing even in the finalists' work that 'play safe' becomes the order of the day, a mentality which is the death of creative talent […]

The training of industrial designers is the most recent chimera to encourage hallucinations. Only in very few fields are the precise requirements of industry known (far closer relationship with specific industries would be necessary for this) and courses labelled 'industrial design' are, in the majority of cases, shots in the gloom […]

Actual industrial experience for a student would be much better left to effective liaison with industry. And what about technical colleges? There is the example in the North of England of a college of art training textile designers without any reciprocal interest in, or the slightest connection with, a technical college stuffed with textile machinery and scientific know-how on the opposite side of the road. There may well develop a farcical situation in which art colleges are staffing laboratories and workshops with engineers to give the industrial design training some 'reality' while technical colleges are staffing design studios with artist-designers to give the light-engineering design training 'a bit of aesthetic'.

It has long been known that the better commercial agencies and design studios prefer their recruits to have escaped an art-school design training. One of the reasons is that commercial design as taught in many schools has succeeded in acquiring the sanctity of high art. Outlook, the concept 'good design' and artistic idiom remain unchanged in designing a beer bottle label and a box of scented soap. Only here and there has the study of ergonomics begun to affect the teaching of design.

Art-teacher training too creates its problems. Of recent years the departments dealing with this field of art education have come under the umbrella of University Institutes of Education (along with Housewifery, Holy Writ, P.E., Eng. Lit … the lot). Not only have attempts been made to dragoon them into accepting part of a uniform pattern of education for educators (without doubt a very proper discipline for a teacher) but a missionary self-consciousness has been developed in them which threatens to disrupt their close relation with the colleges of art that gave them birth. There is often a barely-concealed, sometimes open, hostility to the character and content of a student's earlier training (Man Art–Child

Art dichotomy) and a desire to put the clock back to naïvety – looking at some of the sophistications one can but say that this is often a most laudable aim.

But it means that the student is continually poised between the Scylla of 'specialization' and the Charybdis of 'child art' until he takes the plunge and can be comfortably out of his depth in a comprehensive school, not uncommonly a modern glass palace compared to the makeshift character of his pedagogical training centre […]

In the recent White Paper on art education (Circular 340) the Minister has expressed the hope that colleges of art and the major schools of art may raise their standing to a level comparable with university colleges. Only those who have worked in local authority know what a vain hope this is […] to make this hope a reality it will need more than the raising of students' IQs and the standards of teaching, it will need a revolution in both Ministry and local authority handling of this branch of 'technical' education, and a revolution in the structure of each institution. The Royal College of Art is alone in having achieved the conditions for university college status. A study of Principal Darwin's last annual report to the Chairman and members of Council of the College, already mentioned, provides clear evidence of what the intoxicating air of freedom can accomplish and what some of our major Colleges of Art might aspire to given even a tenth of the intoxication and principals and teaching staff that had escaped the temperance pledge.

4.4 (ii) *Gestation of a diploma* (1961)

Published in *Motif*, No.7 (Summer 1961), pp.2–3.

DIP.A.D. (the Diploma in Art and Design) has at last been conceived. Any time after 1963 it may be brought to birth and the Minister has already named the midwives, the members of the award administering executive body who are destined also for the role of adoptive parents. The National Advisory Council on Art Education, set up in January 1959, published its recommendations at the end of last year and few people will dispute the claim that its proposals are wise, moderate and flexible enough to allow of considerable variety in practical terms. It is in effect an admirable general framework and if the new executive body which is to administer the proposals has a similar breadth of outlook and approach the substance of specialist art education

can be healthy and vigorous. The executive body is asked to consider –
(a) curricula and syllabuses
(b) standards of work of schools
(c) standards of admission to courses
(d) the form of honours within the diploma award
(e) the quality and experience of teachers
(f) accommodation and equipment
(g) libraries, communal facilities and amenities for students
(h) conditions for the conduct of examinations including approval of external examiners.

And the Council has recommended autonomous power for this executive body – 'We consider that such a body should be independent not only of the Council but also of the Minister and that it should have final responsibility for all matters within its purview. There should be no appeal from its decisions to any other body'. Tough stuff and one wonders whether the Ministry with its inspectorate will be prepared to accept fully the implications of the recommendation. The brake handle for them would appear to be the Minister's 'duty to consider the approval of courses from a general administrative and financial viewpoint' and already in paragraph 39 the Council anticipates situations where 'a course which the executive body considers suitable may not satisfy the Minister's requirements and vice versa'. How the executive body and the Minister's inspectorate are going to bed down together is anybody's guess.

The boys to watch

The executive body is made up of two directors of education, six distinguished principals of art colleges, two art historians, two from the field of fashion, three art directors, four independent practising artists and one industrialist. It is clear that for the bulk of its mammoth assignment it will need to use the powers granted to it of drawing 'fairly extensively on the advice of Boards of Studies and/or Subject Panels, and will need to call to some extent on resources outside its own membership for this purpose'. In fact the Council envisaged 'the main function of the executive body as being the supervision and co-ordination of the work of these Boards or Panels' and it follows that the nature of the composition of these Boards will largely determine the forward-looking, backward-looking or myopic character of

the policy; they will be the boys to watch. Critics of bureaucracy may well take some convincing that this way lies greater freedom and initiative. But with an appointing body which numbers amongst its members Mr Robin Darwin, Mr James Fitton, Mr Lawrence Gowing, Professor Pevsner, Mr E. E. Pullee, Mr Claude Rogers and Sir Gordon Russell the prospects should be reasonably bright.

The Council in its Report has suggested a basis upon which schools may be granted permission to conduct diploma courses; it has recommended that each art school shall propose its own diploma course structure. Normally the minimum age of entry to the course should be 18 and a reasonably high general educational performance is demanded as a prerequisite; a level of achievement in art comparable with the standard now reached after the first two years in art schools is also demanded. The diploma course is to be conceived as a liberal education in art in four broadly distinguished fields of specialization, Fine Art, Graphic Design, Three Dimensional Design, Textiles and Fashion. The courses should not try to 'give a complete training in any highly specialized techniques of industry or commerce'.

The Council recommends that there should be a core of general fine art training common to all students which 'ensures that all the diploma students in a school are brought together and have an easy opportunity for educating each other by the exchange of ideas and experience' – a sound idea which like many others may well remain unfulfilled in the working out through the already rigid separation of departments. Serious study of the history of art, both in terms of the major arts in a general context and of the history of the student's special subject, is demanded together with what are termed 'complementary studies' helpful to the study of art which should give scope for practice in written and spoken English. About 15 per cent of the student's working time is for these studies, namely about 5–6 hours per week, i.e. barely sufficient for any formal guidance, and there will inevitably be need for 'out of school' prepared work in these subjects.

It is clear that the Council has in mind courses which are not directed towards the acquisition of narrow vocational techniques but a liberal education and that highly specialized commercial, industrial or 'professional' techniques might be the subject of post-diploma study [...]

Feudal system

To achieve 'undergraduate level' in terms of liberal education one has to create the conditions of study and student life which foster intellectual maturity and independence of spirit and action. It is here that art education will need the most radical revision to make this possible. The Ministry itself, local education authorities and art school administration have all in their various ways produced an institutionalized atmosphere and restrictive regulations which keep the art school in the position of a somewhat up-graded secondary technical school [...]

There are still too many schools where a feudal system prevails, where none of the teaching staff has opportunity to discuss or contribute to the policy-forming of the school, where often there is in fact no knowledge of the policy because no channels exist for the passage of information from the administration to the teaching body.

Limited contracts for part-time staff might have been suggested in place of the present system of annual appointments, thereby encouraging initiative and a sense of having a real place in the community of the school. Part-time staff cannot say 'boo to the goose' for fear of losing their jobs.

A Ministry of Fine Arts?

The Council's vesting of ultimate and absolute responsibility for decisions in the new executive body, 'independent not only of the Council but also of the Minister', calls in question the position of HM Inspectorate. It is not an exaggeration to say that at the present time many schools of art seem to adopt the attitude towards HM Inspectorate of 'there but for the grace of God goes God', a situation which the majority of HMI's surely detest and one which must make all the harder their work as educational consultants (or is it advisors?). But what in fact will be the function, status and power of the HMI in the new dispensation if the executive body is to 'have final responsibility for all matters within its purview' ... 'the determination of any matters and disputes submitted by (the Boards of Studies or Subject Panels) and the final decisions on approval of courses'? For either the inspectorate or the executive body to assume the position of arbiters in the controversies that make the present situation in the arts and in art education so dynamic and healthily productive could bring us dangerously near to having in this country a Ministry of Fine Arts; God forbid! [...]

4.4 (iii) *Diploma Daze* (1963)

Published in *The Guardian*, 27 June 1963.

The outcry which has followed the publication of the Summerson Committee's decision about approval of centres for conducting courses for the new Diploma in Art and Design has been on the score of injustice to students. Hundreds who have been led to expect opportunities for diploma preparation following their pre-diploma training now find they have ludicrous chances, in some cases one in twelve, of continuing. The outcry has provoked an interest in many who have only a hazy idea of the background of the present controversy. Some of these may even have been led to think that employment in the field of art is consequent upon having a diploma: this is partially true of the art-teaching profession, but of absolutely nothing else. Unless society enters a final stage of pretentious madness, it will always be what you can do that gets you a job and not the piece of paper you can wave.

What is likely to become dependent on being in a diploma course is financial assistance from public authorities, in fact for many students the very possibility of getting a training in the field in which they are most anxious ultimately to practice. This is the most serious aspect of the present decisions […]

In 1957 a report by the National Advisory Committee on Art Examinations was published which recommended the introduction of a new diploma of higher standard to take the place of the National Diploma in Design, which is a diploma at present achieved by about 1,200 students each year. In January 1959, the National Advisory Council on Art Education was appointed under the chairmanship of Sir William Coldstream to advise the Minister on all aspects of art education in establishments of further education. Its first report, published in 1960, dealt with courses for a new diploma to be called the Dip. AD to be of 'graduate equivalent' status. As a consequence of its recommendations, the National Council for Diplomas in Art and Design under the chairmanship of Sir John Summerson was empowered to judge which courses should be approved and which colleges applying for recognition merited approval as centres for the conduct of courses and examinations leading to this new diploma.

Last year 85 colleges of art instituted pre-diploma courses while their applications were under review by this committee and students were enrolled for these courses (an average of about 25–30 students in each course). No attempt appears to have been made to dissuade colleges from encouraging pre-diploma student entry, and so over two thousand students for the new diploma were to be expected in 1963, all having completed the necessary pre-diploma year. The publication of the Summerson Committee's decision to approve only 29 centres, the majority with only one or two approved areas of study, i.e. fine art, graphic design, etc., was a devastating blow. The situation created by this can be exemplified by one centre in the London area where 400 applicants were competing for 30 available places on a diploma course […]

On the face of it there appears to have been a disregard of statistics which happen in this case to be young human beings embarking on a life's work. There is still no evidence to show what measures are being taken to prevent a similar situation next year. Are colleges which have failed to get approval still to be allowed to offer pre-diploma courses on the assumption that they may soon be given approval for full diploma courses? […]

The image of the new diploma as primarily a teaching qualification will be hard to dispel. First, its general character, emphasized by the reference in the first Coldstream Report to the need for a post-diploma year to give it a specialist edge. Secondly, the disproportionate weighting of fine art as against applied art courses that have been approved. Thirdly, the fact that some concentrated areas of industrial production have been left without any approved centre, the most conspicuous example being the Potteries.

Could it be that the large college of art at Stoke, with its subsidiaries at Longton, Burslem, and Hanley, may perhaps have been judged more suited to more immediately directed, i.e. vocational, training for the industry?

It must be repeated that there is no qualification other than one's own work in the case of the designer and the professional artist. His ability to 'talk' about psychology or Simone de Beauvoir is not going to get a designer his job or a young painter an exhibition at the Marlborough (at least, one sincerely hopes not).

And it is precisely on this point that there is disquietude about the idea that the closer art education aspires to the liberal – i.e. literary-discursive-character of university education the higher its standards are likely to be as education within its appointed field, i.e. the practice of art and

design. Not only is the pattern of the diploma courses more general in coverage, whereas the pattern of real talent in the creative arts is that of specific commitment, but the concept of education by 'exposure to great names', the idea that half an hour with Graham Sutherland will inevitably result in higher standards than half a year with a teacher however inspired, has come to stay.

All these are assumptions that have little support from tradition. Unfortunately they are not likely to be challenged because there will be no situation in which the backing of public funds will be given to the contrary pattern, based on the concept of education spreading outwards from a concentrated point of commitment. But the sooner the distinction is clearly made between the arts traditionally rooted in craft skills and the arts rooted in discursive intellectual skills the sooner we may arrive at an unpretentious honesty of purpose in this sphere of education. That some revision of art education was needed will not be denied. Much of what is proposed for the Dip. AD could be applauded for a certain type of student if the claim was merely that it is expected to lead to a higher standard in terms of a general education in art. But the assumption is everywhere being made that, *because* of its university-type slant, it will necessarily mean a superior training and a higher standard in the practice of art and design.

An unfavourable light is there passed on vocational courses which, if interpreted generously and given proper financial backing by local education authorities, could well reach a higher standard in specialist practice.

But it is not without relevance that Picasso would today have spent four years in pre-diploma work, because he would need to be 18 before being eligible for entry to a diploma course. Braque, the son of a house painter, and a very indifferent scholar at the Lycée, would almost certainly not have qualified educationally (five 'O' levels for entry to a pre-diploma course), nor would his talent at 17 have been immediately distinguishable.

4.4 (iv) *Notes to Quentin Bell* (c. 1959)

These unpublished notes concerning the future of fine art at Leeds University were among the papers sent by de Sausmarez to Quentin Bell, who was to succeed him as Head of the Fine Art Department in 1959 (Maurice de Sausmarez Archive).

The choice now before the University, as I see it, permits four alternatives:–

(a) Continuation of the present position (working in a general context with no recognition of an Honours course)

(b) Development into a department solely of Art History

(c) Development as a department combining some practice of art with art history within the academic structure (an Honours course)

(d) Development of a relationship with Leeds College of Art to work out joint responsibility for a course combining academic subjects with practice.

Each of these has a precedent in the provincial Universities – (a) at Nottingham, (b) at Manchester, (c) at Reading, (d) at Edinburgh.

Alternative (a). It was my contention in the early days of the department that the association of a practicing artist and an art historian in presenting courses within a general scheme of studies or as a subsidiary subject to an Honours School would be a positive contribution. On the whole I think it has worked well. But having in mind the particular problem of the direction of the department, I have never considered that my responsibility lay only in the academic field; I am quite sure, without being boastful, that only a liberal-minded practising artist could have given the department the breadth of influence throughout the University it has had, and have been able to assist in artistic matters over a very wide field. Many of these have not demanded the equipment of a scholar but a developed artistic judgement and experience in matters affecting the practice of art. There is too the position of the Gregory Fellows and here again I know that to have someone in charge who speaks their language is a *very* necessary thing. I have no doubt that the association of artist and art historian in the department is the best solution but I am equally sure that it is safer in the given context to place the direction in the hands of the artist. (see note under alternative (c))

Alternative (b). It should be realised that Art History by itself is so specialised a subject and its usefulness so limited that only a small number of centres in this country should be concerned with it and only those with abundant facilities for study and research […] While it may be argued that the University does not exist to provide vocational training, it is equally true to say that it is morally wrong to establish departments in the provinces and encourage students to proceed

with studies which present almost no opportunities of subsequent employment […] Also for reasons implicit in my discussion of alternative (a) above I think the University will regret such a course.

Alternative (c). Had I been remaining at the University this is the course I intended to press and I attach a memorandum I had already prepared which sets out fully my reasons and the substance of the proposal. I should perhaps add that the direction needs to be in the hands of someone who has the experience and equipment of both the practising artist and the art-critic/writer. Such people do exist, they are comparatively rare but worth looking for.

Alternative (d). It might be possible to work out some form of collaboration with the College of Art whereby the University assumes responsibility for academic studies, history of art and artistic theory and the College of Art is responsible for practical work. It presents obvious difficulties and I think they are very considerable but it could be a valuable development.

4.4 (v) The Fine Arts as Foundational Training (1959)

Unpublished paper read at a North of England Conference of Art Schools, convened by the Yorkshire Council for Further Education, November 1959 (Maurice de Sausmarez Archive).

[…] To turn now to supporting studies; I am convinced that seminars involving preparatory study and written work on aspects of thought, of experimental science, of technology and of creative arts in the 20th century are a vital necessity. And as a preparation for this an introductory series of lecture-seminars giving instruction in the use of books and a library and also in the use of a camera (and be encouraged to experiment in photography […], photomontage and other creative ways of using this instrument […]). I think also that a college of art should encourage and make allowances for the young student to continue any additional subject in which he has shown special aptitude at school – particularly studies in literature, foreign languages, history and so on. There is at present a tragic shrinking of the students intellectual horizon. Art institutions today operate on an almost factory basis – there is no time in which the student is not being supervised, prodded into activity, kept manipulatively busy until the hooter blows. A quite erroneous idea that art is all a matter of activity. Art is a product of both the emotions and intellect

working mysteriously together – but the intellect is fundamentally reflective by nature. Activity must be adequately balanced by reflectivity, and reflective intelligence in the domain of art is critical reason – as necessary to the potential painter and sculptor as it is to the potential industrial designer, as in fact it is necessary to any truly educated human adult.

The main content of what I have outlined falls within the province of the fine arts, defined by me in introducing this paper as the only aspects of art education which are not circumscribed by utilitarian ends or committed to limitation of means imposed by any one particular discipline or range of materials. It has been no part of my intention to deal with the fine arts in the sense of their traditional special fields of painting, sculpture or graphic processes – this would be a subject in itself. I have limited myself to fundamental training and I am convinced that, as foundational training, the fine arts have an immensely important part to play in the structure of any new scheme of art education.

4.5 Basic Design & The Visual Grammar of Form

4.5 (i) *A Visual Grammar of Form* (1961)

Published in *Motif* 8 (Winter 1961), pp.3–5.

[…] It would be invidious and useless to catalogue the instances of thinly disguised, often open, opposition from the Ministry of Education's Inspectorate, from the national societies of art education, from principals of colleges of art in the early stages, or to mention the stupid bickerings and 'who did it first' wranglings that accompanied the movement later. It will be more instructive to try to deal with some of the major objections and some of the major dangers it faces now […]

It does not profess to be a means of producing art but a means of investigating the primary elements and factors of constructive creative experience, of understanding the nature and behaviour of these factors and of physical materials through testing them in a disciplined variety of ways. Neither does it profess to provide theoretical answers to hypothetical questions, it rather aims at helping the student in the posing of a problem and encouraging the maximum inventiveness in its solution […] Nor does it concern itself with content, in the sense of personal imagery

(c) work by a student of Robert Brazil, of London University's Goldsmiths' College

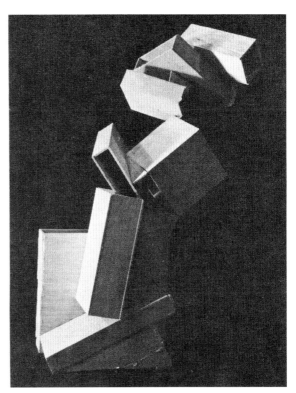

(a) work by a student of Oliffe Richmond, Chelsea School of Art

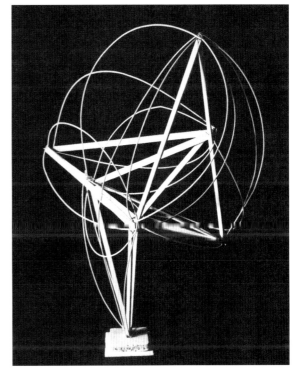

Fig 74 Illustrations from the first edition of *Basic Design*, 1964

(b) work by a student of Oliffe Richmond, Chelsea School of Art

or images of nature being imposed upon materials, but it strives to encourage an identity of form and content so that the student learns to appreciate the expressive potentialities of a medium, a colour, or a line in itself. And, above all, it is basic in that it is as valid for the industrial designer as for the painter or for the graphic designer – it should be the ideal meeting ground for all talents, and, coming at the beginning of training, should encourage later the mutual understanding and respect which is often so sadly lacking.

It is frequently objected that the planned and systematic investigation of basic forms and factors of construction without allowing for free expression through personal image-making will deaden the student's imagination and creative talent and produce a stereotype. This argument might have some serious weight if there was a tacit rejection of any other work done from the student's own volition, but this is not so. The student is free to do what he wants to do outside the Basic Design curriculum – if in fact he does nothing then one must conclude either that he is bone-idle or uninterested, or that he has no imagination at all, in which case there is no good reason for him to be at an art school in the first place […].

The criticism which is sometimes encountered that the students most of the time neither know clearly what it is they are doing nor why they are doing it is invariably based on a limited knowledge of pseudo courses, where the teaching is lamentably inadequate. In such cases the so-called Basic Design course is largely a pathetic waste of time, but this in no way invalidates intelligently and intelligibly planned courses […]

A great deal of the art of this century has concerned itself afresh with the roots and primary elements of the creative experience and since this is also what basic design training seeks to do there is often a marked similarity in what emerges in both instances […] this type of teaching is the most effective path to the understanding of contemporary abstract art; and therein lies its greatest danger, it can be shamefully exploited. Already, because it relates directly, it is being seized upon by many schools of art, slicked up with inappropriate presentation techniques and added to the stock of eminently exhibitable products. The incessant shop-window dressing has been extended, the Principal can refer

with pride to 'our (sic) basic', and the H.M.I. can comment favourably on the effective and efficient look of it all. Edward Poynter, Walter Gropius, any sensitive seriously thoughtful creature is defeated by this lamentable process.

But there is yet another danger […] that within each course ossification may set in. The material must constantly be revised, renewed, extended, so that it remains vital and, for this, it is best served by a team of teachers rather than an individual. These basic workshop courses must find ways of establishing bridges and inter-relationships with the disciplines of the life studio, and representational painting. […]

Out of it all might ultimately come a new art academy pre-eminently fitted to educate and express the consciousness of the age.

4.5 (ii) *Principles and Methods of Basic Design Courses* (1963)

Notes of a lecture given at a short course on Art Teaching at the Royal College of Art, 25 June 1963 (Maurice de Sausmarez Archive).

[…] Basic courses have to be highly programmed in comparison with other art courses for two reasons (i) the students have normally very little previous experience: this is their initiation into professional work in art. (ii) there is a great deal of sheer information to be purveyed, and confusion would result unless this were done in some logical sequence. The instructor must therefore prepare each lesson carefully in advance, preferably rehearsing it himself, but adjusting his method to the response he gets […]

A session of the class typically consists of a short talk by the instructor on the theme under consideration: an exercise carried out by the students: and finally a collective criticism and discussion. Notebooks are essential: students should formulate and record the material of lectures as well as points which emerge in practice and criticism – otherwise much of value gets forgotten […]

Most important of all is the principle that any exercise set should be capable of meaningful

Fig 75 Various covers of *Basic Design*, which has been in print since it was first published in 1964. It has gone through 20 reprints and been translated into 7 different languages

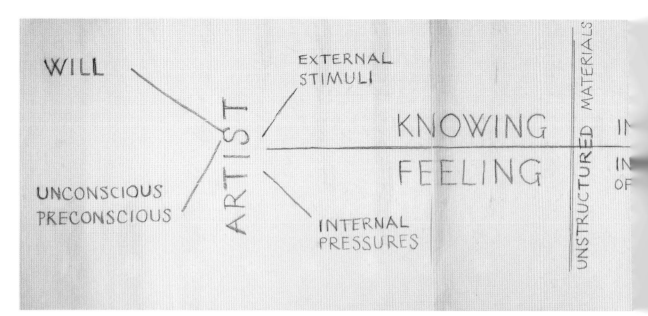

WILL

EXTERNAL
STIMULI

ARTIST

KNOWING

FEELING

UNCONSCIOUS
PRECONSCIOUS

INTERNAL
PRESSURES

UNSTRUCTURED MATERIALS

Fig 76 A diagram to explain the process of artistic creation as discussed in one of the three lectures on Surface and Structure given by MdeS at the Royal College of Art in 1961. Measuring over ten feet long, the paper was gradually unrolled during the course of the lecture

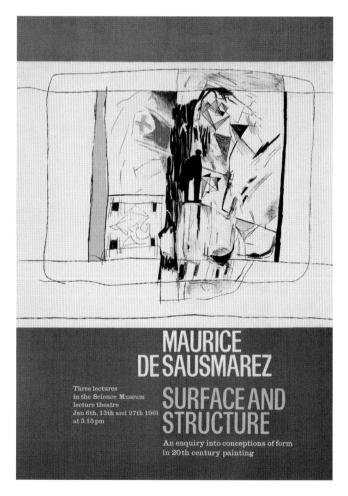

Fig 77 Poster for the series of lectures on Surface and Structure given by MdeS at the Royal College of Art in 1961 (75.5 × 57.2 cm)

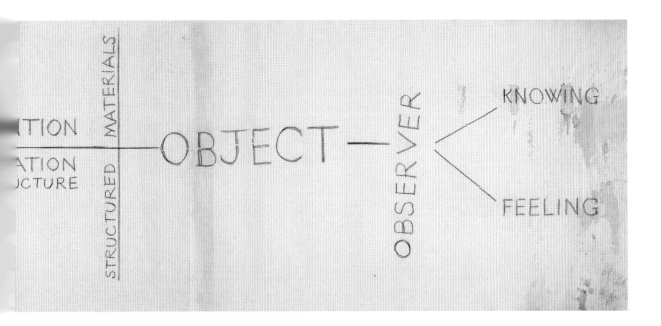

criticism: that critical conclusions of a clear-headed nature are drawn, made explicit, and remembered. The mere making of pretty patterns or textures to a recipe is worse than useless. The instructor should be able to say 'This fails/succeeds in relation to the objective set *because* etc., etc.' (giving precise analytical reasons). Basic design deals in the *constants* of visual art, i.e. things which are universally true, such as the characteristic dynamics of a rectangle compared to those of a square or a line, or the effect of red on grey, etc. Personal aesthetic preference is only secondary, and emerges in the variety of solutions which are found to be possible for a given problem.

4.5 (iii) *Basic Design: The Dynamics of Visual Form* (1964)

The *Preface*, (p.7) followed by extracts from the *Introduction* (pp.9–10), to the book first published by Studio Vista in 1964.

The contents of this book, like the content of any course of basic instruction, are offered as a clarification of certain fundamental areas of enquiry and a spur to the young artist to continue for himself a constant inquisitiveness about the phenomena of pictorial and plastic expression. It does not pretend to be more than an introduction to a field that is capable of almost limitless extension, personal variation and individual emphasis. How a student

approaches this field of enquiry is less important than the fact of him reaching it. Emphatically this is not a primer in a special sort of art. By now we should have realized that it is too easy to dragoon young students in a certain direction by offering them only a censored part of what should be a comprehensive and undogmatic training – it is as easy and as valueless to create hot-houses for producing pseudo constructivists as it was for producing pseudo impressionists. It may, in fact, be necessary for many a young painter to be in active rebellion against what he finds here, or in any training he receives; it will be for him to prove the validity of his rebellion by his work. Johannes Itten's reply to his students cannot be bettered – 'If you, unknowing, are able to create masterpieces in colour, then unknowledge is your way. But if you are unable to create masterpieces in colour out of your unknowledge, then you ought to look for knowledge'.

[...]

Five factors in particular seem to dominate the changes that have occurred in ideas about creative activity, which must inevitably affect ideas of training. First, a rejection of conventions and an acceptance of the idea that only information which is derived from our own experience can be considered valid for us and for our expressive resources. Second, that information which we gain from an appreciation of the physical nature of our materials and their formal

and spatial functioning is as important, if not more important, than information restricted to the visible facts of nature. Third, that a visual art is dependent upon the expressive and constructive use of the specific phenomena of *vision* and that literary or other associations are essentially ancillary. Fourth, that the total personality is involved in making aesthetic decisions and that personal preferences form the inescapable bases of truly individual expression. Fifth, that art is not based on a number of static concepts but changes and extends its boundaries in response to the shifts of emphasis in the intellectual and emotional situation of each period in history.

For us, the consequences can be summarized as follows. Our idea of fundamental training needs to develop personal enquiry on the basis of practice, not theory, seeking always the individual solution to each problem. It needs to place emphasis on intuitive and analytical work with materials and formative principles. There must be a primary concern for visual response to what is taking place and decisions will be dependent on this, inevitably influenced by subjective preference arising out of the differences in psychological makeup. Study will reflect the changed character of our [present] interpretation of some of the fundamental concepts of art and design, of structure and space […]

Accepting then the role of enquiry about the simplest and most fundamental factors of creative visual experience, we need to start from marks made by tools and materials at our disposal, and from the fact of vision itself […] An appreciation of the character and nature of these marks is fundamental to any attempt to build truly within the medium. But already it will be noted that there is a different 'pulse-rate' in each, an inner dynamic which acts upon the surrounding space. This 'pulse-rate' differs with each individual and arises as a consequence of factors too diffuse and deeply embedded psychologically to be susceptible of analyisis. With the merest spot we make contact with the dynamics of visual form and field of subjective response.

Every visual experience is at one and the same time a receiving of fragmentary information, a giving of form to these visual sensations and the arousing of felt response […] we must be careful to remember that, for the artist, what ultimately matters is this quality of feeling which results.

4.6 *The Byam Shaw School of Art* (1963–4)

Unpublished paper on 'The Byam Shaw's place in Art Education', 1963–64 (Maurice de Sausmarez Archive).

[…] The recent radical changes in the structure of art education in England consequent upon the Reports of the Coldstream Council and the work of the Summerson Committee has given the School a special position and a special job to do […]

Courses at the School have been revised and in addition to a Pre-Diploma Course which serves to prepare students for application to Dip. AD courses [at other art schools], it has instituted its own Diploma Courses leading to the Byam Shaw Diploma in Fine Art – Dip. B/S. A. (Lond.) [ratified by the Inner London Education Authority] – which is of comparable standard though not recognized for graduate status in teaching […]

I need hardly say that this [the prescriptive terms of the new Dip. AD] is in almost every respect the reverse of the attitude adopted by the Byam Shaw.

First, our only requirement at entry is that the work submitted and the promise shown should be of a calibre worthy of a place at the school. C.M. Cox in his book 'Genetic Studies of Genius' has produced convincing evidence for stating that Turner, Poussin, Chopin, Baudelaire, Faraday and other geniuses would have failed even the 11-plus if such an examination had then existed.

Second, the Byam Shaw continues to be a school of drawing and painting. Opportunities for some printmaking have been recently introduced but fundamentally it is and will remain a school of painting. Mr. Liam Hudson of Cambridge University in his researches into the psychology of genius found that many first-rate minds do not distinguish themselves as students while their studies remain generalised in character. An acknowledged and important characteristic of creative talent is its single-mindedness. No one will quarrel with the idea that the young artist needs to see his studies related to the wider issues of the society and culture of which he is part, but he needs to be allowed adequate time to develop this through a sense of specific commitment. The slenderest talent gains by learning how to concentrate its effort and in the attempt discovers factors that increase the general scope of understanding. The strongest talent wilts or goes into open rebellion by being kept too long from its appointed field of concentrated study. Third, the

Fig 78 MdeS (top right with Keith Kennard) at the Byam Shaw School of Art

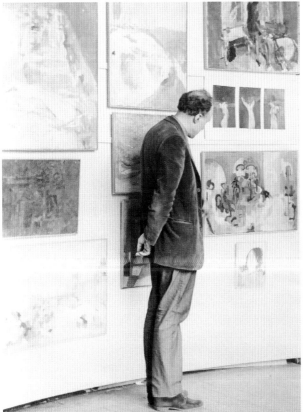

Byam Shaw is a group of studios, it continues the traditions of the workshops not the talking-shops, the academies of the past. By introducing a sizeable content of cerebration and verbalisation at an early stage in a student's training, particularly when this cerebration is conducted under the guidance of non-practitioners, there is the danger of encouraging the notion that painting is made with ideas rather than with paint. It becomes more important to be able to expatiate than to do. Cerebration should come more towards the end than at the beginning [...]

Unfortunately any school which remains outside this scheme broadly defined by the Coldstream/Summerson hierarchy may have to face the following difficulties. A gradual curtailment of financial help for students from public funds. An increasing tendency for public schools and grammar schools to submit their best pupils to the officially 'approved' art schools. A growing difficulty in meeting the financial demands of continuing to offer a training comparable in scope to that provided by the public education authorities.

141

Happily for the Byam Shaw at the present time there are many more good students seeking training than there are places at the government-aided schools. There are also some exceptionally good and sensitive students who find the educational 'multiple-store' totally unsatisfactory for the development of their talents [but] inevitably the introduction of this 'University-level-Diploma' in Art and Design has produced a situation where the Byam Shaw finds some of its ablest young students transferring to the 'approved' schools at the end of their first or second years of study. But a solid core will continue at the school into a third and fourth year and on these students the reputation of the school will largely rest [...]

To those who argue that the Byam Shaw should seek to adapt itself to the requirements of the Summerson Committee I would say, firstly it is financially an impossibility, and secondly, even if it were possible financially it would signify the end of the Byam Shaw's independence, and that is its first claim to continuance. It has a very important role to play by remaining outside and proving the rightness of its policy, but to prove it adequately the school will need all the financial backing it can muster and the support and encouragement of all who believe in its value.

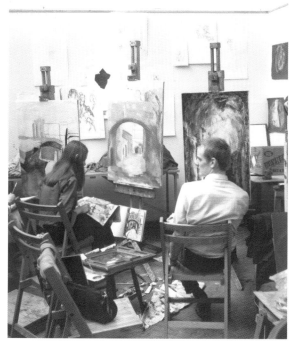

Fig 79 Deirdre Hindmarsh and James Dyson in the painting studio of the Byam Shaw School of Drawing and Painting, 1966

5 HOMAGE TO MAURICE DE SAUSMAREZ

Maurice de Sausmarez died in 1969 at the early age of 54. As *The Times* observed, his death 'has deprived the art and art educational world of an extraordinary and versatile figure'.[65]

A Thanksgiving for his life was held at St Paul's Church in Covent Garden on 15 December. It included a composition by Kenneth Leighton offered and undertaken in Memory of Maurice de Sausmarez. Leighton had been the first Gregory Fellow in Music at the University of Leeds and the close friendship made between him and de Sausmarez at the time continued until de Sausmarez's death.

Of the many tributes paid to de Sausmarez, perhaps the most eloquent was the exhibition arranged by his students at the Byam Shaw. *Homage to Maurice de Sausmarez*, a selling exhibition to raise funds for the benefit of his very young children, was held at the Upper Grosvenor Galleries in 1971. Alongside fourteen of his own paintings, there were 32 donated pieces by other artists, including Lynn Chadwick, Prunella Clough, Elizabeth Frink, Terry Frost, Patrick Heron, David Hockney, John Hoyland, Alan Jones, Henry Moore, Ben Nicholson, Bridget Riley, William Scott, Adrian Stokes, Joe Tilson, David Tindle, Euan Uglow and Carel Weight. It was, as Marina Vaizey commented, 'a small survey of contemporary British art'.[66]

The exhibition catalogue contained moving testimony to de Sausmarez from three professionals who had worked closely with him in the different aspects of his career, as well as a warm expression of gratitude from his students.[67] They are reproduced in full below.

H.D.

Maurice de Sausmarez as a Painter

To gauge the stature of Maurice de Sausmarez's achievement as a painter, it would be well to consider the task he set himself. He aimed to recreate for himself a classical form of painting for today, as Poussin had done three centuries earlier, but his task was much more complex than Poussin's. New factors

had to be contended with. There was the towering figure of Cézanne, Turner and the Impressionists, the Cubists, optics and science. One cannot help feeling how easy in comparison were the tasks of artists like Chagall, Dufy or Grandma Moses, who simply relied on their instincts.

But I must emphasise here that, with all his intellectual resources, Maurice was never a pedant. When he went out to paint a landscape he was as excited as a child. For him each picture was a new adventure. He always retained his innocent eye. In spite of an obvious affinity to abstract art, I do not feel that he would ever have ceased to derive his pictorial inspiration from the visual world.

There was a memorial group of his pictures at the Royal Academy in 1970. There were small, unassuming works. I can remember each one very clearly now, although I have forgotten almost everything else in that exhibition. I do remember, however, walking home and feeling how tragic his death seemed at the height of his powers. If only he could have had a few more years.

Carel Weight, Professor of Fine Art, Royal College of Art

Maurice de Sausmarez as a Writer

For Maurice, writing was an extension of teaching which provided the extra challenge of an absent audience. To it he brought the same qualities of intensive curiosity, perceptiveness and intellectual honesty; from it he obtained the cathartic satisfaction of semi-finalising his thoughts and feelings in the printed word. His method was always the same. Having accepted a brief, he spent as much time as possible on research – through tape-recorded interviews, experiments, discussions – meanwhile revolving in his mind the overall construction of the book or article. Not until the last moment did he set everything aside and start to write – concentratedly, fast, often without a preliminary draft. The actual writing of his *Basic Design*, a book which has had a revolutionary affect

on art education in many parts of the world, occupied a bare ten days.

But although words came easily to him and he wrote with enjoyment as well as precision, the digestive process took a long time; and time, as Maurice knew, was not on his side. For this reason, he wrote little, and only on those subjects which had a strong personal interest for him or were closely relevant to his teaching, painting or concern with education. Often seemingly disorganised because of his multifarious activities and his willingness at any time to discuss any one of them in depth, he had an astonishing capacity to interrelate and inter-involve the things and people that mattered to him most. It was not in his nature to be more selective among the activities themselves; indeed he would have been less vital and less influential as a person if it had been. From this fact also, it seems to me, emerges the real value of what he published. His is not the writing of an art critic or art historian but that of a practising painter and teacher attempting, with unusual success, to explore, analyse and elucidate for the practical benefit of himself and the reader.

David Herbert, Publishing Director, Studio Vista

Maurice de Sausmarez as a Teacher

Maurice de Sausmarez's contribution as a teacher is difficult to measure. The process of teaching which for him was never didactic but rather inspired consultation, gave an additional dimension to his life and complemented his essential work as artist. It is no surprise that this exhibition was initiated by students of the Byam Shaw School where Maurice, as Principal during the last seven years of his life, left his particular mark. He gave to teaching the passion and intelligence that informed his painting and writing: his integrity in all three fields was unqualified, his enthusiasm infectious. The dramatic changes and developments at the Byam Shaw which he brought about need no commentary here. His students remember the compassion and warmth, the concern for the individual and the humility of his teaching, the mesmeric presence, the shrewdness and range of his ideas. At criticisms and seminars his lifelong commitment to painting, combined with his agile and fluent mind to produce an astonishing flow of judgements, questions and probings. Maurice was concerned with the processes of art, communication

and teaching, never with authoritarian absolute conclusions.

To his many friends who were practising artists, Maurice gave his time and intelligence generously. Many of the distinguished cast of artists who have supported this exhibition owe him much. Such was his modesty that it would not have occurred to Maurice that they owed him anything.

Geri Morgan, Principal, The Byam Shaw School of Drawing and Painting

Of the students who came into contact with Maurice de Sausmarez, none could fail to respond to his warmth and sincerity; his enthusiasm must be recognised as one of the most important effects he had on the Byam Shaw School. However within the course that he designed, the emphasis is on the student discovering for himself, rather than waiting to be taught, and thus perhaps one of the most significant responses he provoked was to make the student feel the responsibility for imposing the most rigorous standards on his own work. That is not to say that everyone had to be a brilliant painter, but he did require that there should be nothing half-hearted about the student's activity. He demanded a degree of commitment as total as his own. In discussing a student's work he could be either gentle or somewhat ferocious, but they knew that it was always directed at getting from his students the best that they could possibly do. In organizing this exhibition the students of the Byam Shaw School hope in some measure to demonstrate their gratitude to and affection for him as much as do the artists who are contributing.

Michael Nye, Sally Politzer, Amarylis Pye on behalf of the students of the Byam Shaw School

In the same year, the Council of Management of the Byam Shaw School instituted the annual Maurice de Sausmarez Memorial Lecture. The first was given in March 1971 by Professor Richard Wollheim, who commented: 'Maurice de Sausmarez was a great teacher […] because he put so much not merely of his time and of his energy but of himself into his teaching. And I just find it hard to believe that he would have done this, and on the scale on which he did, if he had not somewhere sensed that in teaching art he was all the while learning about the nature of

that which he taught. And for this supposition there is direct testimony in his pedagogical writing. *Basic Design: the dynamics of visual form*, published in 1964, is a significant contribution to the literature of art education: it continues a tradition to which Kandinsky, Malevich, Klee and Josef Albers have been proud to belong: but it is something else as well. In addressing itself to the question, What should be the content of any course of instruction in the visual arts today?, *Basic Design* is in effect an inquiry into the nature of modern art. I insist that the coincidence of these two aims, that one fulfils itself through the other, is not an accidental feature of the book, nor one read into it by an interested reader.[68]

Nearly fifty years on, former students, younger colleagues and friends still remember Maurice de Sausmarez with great respect and affection. The words of some of them bring this volume to its close.

Roland Piché ARCA FRBS (student at Hornsey College of Art 1956–1960)

I am pleased and grateful to offer a tribute to Maurice de Sausmarez even though my actual contact with him was somewhat limited. His influence has been sadly overlooked and poorly represented, for he remains a significant figure not only for me but also for many artists and art students.

Strictly speaking Maurice was not one of my teachers but his level of commitment and in-depth contribution seemed to me to be exactly what I needed at Hornsey College of Art where I faced the same challenges. His clarity of purpose and vision was exemplary. I attended a lecture of his on the work and life of Vincent Van Gogh. This new kind of research, with evidence formally presented, repositioned this romantic visionary with detailed insight to reinforce Vincent's intellectual strategy. Maurice de Sausmarez demonstrated a speculative teaching and learning model that attracted a more critical dialogue in educational circles and began to underpin the work of many artists here and abroad.

I first met Maurice in the sculpture department at Hornsey College of Art in Crouch End on the hill. I had progressed from the two-year intermediate stage into the two-year major study of sculpture leading to the final exam. I think it was probably due to the fact that I had decided not to follow the final exam rules that Maurice was summoned to talk to me. As I remember, in order to gain the NDD award, all sculpture students from every institution were required to make a small maquette in clay, no bigger than 9 inches, based on a narrative, figurative idea plus a similar small life model, both to be cast in plaster. All would be sent to the Royal Academy in London for the final assessment chaired by a Mr Machin R.A. My discussion with Maurice de Sausmarez went from the ridiculous logistics of this to the fact that I wanted to make something more abstract than that prescribed. What was reassuring for me was that he listened and seemed sympathetic. The outcome of this was that I did what I wanted to do and passed.

The work being carried out by Maurice de Sausmarez and Harry Thubron and the students at Leeds School of Art was an intellectual volcano that became a wonderful catalyst to which so many British artists owe a debt. I remember one student from Leeds, Terry Bartlett, spending some time with me at Hornsey like an evangelist passionately discussing the implications and power of what was referred to as Basic Design, which like a whip spun my enthusiasm with its insights. Such value provided me with an added self-confidence and understanding which underpinned the structure of my teaching programmes for some forty years in Art Education as principal lecturer in charge of Sculpture at Maidstone College of Art and Canterbury School of Art.

Stuart Berkeley – painter and printmaker (student at Hornsey College of Art 1960–1964)

… I shall never forget his Art History lectures, peppered with magical pauses to roll a cigarette in licorice paper while a slide changed, as he reflected on the next insight he was about to give us. His foresight in gathering around him a team of the best young and established artists as lecturers had a profound effect on my art education … In my changing life post-Hornsey and the RCA, I was in need of constructive advice. A chance meeting with Maurice on the Northern Line triggered a letter of recommendation to William Hayter in Paris, who in

turn wrote a letter to Giorgio Upiglio, a masterprinter in Milan. Giorgio became pivotal to my career in Italy and beyond. These connections were a gift from Maurice.

David Noble – painter (student at the Byam Shaw School)

The interesting thing about being a student at the Byam Shaw School in the 1960s was that I never really felt like one. There was no hierarchical structure in the school and the interesting artists whom Maurice de Sausmarez attracted to the school were established practitioners in their own fields. There was a pervading congeniality and a postgraduate-like atmosphere ... The school felt very much like a creative community.

Those of us who joined his continental summer seminars in Italy and France had time to get to know him less formally and see more of his kindness and humour. He attracted much affection and respect because basically he liked everyone and treated each one of us with the same consideration and sensitivity. Could we ever forget those alcoholic picnics in and around Paris where crates of wine were unloaded from his camper van and we danced to the rhythm of road drills?!

When I was at the Byam Shaw I was really much too young to benefit enough from a giant like Maurice de Sausmarez. I have been thinking that if I could choose only one person in my life with whom to discuss my own many creative concerns, the confusing state of the art world now and its evolution since the 1960s, without question it would be him. With that thought I doubt if I'm alone.

Diana Armfield RA (lecturer at the Byam Shaw School)

Maurice was charismatic. He attracted devotion and loyalty from both staff and students. He chose his staff from a very wide range of outlook and talent, and once chosen they felt free to arrange the programmes for their given teaching days in their own way. For each member of staff, he seemed, while with them, to have every sympathy for what they hoped to achieve, to be at one with *them* particularly.

Staff and students found his complex personality fascinating, and so with admiration, mostly, and

affection, he was constantly talked about between them.

Looking back I know that he was directly instrumental in shifting me from being a wallpaper designer to a painter.

I taught at his request 'drawing for painting'. Although not a painter I thought I was aware, being married to Bernard Dunstan RA, of what was needed to be got down in a drawing, for starting off a painting, also aware of how to set about composing from the visual world. At the end of each summer term, Maurice held a staff meeting, to discuss the past year and plan for the future. Just as it was coming to an end he suddenly announced 'By the way, I want Diana to teach "painting from drawings" in the school.' I squeaked that I wasn't a painter, to which he simply replied 'Then you had better get on with it, you have the vacation before you.' I went home in a panic. Bernard said 'I'll make you a box and we will go to Arezzo to paint'. I never looked back!

Professor Peter Green OBE, RE

I first met Maurice de Sausmarez in September 1959. We had both been appointed to the former Hornsey College of Art in north London, Maurice to lead developments in Fine Art while I was to take up a post as senior lecturer in the post-graduate art teacher-training department. It was a meeting that was to lead to dramatically changing my understanding of art education – Maurice had that effect on people.

One of my first jobs at Hornsey was to take charge of the Saturday morning classes for local secondary school pupils, which had been running at Hornsey since the 1930s. The teaching had become rather moribund. Around 150 young people attended these classes, which in the main were taught by local secondary school teachers, largely replicating what went on in schools, and the overall result was rather dull, dated and insubstantial.

We decided to make drastic changes and I approached Maurice with a view to us launching some form of Basic Design studies. Maurice's advice and ideas were inspirational. It was not part of his brief at all but he gave up a great deal of time helping to construct a programme of work and encouraging us to re-evaluate visual education and bring a dynamic and critical element into the work. Subsequently the

classes were taught by post-graduate art teacher-training students, supported by a number of newly appointed part-time tutors. Numbers increased and the programme was popular, and a great success with the young students. Maurice was the guiding influence over the whole project. This was typical of his personal generosity when it came to helping young students and encouraging us to think critically about what we were doing and its relevance to the changing needs of art education.

Subsequently when Maurice moved to the Byam Shaw School as principal he asked us to help set up a basic printmaking facility at the school. We used to go down to the Byam Shaw on Tuesday afternoon and evenings with a group of art students and worked with him to set up a printmaking component of the basic design course. It was a wonderful experience and we learned a great deal. We were not expecting to get paid, it was just seen as an exciting and interesting thing to do as part of our art teacher-training course. But every so often Maurice would take you to one side and quietly slip a five pound note into your pocket, apologising that it was not more, as the school had such limited resources, but it was a typically kind gesture. We thought it was wonderful as it was the only time when we were actually paid cash for teaching!

Such gestures in a sense reflected Maurice's kindness and thoughtfulness. It was all part of his ability to establish a warm, relaxed and informal working relationship – and coincidentally a positive receptive platform for his ideas, which many students may initially have found intimidating and challenging. A friend, the artist Andrew Eden, recalls that about this time he applied to the Byam Shaw as a young 17 year old and was interviewed by Maurice with them both settled into two rather tired armchairs sharing toasted crumpets and tea!

Maurice de Sausmarez was at the centre of the dramatic changes that occurred in art education during the late 1950s and early 1960s. As he said in one of his articles in the *Motif* magazine at that time 'let's face it the artistic and intellectual development of students entering art schools in this country is abysmally low, and apart from acquiring a limited *know-how* in a specialized field of practice, four years in the art school adds little to their mental horizons … even the *know-how* has too often the aroma of mothballs'. Art school education was still set in the

arts and crafts tradition without, he said, 'connecting either to the great traditions of the past, the origins of modern art or the present time'.

It was in the context of these shortcomings in art education that Maurice helped lead the movement towards a more meaningful approach, introducing a more rigorous intellectual and critical approach to visual education.

In his seminal book *Basic Design: the dynamics of visual form*, published in 1964 and never since out of print, he sets out the 'changes and developments in the visual and plastic arts which necessitate the revision and extensions in the training of the young artist'.

His writing, lecturing and teaching formed a major contribution to the changes in art education in this period that began to take art schools into the twentieth century, with ultimately new graduate qualifications and university status.

But it was not just art school teaching that was dramatically affected by his teaching and writing. Art teaching in secondary schools was also significantly influenced by his work and publications. His book sold widely to secondary schools and art teacher training colleges. Throughout the 1960s I was involved in training secondary school art teachers and when visiting schools to assess teaching practice, every art department seemed to have a copy of Maurice's book, and it has clearly influenced generations of young art teachers and students.

However there was some hostility in art schools towards the changes proposed by the teaching of Basic Design. Established art school staff were often resentful and resisted any challenging change to their long held practices. The fact that eventually many of the ideas in basic design became a standard element, particularly in the teaching of foundation art school courses, was due not only to the effectiveness of Maurice's logic and argument, but also to his personal charm and kindly encouragement. He clearly had a persuasive argument but he presented it with such authority and infectious enthusiasm. He was always enthusiastic about what you were doing and he had incredible energy and drive. He was genuinely inspirational both in his personal support and teaching and also in his writing and lecturing.

He was, without doubt, a very significant voice in bringing about major changes in art education. In part he was successful due to the coherence of his

argument and ideas and the intelligent and kindly way it was all introduced, but he also had authority as a practising artist. He was not just an outstanding thinker and theorist about art education and its intellectual development, but also an established painter. This in no small way enhanced his credibility. Any hostility towards the implementation of his ideas from staff or students, was often ameliorated, not only by his personal charm but also by the recognition of his status as an artist. We may tend to forget his work as an artist, it can perhaps be overshadowed in our minds by his achievements as a critic, writer, thinker and educationalist. But he was a very special artist and it is certainly time that not only his writings, but also his work as a painter are reappraised and fully recognised.

Maurice's writings and paintings all actually make a very coherent whole; they are not separate elements but equal parts of the work of a very significant twentieth century artist/teacher.

He was, I recently discovered, an outstanding scholar of Nicolas Poussin's work (I think he wrote about him extensively) and when you look at Maurice's wonderful paintings you can see the intellectual clarity and structural order coming through his paintings. His landscape paintings for example, are not only very beautiful but echo in a subtle way, the wonderful underlying structure that you can see in Poussin's work. This sensitive, concise thinking, apparent in his paintings, is reflected in the similar critical clarity of his writings.

I owe so much to Maurice, as I am sure did many young teachers of my generation. He showed us a way to think about the visual world and how we could introduce young students to a critical rational experience of the plastic arts. He led the way for me towards understanding and questioning the role and nature of the visual arts in our modem world.

Wynn Jones (student at the Byam Shaw School then lecturer and Head of Painting)

From the moment I first met Maurice I was instinctively aware of being in the presence of an unusual and formidable man, a person of great warmth but with something quite steely in the direct, penetrating gaze. I was extremely nervous and unsure of myself in his company but, at the same time fascinated and excited. I had just come to London from Cardiff to take up the Jubilee Painting Scholarship at Byam Shaw and I was pretty naïve and unformed culturally; it became my great good luck to know Maurice shortly after he had become Principal of the school and at the height of his creative and intellectual powers. He had brought with him from Leeds and Hornsey the pioneering principles of Basic Design which formed the bedrock of the ideas that were to transform a long-established but conservative little art school in Kensington into one of the most dynamic in the country. Over the months and years that followed I came to regard Maurice as a mentor, a role model and something of a father figure; he was also my essential guide through the complex and multi-layered world of painting. His lectures were wide-ranging and inspirational, and he was able to call on the likes of Herbert Read and Anton Ehrenzweig as visiting lecturers. His enthusiastic engagement with culture was total, drawing on music and literature as well as art and all that time his incisive intelligence was ticking over, instructive but never dry and academic, his insight often touched by a gentle humour particularly in the more relaxed atmosphere of a pub, with a drink in one hand and his favourite San Toy cheroot in the other.

One of the most impressive and moving things about those early years at Byam Shaw was the way Maurice went about the task of change, making the school more relevant to the times; there were no ruthless, indiscriminate sackings, it was not his way to go around with 'I am the Light' written on his forehead; he took people along with him, worked with and persuaded them, always interested in the other side of the argument, the other person's beliefs. I would guess that his students of that time remember his humanity as much as his wise counsel.

Maurice was a tough-minded idealist, a passionate believer in the cause of art and art education, of art school as a fundamental, imaginative experience for life. How we could do with him now to reinvigorate a stale, moribund system; he left us far too early but at least he was spared the demise of his once proud art school, now swallowed up by Central Saint Martins and of peripheral interest. But his life and example remain an inspiration and his painting endures, solid, sensitive, reflective, like the man, defined by integrity.

Appendix 1 The Maurice de Sausmarez Memorial Lectures 1971–1990

March 18 1971 Professor Richard Wollheim: *The Art Lesson* Introduction by Professor Sir William Coldstream

March 16 1972 Robert Medley: *Answers to Unanswerable Questions*

March 22 1973 John Taverner: *The Music Lesson*

March 21 1974 Peter Cresswell: *The Dramatized Void*

March 20 1975 Jonathan Miller: *Authenticity*

March 24 1976 Germaine Greer: *Women Painters*

June 30 1977 Professor Laurence Gowing: *What is an Artistic Idea?*

March 16 1978 Frederick Samsom: *Who is Faust?*

March 29 1979 Richard Hoggart: *Mass Communications and the New Technologies*

March 27 1980 Keith Critchlow: *Space Time and Integrity*

May 20 1982 Melvyn Bragg: *Television and the Arts*

May 19 1983 Dr John Golding: *Matisse and the Fauves*

May 17 1984 Dr Griselda Pollock: *Modernity and the spaces of Femininity*

May 30 1985 Tom Phillips: *Dante: From Folio to Video*

May 29 1986 Tom Chetwynd: *Dreams and Symbols interpret Life*

May 28 1987 Professor Richard Gregory: *How we see and how you paint*

May 26 1988 Richard Cork: *David Bomberg: towards the spirit in the mass*

May 25 1989 Elizabeth Esteve Coll: *The Role of a National Museum 'You cannot educate, you cannot civilise men, unless you can give them a share in art ...? (William Morris)*

May 24 1990 Richard Hamilton: *Art 2001*

Appendix 2 Exhibitions

One-Man Exhibitions

1949

Paintings by Maurice de Sausmarez, Paul Alexander Gallery, Kensington Church Street, London

1951

Paintings by Maurice de Sausmarez, The Haworth Gallery, Crown Court, Wakefield

Selected Group Exhibitions

1935

Willesden Technical College Art Club Premier Exhibition

Artists against Fascism & War, called together by the Artists International Association & Eric Gill, Duncan Grant, Augustus John, Laura Knight, Henry Moore and Paul Nash, held at 28 Soho Square London WC1

Students' work from Schools of Art in London and London District organised by Winsor and Newton Ltd. held at Foyle's Gallery

1936

Exhibition of the Works of 15 Students' Sketch Clubs, Whitechapel Art Gallery

Spring Exhibition Willesden Technical College Sketch Club

Contemporary British Art, Birmingham Museum and Art Gallery, sponsored by Winsor and Newton

'de olympiade onder dictatuur' tentoonstelling: sport, kunst, wetenschap, documenten [The Olympics under dictatorship' exhibition: sport, art, science, documents], English Section, de Geelvinck Building, Singel 530, Amsterdam

1937

AIA 3rd exhibition *For Peace, Democracy, and Cultural Development*, (held in connection with the First British Artists' Congress) 41 Grosvenor Square

Willesden School of Art Sketch Club Annual Exhibition

Students' Group Exhibition, Royal College of Art

1938

New English Art Club 89th Exhibition

Students' Group Exhibition, Royal College of Art

1939

Royal College of Art Annual Exhibition

AIA Everyman Prints, held at the Picture Hire Gallery, 56 Brook Street, London W1

Unity of Artists for Peace, Democracy, and Cultural Development, AIA exhibition, Whitechapel Art Gallery

Works by the "Twelve and Thirteen" (National Society of Art Masters: Sussex Branch) Towner Art Gallery, Eastbourne

1940

AIA travelling exhibition, in association with CEMA (Council for the Encouragement of Music and the Arts), shown at the Morris Works, Cowley

The New English Art Club 91st Exhibition

1941

Contemporary British Art, CIAD exhibition, New York

1942

Second Exhibition of Drawings executed under the Scheme for Recording the Changing face of Britain, National Gallery London

The New English Art Club 93rd Exhibition

1943

AIA exhibition *Works For Liberty*, sponsored by the *News Chronicle*

Artists Aid China Exhibition, for Lady Cripps' United Aid to China Fund, held at the Wallace Collection, Hertford House

The New English Art Club 94th Exhibition

The London Group, 5th War-time Exhibition

1944

Third Exhibition of Contemporary Paintings organised by CEMA, Belgrave Square London

Art for All, second exhibition organised by the Midland Regional Designers' Group, held at Pearson Bros. Nottingham, as part of City of Nottingham Holidays at home 1944 programme

The New English Art Club 95th Exhibition, and NEAC *Selections* touring exhibition

The London Group, 6th War-time Exhibition

1945

P.E.N.Club Exhibition of Paintings and Drawings by Contemporary Artists, Leicester Galleries London

The New English Art Club 96th and 97th Exhibitions

AIA exhibition *This Extraordinary Year*, Whitechapel Art Gallery

The London Group

1946

Painters Today, AIA Painter-Members Exhibition, 56 Pall Mall

1947

Royal Academy Summer Exhibition, and *RA Selections* Touring Exhibition

The London Group

Contemporary British Art – A Selection of Paintings and Drawings "Crowded Out" from the Royal Academy Summer Exhibition, Grundy Art Gallery Blackpool.

The New English Art Club 100th Exhibition

Pictures to Live With, an exhibition of works by members of the AIA circulated under the *Art for the People* Scheme by the British Institute of Adult Education, for the Council for the Encouragement of Music and the Arts

1948

History of Lithography, Victoria & Albert Museum Circulating Exhibition

Royal Academy Summer Exhibition

15th Annual Exhibition of West Riding Artists, Cartwright Hall, Bradford

1949

Recent Paintings (group exhibition by former students at RCA), Paul Alexander Gallery, Kensington Church Street, London

1950

Royal Academy Summer Exhibition

1951

The New English Art Club 104th Exhibition

Royal Academy Summer Exhibition

Yorkshire Artists' Exhibition, Leeds City Art Gallery

Modern British Paintings, an exhibition collected and arranged for the Arts Council by the British Institute of Adult Education

West Riding Artists' 18th Annual Exhibition, Wakefield City Art Gallery

1952

The New English Art Club 105th Exhibition

Ilkley Artists' Exhibition

Royal Academy Summer Exhibition

Paintings and Drawings by Members of the New English Art Club, J.A. Tooth's Galleries, Cork Street, London

West Riding Artists 19th Annual Exhibition, Wakefield City Art Gallery

1953

Royal Academy Summer Exhibition, and *RA Selections* Touring Exhibition

Yorkshire Artists' Exhibition, Leeds City Art Gallery

Modern Art in Yorkshire, Wakefield City Art Gallery

Figures in their Setting, Tate Gallery

1954

Fifty Years of British Art, Cartwright Hall, Bradford

English Paintings and Drawings from the collection of C. Arthur Humphrey, Derby Museum and Art Gallery

Royal Academy Summer Exhibition, and *RA Selections* Touring Exhibition

1955

Royal Academy Summer Exhibition, and *RA Selections* Touring Exhibition

Self Portraits of Contemporary Painters, Ferens Art Gallery, Kingston-upon-Hull

1956

Maurice de Sausmarez, Terry Frost and Hubert Dalwood, Leeds University

The Seasons, Tate Gallery

1957

Royal Academy Summer Exhibition

Ilkley Autumn Exhibition

1959

Royal Academy Summer Exhibition, and *RA Selections* Touring Exhibition

1961

Malerei und Plastik aus Leeds, Stadthaus Untere Galerie, Dortmund

New English Art Club 114th Exhibition

1962

Royal Academy Summer Exhibition, and *RA Selections* Touring Exhibition

1963

Royal Academy Summer Exhibition

1965

Café Royal Centenary Exhibition 1865–1965

Royal Academy Summer Exhibition

Work by the Federation of British Artists, Richmond, Virginia.

1966

Royal Academy Summer Exhibition

Studies, Drawings and Sculpture in Contemporary Portraiture, Qantas Gallery Piccadilly

1967

Pictures for Schools, Diploma Gallery, Royal Academy of Arts

Royal Academy Summer Exhibition

Contemporary British Landscape Painters, Upper Grosvenor Galleries

Brighton Art Gallery Annual Autumn Exhibition

1968

Royal Academy Summer Exhibition

1969

The Nude, New Grafton Gallery London

Royal Academy Summer Exhibition

Stour Music Festival Art Exhibition, arranged by John Ward, held in All Saints' Church, Boughton Aluph

1970

Works exhibited posthumously at the Royal Academy Summer Exhibition and New English Art Club 123rd Exhibition

Bibliography

Unpublished Source Material

Maurice de Sausmarez Archive, held by his family

Leeds University Library Special Collections and Archive of the University

University of Leeds Central Records Office

Byam Shaw School Archives held at Central St Martins College of Art

The National Arts Education Archive, Yorkshire Sculpture Park

Hornsey College of Art Archive at Middlesex University

Online Sources

Oxford DNB

BBC Your Paintings in partnership with the Public Catalogue Foundation

British Newspaper Archive

Published Writings by Maurice de Sausmarez

Books

Basic Design: The Dynamics of Visual Form (London: Studio Vista, 1964)

Nicholas Poussin's 'Orpheus and Eurydice' (London: Cassell, 1969)

Ben Nicholson: A Studio International Special (London: Studio International, 1969)

Bridget Riley, (London & Greenwich: Studio Vista and New York Graphic Society, 1970)

Pamphlets

Look this Way, An Introduction to Paintings (London: National Association of Girls' Clubs and Mixed Clubs, 1946 & 1950)

Articles in journals, magazines and anthologies

'Post-War Mural Decoration', *The Artist* 26:1–6 (September 1943– February 1944), pp.17–19, 41–43, 65–66, 89–91, 113–115, 137–138.

'The Condition of Art and Crafts among Adolescents', *Club News* (October 1944), pp.2–3, 7

'Values through Expression', *Times Educational Supplement* (November 18 1944), p.555

'Releasing the Individual at Willesden School of Art', *Athene* (Journal of the Society for Education in Art) 3:2 (Spring 1945), p.70

'The Pen Drawings of Thomas Hennell', *Alphabet and Image* 4 (April 1947) afterwards printed in *The Art of the Countryman Thomas Hennell 1903–1945*, Arts Council of Great Britain (London 1948)

'Leeds College of Art', *Young Leeds* (Leeds Education Committee, 1949), pp.77–84

'Realism and the Principles of Decoration', *Journal of Decorative Art* (March 1950)

'The Camden Town Group', *Leeds Arts Calendar* 3:12 (Spring 1950)

'The Artist in a Scientific Society', *Universities Quarterly* 4:4 (August 1950) pp.360–366

'The Professional Artist's View', *Art Appreciation in Yorkshire* Leeds Office of the Arts Council of Great Britain (1950), pp.21–23

'A Note on Martin Froy's Work', *The Gryphon* [Journal of the University of Leeds] (Spring 1952), pp.25–31

'The Painter and the Analytical Attitude', *Studies and Researches* 11 (January 1955), pp.26–31

'The Place of the Arts in Contemporary Society', *Published Papers of the North of England Education Conference, Forty-third Annual Meeting* (1956), pp.20–28

'The Arts of Design', *Universities Quarterly* 10:2 (February 1956), pp.162–165

'Adolescent Art – the next Phase', *Athene* (1956)

'Art Education in Adolescence', *Studies and Researches* 15 (January 1957), pp.33–38

'Methods Change in Art – A reshaping of students' courses', *Yorkshire Post* (November 1958)

'Georges Seurat', *Leeds Arts Calendar* 42 (1959), pp.5–11

'Four Abstract Sculptors', *Motif* 5 (Autumn 1960), pp. 32–43

'Playing it Safe', *Motif* 4 (March 1960), pp.2–3

'Gestation of a Diploma' *Motif* 7 (Summer 1961), pp.2–3

'A Visual Grammar of Form', *Motif* 8 (Winter 1961), pp.3–29

A Visual Grammar of Form (2), In Three Dimensions', *Motif* 9 (Summer 1962), pp.47–67

'Diploma Daze' *The Guardian* (27 June 1963)

'Four drawings by Ben Nicholson', *The Connoisseur* 154:619 (September 1963), pp.32–36

'Four British Sculptors', *Motif* 12 (Winter 1964), pp.63–78

'Bryan Robertson's achievement at the Whitechapel', *Studio International* 177 (February 1969), p.58

'Landscape and Marine Painting', and 'How to Visit an Art Gallery, *Mind Alive* (Marshall Cavendish: London 1970)

Introductions and forewords for exhibition catalogues and books

Paintings by some members of the Camden Town Group, Lefevre Gallery London (1950)

The Paintings and Drawings of Isaac Rosenberg 1890–1918, Leeds University (1959)

Recent Figurative Painting, University of Nottingham Art Gallery (1960)

William Culbert Recent Paintings, Commonwealth Institute of Art London and Edinburgh (1961)

Bridget Riley, Gallery One London (1962)

William Culbert, Piccadilly Gallery London (1964)

Recent Paintings by Stella Marsden: Sea-Space-Sky, Upper Grosvenor Galleries London (1965)

Bill Culbert Paintings, Nottingham University Art Gallery (1965)

Carel Weight / Roger De Grey, Nottingham University Art Gallery (1966)

Ben Nicholson, New Works, Wash Drawings in Relief and Mixed Media, Marlborough Fine Art London (1968)

Bridget Riley's Working Drawings Bear Lane Gallery, Oxford (1969) afterwards reprinted in *Art and Artists*, 4:2 (May 1969) p.29

Margaret Benyon Nottingham University Art Gallery (1969)

Natalie D'Arbeloff's Workbook (Studio Vista: London, 1969)

Reviews

'Landscape into Art' [Sir Kenneth Clark], *Universities Quarterly* 4:2 (February 1950), pp.194–8

'The Van Eyck Problem' [Maurice Brockwell], *Universities Quarterly* 10:2 (1955), pp.103–4

'Mondrian's Vision' [David Lewis], *Yorkshire Post and Leeds Mercury* (May 1957), p.7

'A modern master of sculpture, Brancusi' [David Lewis], n.d.[1957]

'Rembrandt and the Gospel' [W.A.'t Hooft], *Scottish Journal of Theology* (Summer 1958)

'Dubuffet in Paris', *Motif* 6 (Spring 1961), pp.1–2

'The Mechanics of Perception' [Paul Klee, Johannes Itten], *Motif* 9 (Summer 1962), pp.98–99

'The Schools of Design' [Quentin Bell], *The Listener* 1794 (August 15 1963) p.248

'Royal Academy Summer Exhibition at Burlington House', *Studio International* 175:901 (June 1968), p.316

Radio Broadcasts

'Dissipated Octopuses: On the Teaching of Art to Adolescents' *The Listener* LXL:1567 (9 April 1959), pp.629–631

'Modern Art: The artist and public today', *Talks for Sixth Forms, BBC Broadcasts to Schools* (1960), pp.3–8

'Tradition and Experiment in Art 4. Cézanne'. *Notes for the Teacher* BBC Broadcasts (Autumn 1965)

Published letters

'Cezanne', *Journal of the National Society of Art Masters*, XI:9 (June 1939), p.236

'The Rooseveldt Memorial', letter sent to the editor of the News Chronicle, reprinted in AIA *Bulletin*, 92 (1947)

'The Camden Town Group', *The Listener*, 1134 (23 November 1950), p.597

'Holy Trinity Church Leeds' *Yorkshire Post* (23 October 1954)

Notes

1 Unpublished letter to Angela Lambert at Marshall Cavendish Ltd., dated October 21 1967 (Maurice de Sausmarez Archive).

2 'Releasing the Individual at Willesden School of Art', published in *Athene*, The Journal of the Society for Education in Art, Vol.3, No.2 (Spring 1945), p.70.

3 'Values through Expression – Experiment in a Junior Art School', TES, November 18 1944, p.555.

4 National Life Stories Artists' Lives, Bernard Gay interview by Melanie Roberts, British Library Board, Bernard Gay C466/57/01 F5897B Page 15.

5 Letter to Jessie de Sausmarez dated November 6 1949 (Maurice de Sausmarez Archive).

6 'The Place of the Arts in Contemporary Society', paper delivered at the North of England Education Conference 43rd Annual Meeting, January 1956, afterwards published in the North of England Education Conference, Harrogate 1956, pp.20–28.

7 John Ruskin, *Lectures on art delivered before the University of Oxford in Hilary term*, 1870 (Oxford: Clarendon Press, 3rd edition 1880), pp.3–31.

8 *Charles Darwin : his life told in an autobiographical chapter, and in a selected series of his published letters*, edited by his son, Francis Darwin (London: J.Murray,1902), pp.50, 51.

9 J.A.M.Whistler, *The Gentle Art of Making Enemies* (London: Heinemann, 1890), p.155.

10 The abbreviated Schopenhauer quotation comes from a much longer passage in *Die Welt als Wille und Vorstellung*, where he contrasts science with art: 'Science pursues the never-resting and unsettled stream of causes and effects and their fourfold form, so that once it has reached its goal it is always pushed onwards and never reaches a final goal. Science can never achieve complete satisfaction, just as by running one can never reach the point where the clouds touch the horizon, *whereas art, on the other hand, is everywhere at its goal. For art tears the object of its contemplation out from the stream of the world's dynamic, and has isolated that object before it.* That single object, that was a small shrinking part of that stream, becomes for art a representative of the whole, an equivalent of the infinite in space and time. So art remains focused on this single object. The wheel of time is suspended, and the inter-relations of the object are of no concern to art. Its only object is the essential, the idea.' *Die Welt als Wille und Vorstellung, Volume One, Third Book. The World as Representation, second observation: Representation, independent of the foundational sentence: the Platonic idea, the object of art §36.*

11 C.H. Waddington, *The Scientific Attitude* (West Drayton: Penguin, 2nd edition, 1948), p.172.

12 De Sausmarez does not cite his source, but it appeared originally in Sickert's review of the XIV exhibition of the International Society of Sculptors, Painters and Gravers, published in *English Review*, May 1912, and is reprinted in *Walter Sickert, The Complete Writings on Art*, edited by Anna Gruetzner Robins (Oxford; New York: Oxford University Press, 2000), p.312.

13 Kenneth Clark, *Landscape into Art* (London: J. Murray, 1949), p.16.

14 Waddington, (p.82).

15 George Sarton, *The Life of Science: Essays in the History of Civilisation* (New York: H. Schuman, 1948).

16 John Piper, *British Romantic Artists* (London: Collins, 1942), p.35.

17 R.G. Collingwood, *Outlines of a Philosophy of Art* (London: Oxford University Press, 1925), p.100.

18 Herbert Read, *The Grass Roots of Art* (1946) (London: Lindsay Drummond, 1947), p.71.

19 André Breton, *Manifeste du surréalisme* (Paris, 1924), p.21.

20 Cited in exhibition catalogue, *Matthew Smith: paintings from 1909 to 1953* (London: Tate Gallery, 1953).

21 Selections from the Notebooks of Leonardo da Vinci, edited by Irma A. Richter (Oxford: Oxford University Press, 1952), p.182.

22 Herbert Read, 'Conflicts in Contemporary Art', the third Annual Foundation Lecture delivered at Bretton Hall, Wakefield, 1953 (Wakefield: County Council of the West Riding of Yorkshire Education Committee, 1953).

23 Vincent van Gogh, *Further Letters of Vincent van Gogh to his Brother, 1886–1889* (London: Constable, 1929), Letter No. 504.

24 Etienne Charles, 'Les mots de Degas', in *Renaissance de l'art français et des industries de luxe* (Paris, 1918), No.2.

25 Read, *Conflicts in Contemporary Art*.

26 ibid.

27 Leonardo da Vinci, *Paragone: a comparison of the arts*, translated by Irma A. Richter (London: Geoffrey Cumberlege/Oxford University Press, 1949), p.49.

28 William Blake's letter to the Reverend Dr Trusler, August 23 1799, in *Poetry and Prose of William Blake*, complete in 1 volume (London: Nonesuch Press, 1927), p.835.

29 R.G. Collingwood, *The Principles of Art* (Oxford: Clarendon Press, 1938), p.273.

30 From a recorded conversation with Joachim Gasquet, in J.Gasquet, *Paul Cézanne* (Paris, 1926).

31 Cézanne's letter to Bernard, May 26 1904, *Paul Cézanne Letters*, edited by John Rewald, (London: B.Cassirer, 1941), pp.236–37.

32 The second part of the epigraph for *Caprichos*, 43, 1797–99.

33 Eugène Delacroix, *The Journal of Eugène Delacroix*, translated from the French by Walter Pach (London: J.Cape, 1939), p.194.

34 Vincent van Gogh, *The Letters of Vincent van Gogh to his Brother 1872–1886* (London: Constable, 1927), Letter No. 381.

35 D. H. Kahnweiler, *Juan Gris: his life and work*, translated by Douglas Cooper (London: Lund Humphries, 1947) pp.139–44.

36 Georges Braque, 'Pensées et réflexions sur l'art', *Nord-Sud*, X (1917).

37 Leon Battista Alberti, *De Pictura* (1435–6), Book 1.

38 *Bauhaus 1919–1928*, edited by Herbert Bayer, Walter Gropius, Ilse Gropius (New York: Museum of Modern Art, 1938), p.172.

39 *Vincent van Gogh, The Letters of Vincent Van Gogh to his Brother*, Letter No. 237.

40 Susanne K. Langer, *Problems of Art* (London: Routledge and Kegan Paul, 1957), p.70.

41 Letter to the Editor, published in *The Listener*, Vol. XLIV, No.1134, November 23 1950, p.597.

42 Letter written from Croagnes, September 3, 1968 (Maurice de Sausmarez Archive).

43 The interview was reprinted in *Bridget Riley: Works 1960–1966* (Ridinghouse in association with Karsten Schubert London and Hazlitt Holland-Hibbert, 2012).

44 *An Artist's Workbook: line, shape, volume, light* (London: Studio Vista/Van Nostrand Reinhold, 1969).

45 From Husserl's *Cartesian Meditations* (1931).

46 Frank Popper, *Origins and Development of Kinetic Art* (London and New York: New York Graphic Society, 1968), p.96.

47 Charles Biederman, *The New Cézanne: From Monet to Mondrian* (1958), p.65.

48 Bridget Riley, *Art News*, New York, October 1965.

49 ibid.

50 Maurice de Sausmarez, 'The artist in a scientific society', *The Universities Quarterly*, Vol.4, No.4, August 1950, pp.360–66 (p.362).

51 Charles Blanc, *Grammaire des arts du dessin* (Paris, 1967).

52 Paul Sérusier, *ABC de la Peinture* (Paris, 1921).

53 Percy Horton, introduction to the catalogue for the exhibition *Paintings by Maurice de Sausmarez*, held at the Paul Alexander Gallery, London 1949.

54 Marina Vaizey, 'Homage to Maurice de Sausmarez', *Arts Review* Vol.XXIII No.12, 19 June 1971, p.372.

55 Maurice de Sausmarez, 'Dissipated Octopuses: On the Teaching of Art to Adolescents', *The Listener*, Vol. LXL, No. 156 (April 9 1959), pp.629–63.

56 Ministry of Education, *First Report of the National Advisory Council on Art Education* (First Coldstream Report) (London, 1960); Ministry of Education, *Second Report of the National Advisory Council on Art Education*; 'Vocational Courses in Colleges and Schools of Art', (Second Coldstream Report) (London, 1962); Department of Education and Science, *Third Report of the National Advisory Council on Art Education*: 'Post-Diploma Studies in Art and Design' (Third Coldstream Report) (London, 1964).

57 The NDD was phased out gradually. The first DipAD was awarded in 1963 and the last NDD in 1967.

58 Department of Education and Science, Joint Report of the NACE and NCDAD: 'The Structure of Art and Design Education in the Further Education Sector' (London, 1970). For an account of student unrest at Hornsey see Lisa Tickner, *Hornsey 1968* (London: Francis Lincoln, 2008). For a contemporary account see Students and Staff of Hornsey College of Art, *The Hornsey Affair* (Harmondsworth: Penguin, 1969).

59 E.H. Gombrich, 'Reflections on teaching art history in art schools' paper given 4 January 1966. Accessed at https://gombricharchive.files.wordpress.com/2011/04/showdoc34.pdf on 15 May 2015.

60 Maurice de Sausmarez, *Basic Design: The Dynamics of Visual Form* (London: Studio Vista, 1964 repr. 1966), p.9.

61 ibid., p.10.

62 ibid., p.13.

63 'A Visual Grammar of Form' in *Motif 8* (Winter 1961), p.5.

64 Richardson's methods are described in her book, published posthumously, *Art and the Child* (London: University Press, 1948).

65 'Mr M. de Sausmarez Noted Figure in Art Education', *The Times*, 30 October 1969.

66 Vaizey, op.cit.

67 'Homage to Maurice de Sausmarez : An Exhibition of Works by Maurice de Sausmarez and Some of his Friends', catalogue of the exhibition held at the Upper Grosvenor Galleries, London, 16 June – 3 July 1971.

68 Richard Wollheim, 'The Art Lesson', the first of the annual Maurice de Sausmarez Memorial Lectures, given on 18 March 1971 (London: Studio International in association with the Byam Shaw School of Drawing and Painting Limited, 1971). The Memorial Lecture series continued until 1990. A full list of speakers and topics is given in Appendix 1.

Picture credits

Front cover image: Photo credit Douglas Atfield (DA)
Back cover images: Photo credit DA
Page 2 (frontispiece) Passport photograph c.1960/Photo credit DA

Chronology images
page 11 Bottom (B) © Peggy Angus Estate, photo credit DA
page 12 Top (T) photo courtesy Royal College of Art Archives
page 13 (T) Photo credit DA; (B) Courtesy of the Martin Bloomfield Collection/Photo credit DA
page 14 (T) Photo credit DA; Middle (M) Photo credit Hilary Diaper; (B) Photo credit DA
page 15 (T) Photo credit DA; (M) Courtesy of Yorkshire Post Newspapers; (B) Photo credit DA
Page 16 (T) Photo credit DA; (M) Courtesy of Yorkshire Evening News
Page 17 (T) Leeds University Alumni website
Page 18 (T) Courtesy of Hornsey College of Art Archive, Middlesex University; (M) Photo credit DA
Page 19 (T) Reproduced by permission of Historic England
Page 20 Photo credit Sandrini Junior – Vicenza
Page 21 (M) © David Noble 1968
Page 22 (T) Photo credit Nicholas Flower

Section 1 The Nature and Values of Art
Fig 2 © The Estate of Francis Bacon. All rights reserved. DACS 2015
Fig 3 Wikimedia Commons – Public domain
Fig 4 Photo credit DA
Fig 5 Photo credit DA
Fig 6 Philadelphia Museum of Art, The George W. Elkins Collection 1936

Section 2 The Painter's Eye
Fig 7 Cover illustration by Edward Bawden (1962), photo credit DA
Fig 8 Artist: Hennell, Thomas © Tate, London 2015
Fig 9 Artist: Hennell, Thomas © Tate, London 2015
Fig 10 © Leeds Museums and Galleries (Leeds Art Gallery) U.K 2003 Topham Picturepoint / TopFoto

Fig 11 © Leeds Museums and Galleries (Leeds Art Gallery) U.K/ Bridgeman Images
Fig 12 National Gallery of Art, Washington, Collection of Mr. and Mrs. Paul Mellon 1983.1.33
Fig 13 Photo credit DA
Fig 14 Photo credit DA
Fig 15 The Granger Collection, Yale University Art Gallery/Topfoto
Fig 16 © Frank Auerbach/image courtesy of Hartlepool Museums Service
Fig 17 Allen Memorial Art Museum, Oberlin College, Ohio, USA/ Gift of Joseph and Enid Bissett/ Bridgeman Images © ADAGP, Paris and DACS, London 2015
Fig 18 Photo credit DA
Fig 19 © Bill Culbert/Photo credit DA
Fig 20 © Bill Culbert /Courtesy of The University of Nottingham
Fig 21 © Carel Weight/Southend Museums Service
Fig 22 © Roger de Grey /photo credit: Newcastle University
Fig 23 RA Archives
Fig 24 © Margaret Benyon/UK Government Art Collection
Fig 25 © Margaret Benyon/image courtesy of Nottingham City Museums and Galleries
Fig 26 © Peter Sedgley/image courtesy of Leicestershire County Council Artworks Collection
Fig 27 Public domain
Fig 28 a, b, c Photo credit DA
Fig 29 © Ben Nicholson/courtesy by La Malcontenta, Venice
Fig 30 © Angela Verren Taunt 2015. All rights reserved, DACS / image courtesy of the British Council Collection
Fig 31 © Henri Cartier-Bresson/Magnum Photos
Fig 32 Photo credit Errol Jackson/ Reproduced by permission of The Henry Moore Foundation
Fig 33 Artist: Unknown, Photographer © Tate, London 2015
Fig 35 © Bridget Riley 2015. All rights reserved, courtesy Karsten Schubert, London. Photo credit John Minshull
Fig 36 © Bridget Riley 2015. All rights reserved, courtesy Karsten Schubert, London.
Fig 37 © Bridget Riley 2015. All rights reserved, courtesy Karsten Schubert, London.

Fig 38 © Bridget Riley 2015. All rights reserved, courtesy Karsten Schubert, London/British Council Collection

Section 3 The Art of Maurice de Sausmarez
Fig 39 Private collection/Photo credit DA
Fig 40 Private collection courtesy of Liss Llewellyn Fine Art
Fig 41 Photo credit DA
Fig 43 The Stanley and Audrey Burton Gallery, University of Leeds (University of Leeds Art Collection)
Fig 44 The Stanley and Audrey Burton Gallery, University of Leeds (University of Leeds Art Collection)
Fig 45 The Stanley and Audrey Burton Gallery, University of Leeds (University of Leeds Art Collection)
Fig 46 Photo credit DA
Fig 47 Leeds Museums and Galleries (Leeds Art Gallery) U.K. / Bridgeman Images
Fig 48 Ferens Art Gallery: Hull Museums
Fig 49 Photo credit DA
Fig 50 Photo credit DA
Fig 51 Photo credit DA
Fig 52 Photo credit DA
Fig 53 The Hepworth Wakefield (Wakefield Council Permanent Art Collection)
Fig 54 Private collection/Photo credit Graham Kirk
Fig 55 Photo credit DA
Fig 56 Photo credit DA
Fig 57 Torre Abbey Historic House and Gallery
Fig 58 Photo credit DA
Fig 59 Photo credit DA
Fig 60 Photo credit DA
Fig 61 Photo credit DA
Fig 62 Photo credit DA
Fig 64 Photo credit DA
Fig 65 Photo credit DA
Fig 66 Photo credit DA
Fig 67 Photo credit DA
Fig 68 Photo credit DA
Fig 69 Photo credit DA
Fig 70 Photo credit DA
Fig 71 Photo credit DA
Fig 72 Photo credit DA

Section 4 Fostering the Creative Impulse
Fig 73 Photo credit DA
Fig 74 a,b,c Photo credit DA
Fig 75 Photo credit DA
Fig 76 Photo credit DA
Fig 77 Photo credit DA
Fig 79 © David Noble 1966

Index

Index